# POLYMER CLAY
# COLOR INSPIRATIONS

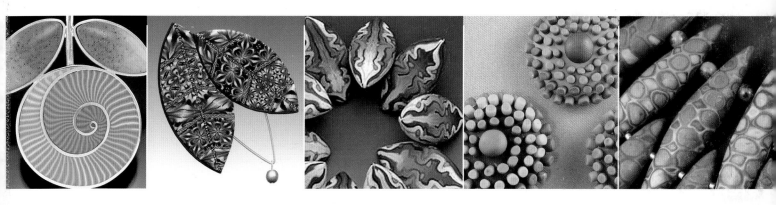

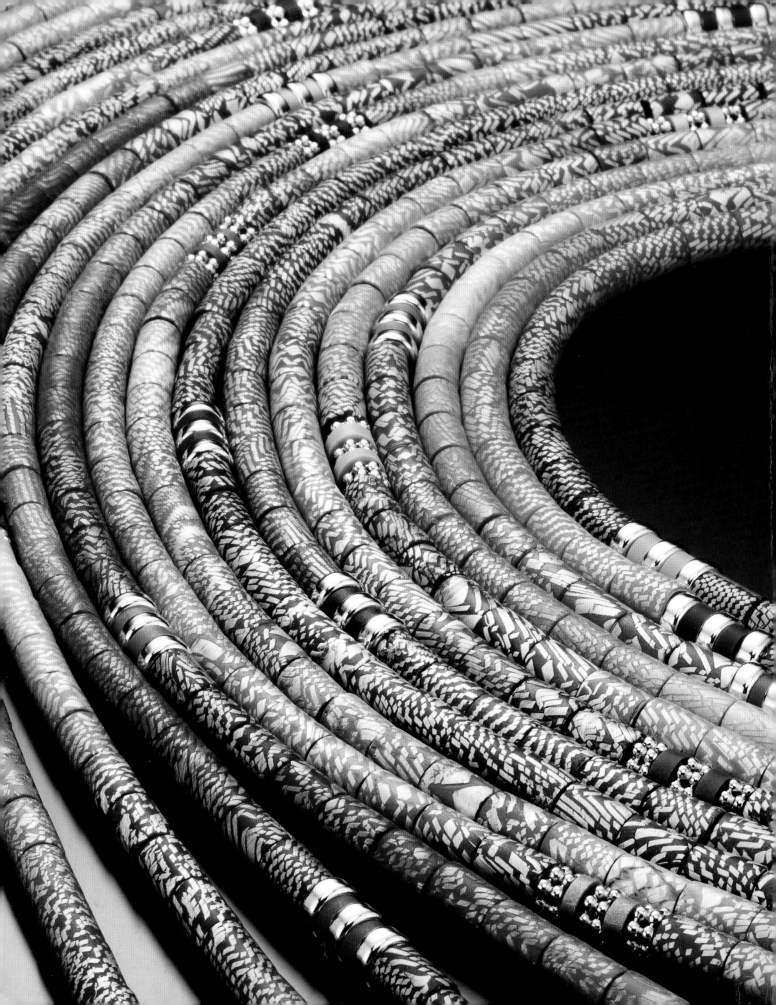

# POLYMER CLAY
# COLOR INSPIRATIONS
## TECHNIQUES AND JEWELRY PROJECTS FOR CREATING SUCCESSFUL PALETTES

Lindly Haunani and Maggie Maggio

Foreword by Cynthia Tinapple

WATSON-GUPTILL PUBLICATIONS / NEW YORK

## ACKNOWLEDGMENTS

WE ARE BOTH DEEPLY grateful to be part of a community of polymer clay artists who continue to explore, innovate, and generously share their discoveries. Over the years our workshop students have taught us an enormous amount. A special group of artists, "The Color Explorers"—Dayle Doroshow, Jan Frame, Judy Kuskin, Hollie Mion, Carol Simmons, and Cynthia Tinapple—provided the ongoing encouragement we needed to write this book. Homage must be paid to our dear friend Judith Skinner, who invented the Skinner blend, which is integral to many of the techniques presented in this book. Two artists no longer working in polymer clay also deserve our special thanks for sharing their insights: Laura Liska and Pier Voulkos.

Thanks are also in order to three of the polymer clay manufacturers—Eberhard Faber, Polyform Products, and Van Aken—who generously donated the clay that was used for the exercises, projects, and charts included in this book.

We deeply appreciate the patient support and technical assistance we have received from Chuck Maggio, Annie Maggio, Monica Maggio, David Vanover, our project editor Patricia Fogarty, and our editor Joy Aquilino.

**Editorial Director:** Victoria Craven
**Executive Editor:** Joy Aquilino
**Editor:** Patricia Fogarty
**Art Director:** Jess Morphew
**Designer:** DelicARTessen Design
**Production Director:** Alyn Evans

First published in 2009 by Watson-Guptill Publications,
an imprint of the Crown Publishing Group,
a division of Random House, Inc., New York
www.crownpublishing.com
www.watsonguptill.com

Library of Congress Control Number:2009920543

ISBN: 978-0-8230-1501-6

Unless otherwise specified, photographs are by Doug Barber.

Typeset in Nexus Mix

Printed in China

1 2 3 4 5 6 7 8 9 / 17 16 15 14 13 12 11 10 09

# CONTENTS

# FOREWORD

YOU MAY THINK YOU'LL never "get" color the way Lindly and Maggie do, but don't let the weight and complexity of this book fool you. If you read a bit, play with some color exercises, and push through your resistance to color theory, your work and your understanding will take a giant leap forward.

As in all disciplines, it takes just one glimmer of recognition for learning to begin. Whether your approach to color is visceral or cerebral, through your head or your hands, you'll benefit immensely by following along as Lindly and Maggie share the secrets they've learned from their years of research.

In the 1990s, I edited their early articles for the National Polymer Clay Guild newsletter. Scrutinizing their grammar forced me to read and reread the articles, and I began to understand color. For years after that, I arranged to sit near Lindly and Maggie at conferences and classes because I knew that at some point, the oracle would speak. As I muddled and fussed with a design, over my shoulder I'd hear a calm voice say, "Add blue," or "You have only middle values. A light and a dark will help." My goal has been to internalize that oracle.

Every day I browse through hundreds of designs and sculptures on the Web, as I hunt for good polymer clay art examples for my blog PolymerClayDaily.com, which is frequented by artists around the globe. What I've found is that excellent color can rescue a mediocre design. And color that's off the mark or muddied can ruin the finest concept. Your palette becomes your signature.

That signature is very personal. It's tied to culture and geography and weather. It shifts with latitude, with attitude, and with age. Learning about color means learning about yourself.

Read through the concepts in this book. Some exercises will seem elementary. Do them anyway. Some won't make sense to you. Trust them and experiment a little. I guarantee that if you persist, you'll hear the oracle.

—Cynthia Tinapple

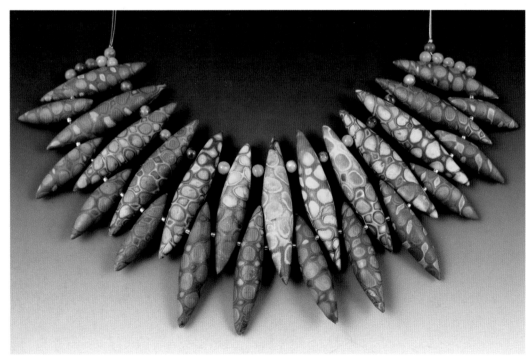

**JUDY DUNN.** *Shibori Collar.* 28 inches long. Polymer clay, blue-dyed lace agate beads, rhodium-plated seed beads, nylon-coated bead cord, and sterling silver friction clasp.
"The pattern on the surface of these beads reminds me of the patterns found in shibori—subtle variations in color, lines and borders that feather. The beads combine in a variety of ways, creating a flow of dashes, lines, rays, sometimes static and sometimes kinetic."
Photo by Judy Dunn

WE HAVE FOUND COLOR TO be the most challenging and directly expressive way of imparting voice and message to our work. While we share the same ultimate goal when working with color—to create successful color combinations—there are differences in our approaches.

Maggie is fascinated with the analysis of color systems that have appeared throughout history. Her library contains hundreds of books about color. She is always asking "why?" and conducting color experiments to find the answers. She considers polymer clay the best medium for exploring the various systems' strengths and shortfalls while attempting to simplify a very complex subject. This is evidenced in her unique base-mixing system for making color-mixing scales using polymer clay.

Lindly is inspired by the visceral and emotive potentials of working with color. Her approach to color is informed by her lifelong passion for cooking. She prefers to rely on her experience and intuition—as in a bit of this, a bit of that, taste, then adjust. When designing a color scheme, she is often inspired by the different interlocking colors of food as they appear in a recipe, season, or cuisine.

There are times when we "miss the mark." When a color choice turns out to be too strident or passive when combined with other colors, we need to make adjustments in our mixes, try new colors or adjust the proportions. How we arrive at our "solutions" is as different as our unique personalities and our personal color preferences. For both of us, the underlying concepts are the same—combine knowledge with instinct, take time to gain perspective while looking closely, and be prepared to make adjustments.

### Learn to trust your instincts, while relying on swatches.

Through your life experiences you have learned a lot about your color preferences and have compared colors while making choices many times. Shopping for clothes is a great example. Suppose you want to buy a red sweater to match a pair of pants in your wardrobe. You could conduct an analysis of the color of the pants and make a list of possible "red" color matches. In a more likely scenario, you take the pants to the store and hold them next to the red sweaters and decide which one looks "right." In the same way, when

you are working on a polymer clay project, having a number of swatch variations available will allow you to make more instinctual color choices.

### The "rules" are not always helpful and are meant to be broken.

Suppose you look at a color wheel and, going by the rule "Complementary color combinations offer vibrant, exciting contrast," decide to work with yellow and purple. While the "rule" may be helpful as a starting point, it doesn't give you a clear idea about how to proceed in making your ultimate color choices. As you make your way through this book, you will identify your favorite colors and learn how to use them as starting points to design successful color schemes that include the hue, value, and saturation contrasts that please you.

### Do the work.

The exercises and projects in this book are cumulative and geared toward increasing your confidence as you put colors together in your own projects. Each lesson expands upon the concepts and skills presented in the previous lesson(s). However, reading about something is rarely a substitute for actually learning and experiencing it hands-on.

### Remember to have fun.

You will enjoy some parts of the process more than others. If you are a gatherer, amassing all the supplies, tools, and materials will be fun for you. Or you might love collaging but hate mixing colors to exact recipes using the color scales, or vice versa. Remember, you will not be graded on how fast you complete the exercises, on how neat your clippings are, or on the colors you love to work with.

This book will show you how to make a series of invaluable reference tools that you can use in your studio. It is also intended to guide you, through the exercises and projects, as you analyze your personal color preferences, mix a personal palette, study how colors interact with each other, and use colors confidently in carefully orchestrated, harmonious combinations.

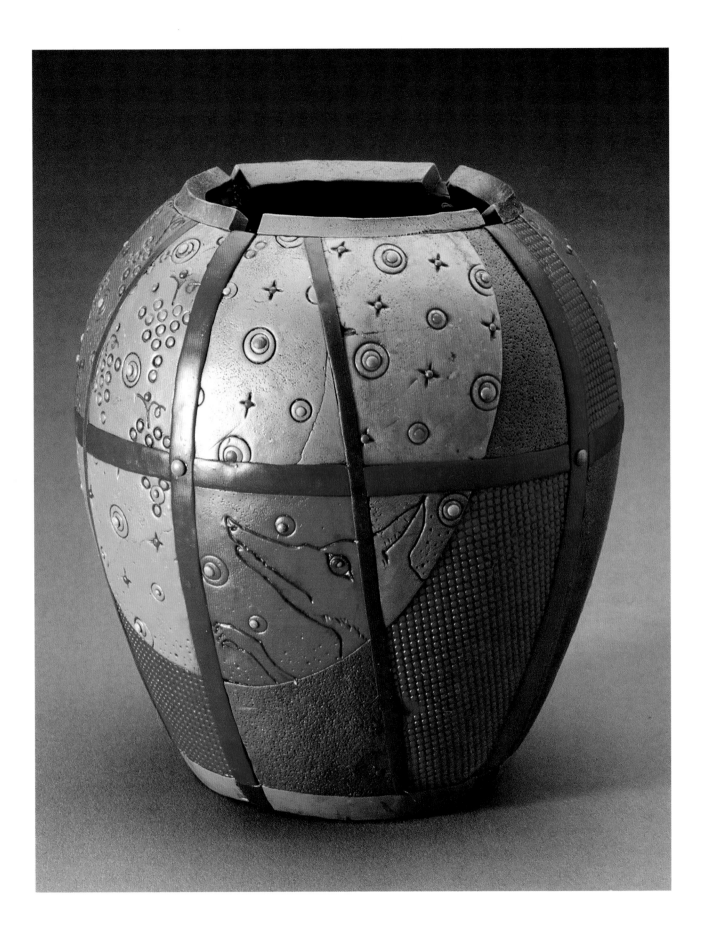

CHAPTER ONE

# Polymer Clay Color Basics: A Primer

ONE WONDERFUL ASPECT OF WORKING with polymer clay is that you don't need to have a lot of expensive equipment and tools on hand to begin working with the material. Of course, if you are an artist who enjoys collecting new tools and materials, there are a lot of specialized products available in the marketplace. You should be able to find everything you need to execute the projects and exercises in this book at a large art-supply or craft-supply store, either locally or online. Your local hardware store, kitchen-supply store, or variety store are other possibilities.

# POLYMER CLAY TOOLS AND SUPPLIES

BELOW ARE BRIEF DESCRIPTIONS of the tools and supplies you will need to do the exercises in this book, to make the studio tools, and to complete the projects. In some instances, we've provided several different options, selected from our favorites.

## Clay

Polymer clay is a polyvinyl chloride (PVC) thermosetting modeling compound that hardens at about 275 degrees F. There are many brands available; each has slightly different working characteristics, baking temperatures, and surface reflectivity.

For the exercises and projects in this book, we are using opaque polymer clay. Many of the projects were executed using Polyform's Premo Sculpey brand clay because it comes in a range of warm and cool primary colors and is fairly easy to condition.

Before baking, polymer clay can be sculpted, impressed with textures, or molded. One of the most popular techniques for working with polymer clay draws inspiration from the ancient Venetian hot-glass technique, in which rods of colored glass are bundled to form three-dimensional pictures. These bundles are then heated and pulled lengthwise to reduce the size of the image. Once cooled, these *millefiori* (Italian for "a thousand flowers") *canes* of glass are sliced and applied to beads or vases or used to make the interiors of glass paperweights.

It is easier to make a cane with polymer clay than with glass, since, before baking, there is no heat involved. Work using polymer clay doesn't necessarily involve flower images, and often includes flat sheets of clay, so polymer clay artists have simplified the term *millefiori cane* to *canework* and just plain *cane*. Simply defined, a polymer clay cane is a length of clay with a pattern that runs through it from one end to the other. After baking, a polymer clay cane can be drilled, sanded, polished, carved, and cut with a sharp knife.

Polymer clay can be compared to cheese and wine—all continue to age after leaving the factory, farm, or winery. There is an optimal time window of several years during which the clay is not too soft to work with and has not become too hard and crumbly to easily "condition." The clay is sensitive to heat and light, and should be stored away from direct sunlight in a cool room. Since it bakes at a relatively low temperature (275–325 degrees F), avoid mail-ordering clay in the height of the summer or leaving it in a closed car, as it can begin to bake and harden.

Several manufacturers offer polymer clay in liquid form that can be used as a polymer clay "glue." You can use the liquid clay to attach unbaked clay to baked clay or to attach baked clay to baked clay.

## Work Surface

Our favorite work surface is a 2 x 3–foot piece of white Formica mounted on a piece of plywood. The white Formica doesn't interfere with the look of colors, and the surface doesn't dull cutting blades. Avoid working with polymer clay directly on wood furniture, as it reacts unfavorably with many types of wood finishes.

Other options for work surfaces: Plexiglas, glass, ceramic tile, or a flexible plastic cutting mat.

## Pasta Machine

While it is possible to sheet and blend clay by hand using a rolling pin, a pasta machine makes things a lot easier and faster. Good sources are garage sales, large craft stores, and kitchen-supply stores.

## Rolling Tool

You will also need a handheld roller to help adhere stacked sheets of clay to one another. Our favorite is a solid Plexiglas (acrylic) rod 1 inch in diameter and 8 inches long. Other

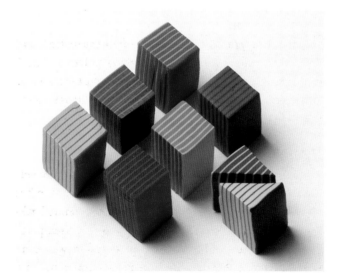

**EIGHT POLYMER CLAY STRIPE CANES**
Note that the stripes run through the entire solid.

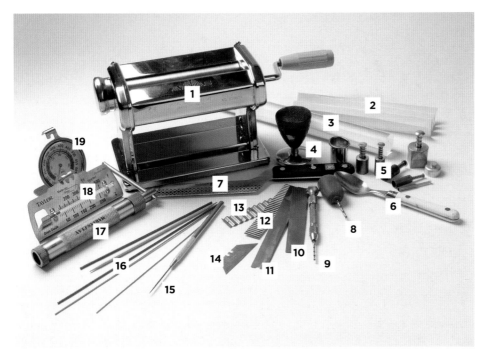

options: a glass bottle or vase, a pastry rolling pin, or a clear plastic brayer.

## Cutting Blade

In our studios, we use many different cutting blades, including blades designed for microsurgery and an X-acto knife with a #11 blade. There is one blade that we both use almost all of the time. This "tissue blade," ¾ wide x 4⅝ inches long, is very sharp, thin, and flexible, and it can be sharpened. If you are just starting out working with polymer clay, there is no need to have more than one cutting blade.

## Shape Cutters

To aid in cutting and measuring your polymer clay, you will need a set of small circle cutters and a ¾-inch square cutter. You could substitute small canapé or cookie cutters of a similar size, but Kemper brand cutters, designed for use with ceramic clay, have a plunger that makes removing the clay much easier.

## Bead Mandrel

To make the pivot tube beads in the project in Chapter Two (see page 36), you will need a metal rod ⅛ inch in diameter x 8 inches long to use as a mandrel (a support around which you will form the beads). Your local hardware store should have a selection of brass rods available. Another alternative is to use double-pointed, aluminum knitting needles.

## Extruder

An extruder is a tool with three main parts: A cylindrical barrel holds (in this case) clay. Attached to the end of the barrel is a metal disk with a die-cut hole. A plunger pushes the clay in the barrel through the hole in the disk. The extruded clay conforms to the profile of the hole.

For the projects in this book, a small aluminum extruder, preferably with a metal screw arm for added torque, will suffice, along with a basic die set that includes a ¹⁄₁₆-inch circle and ¼-inch square.

## Baking Support

A sheet of heavy cardboard or picture framer's matte board works very well as a support for baking polymer clay. A bead-baking tray may be fashioned from poster board or an index card by folding the sheet or card lengthwise, accordion style.

## Oven Thermometer

An oven thermometer is essential, as the temperature settings on ovens can vary widely, and some ovens have hot spots. Always follow the manufacturer's recommended baking temperature. Polymer clay that is baked at a temperature that is too low will not cure properly and may become brittle and break. Polymer clay baked at a temperature that is too high is subject to adverse color shifting and possibly scorching.

## Oven

One option is a separate convection oven or toaster oven dedicated exclusively to baking polymer clay. If you are just getting started or don't have room for a separate oven, it is possible to use your home oven; if you do, make sure not to bake the clay in an open container. Many artists place their clay inside a polymer clay–dedicated covered roasting pan before baking.

## Storage

Plastic wrap and plastic sandwich bags are great for storing polymer clay; they allow you to see the color inside and won't react with the clay.

> **NOTE**
> Polymer clay reacts with hard plastics, such as those used in CD jewel cases.

CLAYS AND GLUES

## String

Your necklaces and some of your color samples will need to be strung together. Black waxed-linen cord, available at most large craft stores and bead stores, works well for this task.

## Glue

Two different types of glue are used in this book. We use fast-curing superglue in finishing some of the projects. For the final project (your collage box), if you choose a wood base you will need a PVA white glue, such as Sobo, to help adhere your clay pieces to the wood.

## Cleaning Supplies

Warm polymer clay has a tendency to stick to your hands, and you will need to remove it—especially when you are mixing color samples and want to avoid contaminating your mixtures with the clay on your hands. You may want to use a good-quality hand lotion and a stiff towel to remove the bulk of the clay before washing your hands with cold water and a mild soap.

To clean your tools and work surface, isopropyl alcohol on a paper towel works well.

## Supplies for the Exercises and Studio Tools

To carry out the exercises and create the studio tools provided throughout this book, you will need:

- AN EXTRA-FINE-POINT PERMANENT MARKER (THE SHARPIE BRAND IS THE BEST FOR WRITING ON BAKED POLYMER CLAY)
- INDEX CARDS: 4 X 6 INCHES, PREFERABLY UNLINED (TO MAKE TEMPLATES AND BAKING SUPPORTS)
- SKETCHBOOK PAPER OR PLAIN WHITE WRITING PAPER
- POSTER BOARD: 11 X 17 INCHES
- GLUE STICK
- SCISSORS
- 1-GALLON AND SANDWICH-SIZE PLASTIC STORAGE BAGS
- ¾-INCH SQUARE CUTTER
- ³⁄₁₆-INCH CIRCLE CUTTER
- ½-INCH CIRCLE CUTTER
- ¾-INCH CIRCLE CUTTER
- 1½-INCH CIRCLE CUTTER

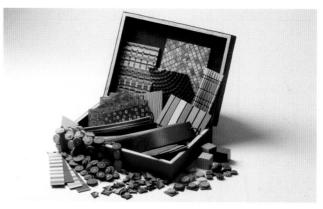

COLOR BOX WITH STUDIO TOOLS

Maggie Maggio's color inspiration box, filled with a selection of the tools presented in this book, including fan decks, push and pull stripes, color scales, and contrast tables.

Photo by Bob Barrett

# ESSENTIAL TECHNIQUES

THIS SECTION PROVIDES THE basic information that you need to start creating with this exciting medium and how to handle (condition, leach, and sheet) polymer clay, as well as how to measure and label it.

## Conditioning Polymer Clay

Just because a piece of clay, upon being taken from its package, is soft and easy to roll into a sheet does not mean that it is ready to use. All polymer clays must be conditioned prior to use to help realign the particles. This helps make the clay optimally malleable for use and the strongest it can be after baking.

If you were to take just one concept from this book and embrace it when working with polymer clay, it should be: *The amount of time it takes to properly condition clay before using is the same as the time it takes to thoroughly mix two colors together.*

Rather than rely on the prepackaged colors available from manufacturers, we recommend that you mix the exactly perfect colors of polymer clay for use in your projects while you condition your clay.

**CONDITIONING CLAY**
In this sequence, ½ ounce of blue and 1½ ounces of yellow clay are rolled into logs, then made into a bundle of four snakes that eventually becomes a blended green.

A good way to condition clay is to roll and twist a snake of clay on your work surface. For example, start with 2 ounces of clay—½ ounce of blue and 1½ ounces of yellow. Roll each color into a log, then group the four logs into a bundle. Twist the logs together and roll it back into a snake on your work surface.

Once the snake gets to be about a foot long, cut it into four pieces and recombine them by restacking them into a bundle. Repeat this at least twelve times or until a ½-inch-diameter snake 4 inches long can be folded in half without exhibiting any cracking or internal stress marks when cut in two. Or, if—as in this case—you are mixing two colors while conditioning, repeat until the yellow and blue clay are totally blended.

Another way to condition clay (and mix colors) is to use a pasta machine. Roll the clay through the pasta machine to make a sheet. Fold this sheet in two and insert it into the machine fold side first, which helps avoid the formation of air bubbles in the clay. Repeat this twenty times to adequately condition the clay. By then the colors will be blended.

Depending on the brand of clay, once conditioned it should be ready for immediate use for several weeks or easily "tuned up" with a few passes through a pasta machine. Properly stored (wrapped in plastic and away from heat and light), polymer clay canes (three-dimensional design patterns) can remain useable for up to a year.

## Leaching Polymer Clay

There may be times, depending on the brand, when polymer clay is very soft and sticky and difficult to work with. Leaching some of the plasticizer out of the clay will make the clay stiffer. Sheet the clay (see below) and place it between two sheets of plain white printing paper, then place a weight on top of this stack; a heavy book works well. Allow this stack to rest for an hour or until there is an oily residue on the paper. The clay will then be easier to work with.

## Sheeting Polymer Clay

Pasta machines are available in many different makes and models. The rollers range from 3 to 12 inches wide. Pasta machines have between six and nine thickness settings. These thickness settings are not standardized. The thickest sheet setting on some machines is indicated as setting #1, while on others the thickest setting is #9.

The instructions in this book are calculated to work with a 5½-inch-wide pasta machine and three sheet thicknesses: thickest, medium, and thinnest. The dial number corresponding to each of these three thicknesses is different depending on the pasta machine you are using. For example, even though

we have the same make and model pasta machine (an Atlas 150), our two machines were manufactured in different years, and the settings are not the same. On Lindly's machine, the dial settings are #1 (thickest), #4 (medium), and #6 (thinnest). On Maggie's, the correlating dial settings are #1 (thickest), #5 (medium), and #8 (thinnest).

Take a moment to examine your pasta machine. By moving the thickness dial you can vary the space between the rollers, determining just how thick a sheet will be formed. The setting that corresponds to the thickest setting is the one at which the rollers are farthest apart. To find your settings, run a piece of clay at the thickest setting and cut out a 1 x 1–inch piece. Move the dial one setting at a time until the piece of clay is twice as long, or close to 2 inches. This is your medium setting. Run this piece through the remaining settings until it is twice as long again, or close to 4 inches. This is your thinnest setting. On some machines the thinnest setting may work for pasta dough but be too thin for polymer clay. If your clay shreds and sticks to the rollers, the setting just before that point is your thinnest setting.

### Measuring Clay

Some manufacturers package polymer clay in grams and some in ounces. The amounts of clay we specify (in ounces) for the projects, exercises, and studio tools are approximate, but they insure that you will have enough clay prepared to successfully complete the project. To convert grams to ounces, multiply the number of grams by 0.035; to convert ounces to grams, multiply the number of ounces by 28.35. Or use the instant converter at www.metric-conversions.org.

In order to successfully make Skinner blends (much more on these below), you need enough clay to accurately fold the sheet in half lengthwise multiple times and align it with the rollers in your pasta machine. For some of the projects in this book, you will need only a portion of the Skinner blend that you will make according to the instructions. You may opt to save leftover pieces to use in an upcoming project or experiment with variations on the current project.

All brands of clay are sold in small blocks of approximately 2 ounces each, and most are also available in 1-pound bricks. Most manufacturers score the surface of the blocks of clay to make measuring easier.

Manufacturers make 2-ounce blocks of clay in different shapes. These blocks can be cut into ½, ¼, ⅛, and 1/16 parts by first cutting the block in half, then cutting that piece in half, etc. (see Measuring Clay). Note that a block of Studio by

FIMO
56 GRAMS - 2 OUNCES

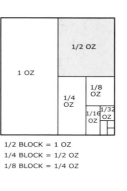

1/2 BLOCK = 1 OZ
1/4 BLOCK = 1/2 OZ
1/8 BLOCK = 1/4 OZ

SCULPEY III
and PREMO!
56 GRAMS - 2 OUNCES

KATO
56 GRAMS - 2 OUNCES

STUDIO by SCULPEY
79 GRAMS - 2.8 OUNCES

**MEASURING CLAY**
Blocks of clay can be cut into ½, ¼, ⅛, and 1/16 parts. The full-size template for your use in cutting clay appears on page 132.

Sculpey clay is 2.8 ounces and needs to be cut down to 2 ounces, as shown in the diagram, before you measure it into parts for the exercises and projects in the book.

### Using Templates and Worksheets

For the exercises and projects throughout the book, we suggest that you make and use a variety of templates, fashioned from card stock, as aids in cutting and laying out clay. For the templates that are simple rectangles, we provide the dimensions but don't show an illustration. For the two Skinner blend templates (see much more below), we provide an illustration that shows the overall external and internal measurements.

We also provide a few charts—the Classic Color Sorter (page 133), the Color Scales Worksheet (page 136), and the Color Triangle Worksheet (page 137)—to help you see the

# How Confident Are You in Working with Color?

HERE'S A SHORT QUIZ designed to rate your color confidence and experience level. Take this quiz twice—before you begin working through the exercises in this book and after you have completed them.

| Circle one number, with 5 indicating "yes/most/always" and 0 "no/the least/never." | | |
| --- | --- | --- |
| I have read more than one book on color designed for artists. | | 0 1 2 3 4 5 |
| People often comment favorably on my ability to choose and combine colors. | | 0 1 2 3 4 5 |
| I have taken a college-level course on designing with color. | | 0 1 2 3 4 5 |
| When I see a color, I know exactly how to mix it using pigments. | | 0 1 2 3 4 5 |
| I am confident combining colors. | | 0 1 2 3 4 5 |
| I am never disappointed with my color choices. | | 0 1 2 3 4 5 |
| I am familiar with the vocabulary of color. | | 0 1 2 3 4 5 |
| I am aware of my preferences regarding contrasts of hue, value, and saturation. | | 0 1 2 3 4 5 |
| I often use color in my environment or choice of clothes to uplift my spirits or to provide a sense of calm. | | 0 1 2 3 4 5 |
| I have downloaded the Pantone seasonal color forecast and understand how this relates to color choices in the manufacturing sector. | | 0 1 2 3 4 5 |

## Add up your scores. If your score is . . .

40–50: You probably feel very comfortable choosing, mixing, and combining colors and enjoy working with color. Remember to challenge yourself to try new color combinations and experiment with hues, contrasts, and saturations outside your comfort zone. If you always do what you always did, you will always get what you have already done.

30–40: You feel somewhat comfortable mixing colors and making color choices, but sometimes feel overwhelmed or in a quagmire when asked to try different approaches. The pivot-mixing exercises in Chapter Three may help you codify your preferences and provide a starting point for explorations.

20–30: You often feel challenged when making color choices and may find yourself returning to the same color combinations because they have worked in the past. Challenge yourself to try making color collages, as presented in Chapter Four, that include colors you don't like.

10–20: You often feel overwhelmed when making color choices. Remember to be gentle with yourself and to work at your own pace as you play through the exercises in this book. Be ready to be amazed by your expanded awareness and attunement to the colors around you as your confidence grows.

relationships of colors, and it can be helpful to use these as work surfaces during the projects. To use the charts as sorting guides and work surfaces, photocopy them onto card stock, and have them laminated.

## Labeling Samples

As you build your reference library of polymer clay color samples through the exercises and studio tools in this book, you will want to label your samples. While some of your baked samples may be large enough to write on with a permanent marker, a pie chart, made from polymer clay that indicates the base colors used to mix a sample is a "visual" label that is very helpful as a reference.

Sheet the polymer clay to be used for these labels on your thinnest pasta-machine setting and cut it into circles, using a circle cutter that is slightly smaller than the piece you wish to attach it to. To label a sample green mixed with three parts zinc-yellow and one part cobalt-blue, cut a circle of each color. Out of the yellow clay, cut out a pie-shaped wedge that is one-quarter of the circle. Then, out of the blue clay, cut a pie-shaped wedge that is one-quarter of the circle and place it in the empty spot in the yellow circle. Press lightly to adhere.

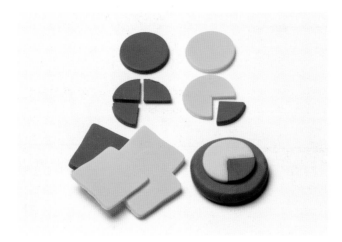

PIE-CHART LABELS MADE FROM POLYMER CLAY

## Test Twists

To preview a color combination, twist two or more small snakes of polymer clay together. With this method, you do not have to commit to a larger quantity of clay to see how the colors will look together. Twisting the resulting rope tighter at one end lets you preview how the differences between the colors will look at a smaller scale.

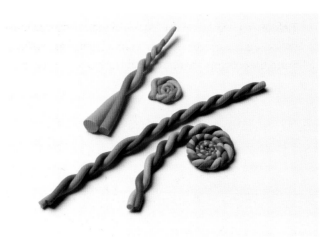

TEST TWISTS

## Skinner Blends

The method of blending sheeted clay in a pasta machine was first presented to the polymer clay community in 1996 by Judith Skinner, a pioneering computer programmer who brought her mathematical troubleshooting talents to polymer clay. Since then there have been several adaptations and refinements to the technique. Here you will make two different Skinner blends—a basic (two-color) blend and a rainbow (three-color) blend.

## Basic (Two-Color) Skinner Blend

The easiest way to make a smooth transition between two colors is to make a two-color Skinner blend. These blends may be used as flat sheets or used to make canes. A basic Skinner blend can be used in many different ways. For example, it might become a rolled log or an accordion-fold, stacked sheet.

| MATERIALS | |
|---|---|
| | • 2 OUNCES OF PURPLE CLAY |
| | • 2 OUNCES OF WHITE CLAY (THE LIGHTER CLAY PICTURED IN THE STEPS BELOW IS WHITE MIXED WITH ¹/₁₆ OUNCE OF ULTRAMARINE) |

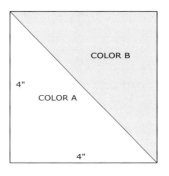

BASIC (TWO-COLOR)
SKINNER BLEND TEMPLATE

Before you begin, use card stock to make a square template measuring 4 x 4 inches, and mark a diagonal as shown in the Basic (Two-Color) Skinner Blend Template illustration.

the same direction. If you inadvertently make a quarter turn before folding, you will end up blending the two colors into one new color.

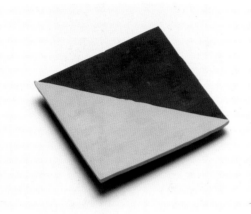

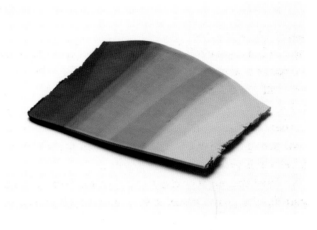

**1.** Condition and then sheet two different colors of polymer clay using the thickest setting on your pasta machine, making sure the two colors have the same stiffness. If one of the colors is not as soft and supple as the other, continue folding that sheet in half and rolling it through your pasta machine; do this ten times or until its consistency is similar to the softer sheet. Cut the two sheets into equal-size squares using the square template you made. Then cut the squares in half on the diagonal. Reassemble these triangles into squares, two sheets thick, of the same color.

**3.** The top photo shows two colors partially blended. In the bottom photo the colors are fully blended.

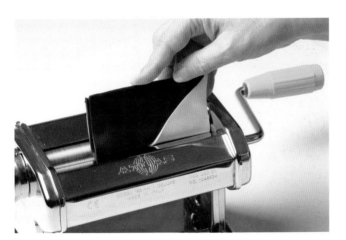

**2.** Adhere the seams of the two new squares by pressing gently, and roll them through your pasta machine. Then fold the sheet in half while aligning the edges. Insert this sheet—fold side first, with both colors touching the rollers—into your pasta machine, and roll through again. Continue to fold and roll the sheet through at least fifteen times or until it is blended. *Important:* Keep rolling and sheeting the blend in

## Rolled Skinner Blend Log with Wrap

A rolled Skinner blend log with a contrasting wrap, in this case black, makes for a dramatic graphic element by itself as a cane or as part of a more complex millefiori cane.

**MATERIALS**

- ½ OUNCE OF PURPLE POLYMER CLAY
- ½ OUNCE OF BLACK POLYMER CLAY
- A BASIC SKINNER BLEND SHEET TO WRAP

**3.** Trim the lightest end of the blend even. Using a pea-size ball of the lightest clay, fashion a snake about $1/32$ inch in diameter. Place this snake of clay at the farthest edge of the lightest clay, and use it to help in rolling the blend up into a tight cylindrical cane.

**1.** Using your cutting blade, trim the edges of your blend sheet. Cut a 1-inch-wide strip that includes all the colors of your blend. Roll this sheet up, starting at either the lightest or darkest edge, to form a round log. Since the blending happens over a relatively short distance across the section, the slice will appear as a spiral.

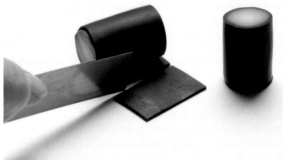

**4.** Roll the resultant cylinder gently until the seam disappears. Fashion a sheet of clay at least the width of your cane on your pasta machine's medium setting, using a contrasting color that you have chosen. Pictured here is a dark purple that is a mixture of ½ ounce of purple clay and ½ ounce of black. Trim the front edge even. Place the Skinner blend cane on the front edge of this sheet of clay, attach the edge to the cane, then gently roll forward past where the seam should be. Roll the clay backward, and using a bright side light, trim the clay where the edge made a demarcation on the sheet. Join the two edges together, and roll gently through the entire circumference to obliterate the seam.

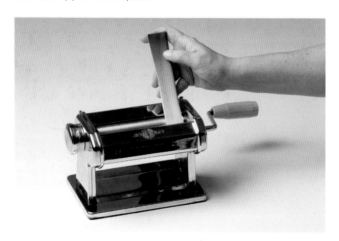

**2.** To achieve a more subtle blend, lengthen your blend before rolling it up. Fold the Skinner blend in half lengthwise so that the light edges are together. Reduce the thickness setting on your pasta machine to medium and, starting with the light end of the blend, roll the sheet through.

## Accordion-Fold Stack

Instead of rolling a Skinner blend, you can stack it to create a square log of polymer clay.

### STACK BLEND

**1.** Sheet your blended sheet on your pasta machine's thickest setting. Using your cutting blade, trim the edges of your blend sheet. Fold your Skinner blend in half lengthwise, so that the light edges are together. Reduce the thickness setting on your pasta machine to medium and, starting with the light end of the blend, roll your sheet through. You now have a thin, long sheet of clay.

**2.** Trim the lightest end square, and allow the first 2 inches of the sheet of clay to rest on your work surface. Fold the rest of the sheet back onto the clay on the work surface and, allowing it to adhere to that sheet, press gently. Continue folding, accordion style, until all the clay is stacked up.

**3.** Press all the layers together gently, using an acrylic brayer or rod to eliminate any air pockets, and trim the edges.

## Rainbow (Three-Color) Skinner Blend

A great starting point when making projects and designing canes is a rainbow Skinner blend. When made with yellow, blue, and magenta, the blend contains a large range of colors—including violets, greens, and oranges.

Before you begin, use card stock to make a rectangular template measuring $5\frac{1}{2}$ x 4 inches, and mark diagonals as shown in the Rainbow (Three-Color) Skinner Blend Template illustration.

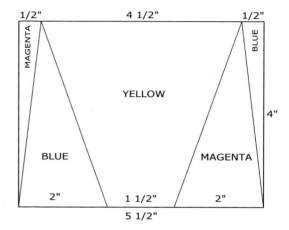

RAINBOW (THREE-COLOR) SKINNER BLEND TEMPLATE

| MATERIALS | |
|---|---|
| | • 1 OUNCE OF MAGENTA POLYMER CLAY |
| | • 1 OUNCE OF BLUE CLAY |
| | • 2 OUNCES OF YELLOW CLAY |
| | • RAINBOW SKINNER BLEND TEMPLATE |

**1.** Thoroughly condition all three colors separately, and sheet them at the thickest setting on your pasta machine. Using the rainbow Skinner blend template, cut out the triangles as indicated, then realign them into a rectangle.

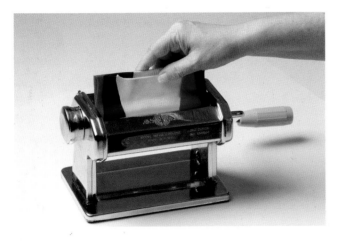

**2.** Press gently to adhere all the seams, align the sheet with your pasta machine so that all three colors are touching, and roll them through the machine at the thickest setting. Aligning the magenta to the magenta and the blue to the blue, fold your sheet in half. Align all colors so that they touch the pasta machine fold first, and roll through again.

**3.** After ten folding passes, your blend will look similar to the upper blend in the photo. Notice how even though there is twice as much yellow in the blend, the pure yellow is beginning to disappear as it blends on one side to green and on the other side to orange. After about twenty-five folding passes, your rainbow Skinner blend will look like the lower blend in the photo.

> **NOTE**
>
> For some of the projects in this book, you will make a rainbow Skinner blend that doubles this recipe to incorporate 8 ounces total of polymer clay. Using the rainbow Skinner blend template, cut two pieces of each segment, then assemble them as pictured with step 1 above so that each segment is two layers of the thickest sheet your pasta machine makes.

## Attaching a Pin Back

A small piece of polymer clay, patterned or not, is a nice way to finish off the backs of your pieces and attach a pin back. Roll a small sheet of polymer clay out on your pasta machine's medium setting. Using the internal width of your pin back as a guide, trim the piece into a rectangle that is slightly shorter than the pin back and 1 inch wide. Open your pin back and place it on the piece. Then center your cut rectangle over the base of the pin back. If you are applying the pin back to an unbaked pin, firm pressure is all you need to make the connection. Pressing a piece of sandpaper on top of the added rectangle of clay adds textural interest and eliminates any fingerprints you have made in the clay.

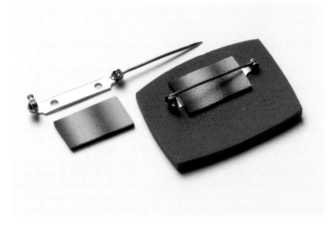

ATTACHING A PIN BACK

There are times when you will want to attach a pin back to an already baked piece of clay. The mosaic brooch (see page 106) features multiple bakings. In cases such as this, you can use liquid polymer clay (see page 10) as "glue" to hold the two pieces together. Apply a small drop of liquid polymer to the small rectangle, spread it thinly using a cotton swab or your fingertip, then put the pin back in place before baking to cure the liquid polymer clay.

WHILE SEATTLE ARTIST Cynthia Toops has always been fascinated with beads, it was Lois Sherr Dubin's book *The History of Beads* that catapulted this fascination into a passion and career. Cynthia fell in love with the Roman face beads on the cover and was inspired to make her own versions. During a visit to her native Hong Kong, she discovered polymer clay and immediately saw its potential for reproducing ancient glass beads. Cynthia is also inspired by eighteenth-century Italian micro-mosaics, as well as the elaborate works of Mexico's native Huichol people, who embed seed beads in hot wax. Adapting these styles to polymer clay, Cynthia developed techniques that work for her and are "simple and very low-tech."

The very thin "threads" that Cynthia uses in her work create a fine texture that gives depth to her intricate micro-mosaic pieces.

*Color is usually the first consideration in my jewelry. I find myself drawn more to muted/tertiary colors than primary hues. Perhaps they seem more complex and richer to my eye. Sometimes the color of a piece could be inspired by a physical object like the moss on a stone, or sometimes it could be a memory, perhaps a scene in a movie or the summer sky at twilight. Since I often collaborate with Dan Adams, who works in glass, where the color palette is more limited, and even though polymer clay allows you to mix any color you desire, I often plan in terms of what is possible with the glass. In mosaic work, free from the constraints of glass, my palette is often a more saturated, complex combination of colors.*

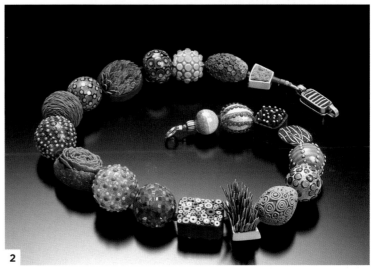

**1.** *Orange Rolodex Bracelet.* 4 x 4 x 4 inches. Polymer clay. Cynthia used more than 150 flat beads to make this bracelet. By cutting the edges in an offset pattern and arranging the cuts so they don't shingle evenly, she created a dynamic texture.

**2.** *Flora 11 Necklace.* 20 inches long; largest bead 1½ x 2 x ¾ inches. Polymer clay, glass by Dan Adams, and silver. Cynthia and her husband, Dan Adams, often collaborate on projects. Alternating the glass, silver, and polymer clay in this piece adds the contrast of surface reflectivity.

Photos by Roger Schreiber (top) and Doug Yaple (bottom)

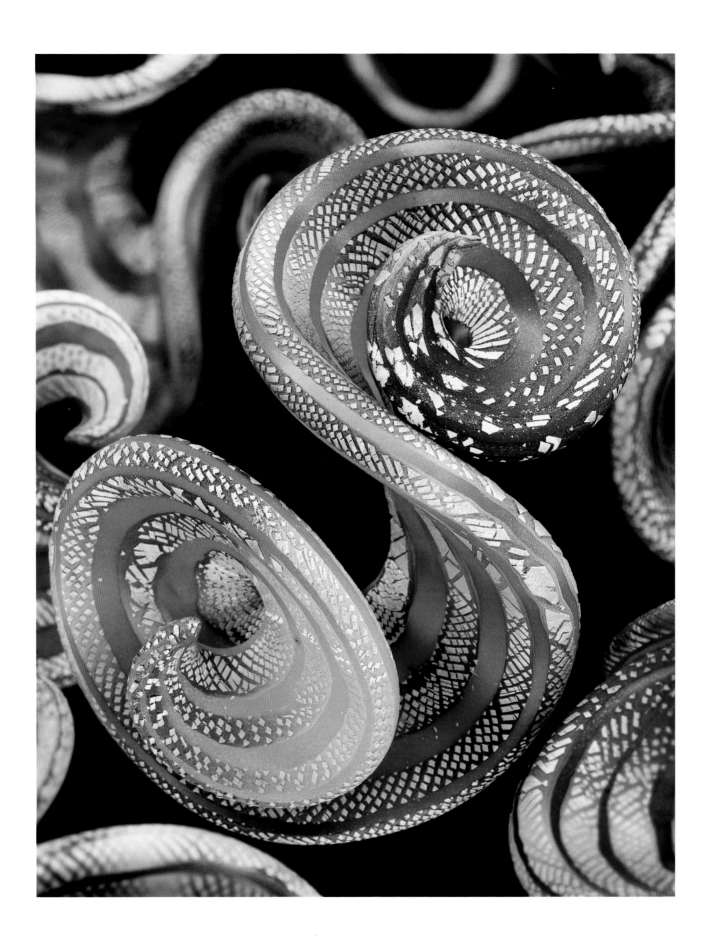

CHAPTER TWO

# Understanding the Three Properties of Color

WORDS USED TO DESCRIBE COLORS can be very evocative ("Miami sunrise") or literal ("the color of fresh salmon") or abstract ("a very light, slightly muted orange-red"). Each of these ways of describing color has a place. When you want to talk about the feelings generated by colors, subjective color terms may be a good choice. When you want to describe colors more specifically, objective terms are the way to go. The language of color is not standardized, but there are a few key terms that are universal. "Hue," "Value," and "Saturation," are used to define the three properties of color.

# THE FIRST PROPERTY OF COLOR: HUE

THE TERM "HUE" IS often used interchangeably with the word "color." You might ask a friend "What is your favorite color?" What you are really asking is "What is your favorite hue?" Physicists define hue by measuring wavelengths. Artists define hue by the color's family name.

## Hue Families

The traditional hue families are Red, Orange, Yellow, Green, Blue and Violet. (See Traditional Color Wheel—RYB.) The primary colors in this system—colors that cannot be made by mixing with any other colors—are Red, Yellow, and Blue. The secondary colors—colors made by mixing two primaries together—are Orange (Red and Yellow), Green (Yellow and Blue), and Violet (Blue and Red).

A contemporary alternative to the traditional six-hue families is the CMY system. (See Printers' Color Wheel—CMY.) The six contemporary hue families include Cyan, a light blue; Magenta, a deep pink; and Yellow. These are the three primary colors of ink used in printers. The secondaries of the CMY system are Blue (Cyan and Magenta), a blue-violet color; Red (Magenta and Yellow), a red-orange color; and Green (Yellow and Cyan), a grass green color.

We combined the traditional and contemporary versions of the hue families into a triangular diagram that makes mixing colors more accurate and more intuitive. We call the three primaries Magenta, Yellow, and Blue and show them on the corners of the diagram. We call the three secondaries Orange (Magenta and Yellow), Green (Yellow and Blue), and Violet (Blue and Magenta) and show them between the primaries. The center of the diagram is called "mud"—a name we use for the neutral color that results when all the hues are mixed together. One of the most basic rules of color theory is to show complementary colors opposite each other. Complementary colors are defined as colors that "complete" each other. The complement of each primary color is the color that is mixed from the other two primaries. (See Polymer Clay Hue Families with Complementary Colors.)

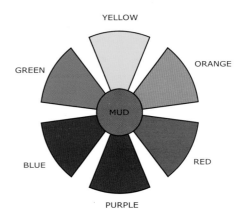

**TRADITIONAL COLOR WHEEL—RYB**
The traditional primaries of colorants were red, yellow, and blue. The traditional secondaries were orange, green, and violet. This system is still taught in many schools and used by many contemporary artists.

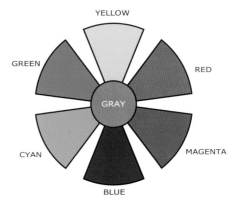

**PRINTERS' COLOR WHEEL (THEORY)—CMY**
The switch to using cyan, magenta, and yellow as subtractive primaries began as a result of the development of color photography in the early 1900s. Using CMY colors that are similar to the light secondaries produces a larger range of colors than RYB primaries.

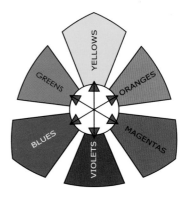

**POLYMER CLAY HUE FAMILIES WITH COMPLEMENTARY COLORS**
Finding the exact complementaries is not as important as knowing the range of colors that are visually opposite each of the hues.

# COLOR SORTERS

IT HELPS TO HAVE a way to sort colors into hue families while you are working in your studio. For our Basic Color Sorter, we expanded the six polymer clay hue families to include two versions of each hue based on color bias. (See Basic Color Sorter Showing Hue Biases.)

## Temperature and Bias

In our workshops, we often talk about colors as warm or cool, but color temperature is one of the most controversial concepts in color theory. Some artists like to think of temperature as a fourth property of color. We prefer to think of it as a modifier of hue. It's the temperature of a hue that determines its bias.

The purest versions of the primary colors are not shown on our color sorter; you have to imagine them at each corner of the triangle. Instead of three pure primaries, we show the two biased variations of each primary, one on either side of the points in the triangle. On the lower left we have the blues, with colors ranging from a warm turquoise through a cool ultramarine. Other blue colors, like cobalt and brilliant blue, are not shown, but they fall between the turquoise and the ultramarine. On the lower right are the magentas, with colors ranging from a cool fuchsia to a warm cherry red. On the top of the triangle are the yellows, with colors ranging from a cool lemon to a warm sunshine.

The secondaries are also shown as a range of colors. Violets range from a cool blue-violet to a warm purple. Oranges range from a cool tomato-red, a red that turns orange when white is added, to a warm yellow-orange. The greens range from a warm lime to a cool emerald.

Is it possible to find three perfect primaries in polymer? Not really. Manufacturers try to make colors that come close, but perfect pigment primaries do not exist in any medium. Because of this we have an assortment of colors in polymer clay that come close to pure blue, magenta, and yellow, and each of these can be used as primaries. (See Polymer Primaries and Secondaries Chart, page 138.)

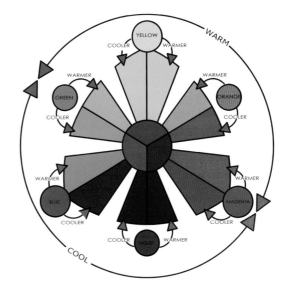

**COLOR TEMPERATURE**
A hue's bias can also be thought of as its temperature. The coolest color is ultramarine-blue, and the warmest is yellow-orange.

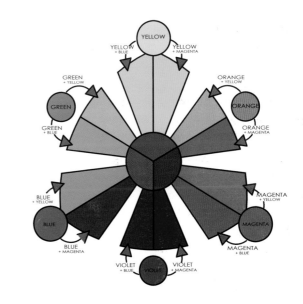

**BASIC COLOR SORTER SHOWING HUE BIASES**
There is no such thing as a pure hue. Every hue has a "bias," a little bit of another hue that causes it to lean toward that color.

Just as there's no such thing as a perfect primary, there's no perfect "mud." Instead of showing black or gray in the center of the diagram, we show three neutral colors—colors made from mixing variations of the three primaries in almost equal amounts. In order to help you visualize these colors, we give distinct names to each of the three muds that come from the primaries. We call the mud in the yellow section "ochre," the mud in the blue section "gray," and the mud in the magenta section "brown."

The Basic Color Sorter can be expanded to show the earth colors that fall in the zone between the outside of the triangle and the muds in the middle. Just as the diagram implies, earth colors are the rainbow colors that have been mixed with some amount of mud. The colors closest to the outer edge will be less muddy than the colors closest to the center. (See Classic Color Sorter.)

In addition to serving as a framework for an understanding of color, a laminated color copy of the Classic Color Sorter can be used as a palette to help keep your polymer clay colors organized. It can also be used to sort any small pieces of clay that you have mixed and not used in a project, in anticipation of auditioning the colors for future projects or using them as mixing components.

Each of these variations of hues—rainbows, earths, and muds—can be lightened, or tinted, by adding white or another very light neutral. Tinting changes the feelings evoked by the colors; the pastel versions have a softer, lighter feel. The Pastel Color Sorter (see illustration) is the tinted version of the Classic Color Sorter.

## NAMING COLORS

MANY COLOR SYSTEMS USE abstract color names that come from modifying the hue name; for example, instead of caramel, they would call the color in that section of the sorter a dark, or shaded, yellow-orange. We prefer to use specific names that conjure up mental images so that you can visualize the colors more easily and, we hope, more intuitively connect with the feeling of the colors. By giving these sections their own names we have awarded them some status as colors in their own right. You may not agree with the names we use. Feel free to label them with names that mean something to you.

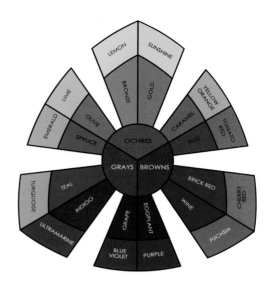

**CLASSIC COLOR SORTER**
This expanded color sorter divides each hue family into two variations of the six hue families and shows the rainbow and earth colors for each of these twelve colors. It also shows three muds in the middle—yellow mud (ochres), blue mud (grays), and magenta mud (browns). The full-size Classic Color Sorter appears on page 133. Copy it at full size and laminate it, then use it to sort clay into the different hue families.

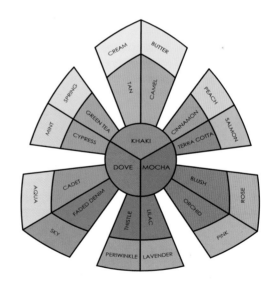

**PASTEL COLOR SORTER**
This color sorter is the tinted version of the Classic Color Sorter.

# THE SECOND PROPERTY OF COLOR: Value

VALUE IS THE AMOUNT of light reflected by the color. Value is commonly shown using a vertical scale with black at the bottom and white at the top. Just as we use the term families to describe hues that are similar, we can also describe colors with similar values as belonging to a value family.

The *value scale* we use is divided into five *value families*: white, light, medium, dark, and black. (See Value Scale.) Colors that fall into the light value family are called high-value colors because they reflect the most light. Dark colors are low-value colors that reflect the least light.

You can shift the value of a color in a number of different ways. If you make it lighter, you are "tinting" the color. If you make it darker, you are "shading" the color. These shifts can be slight variations that keep the color in the same value family, or they can be major changes that move the color into a different zone on the value scale.

A common misconception is to imagine that all pure colors are the same value. Many color charts encourage this misconception by showing the pure colors across the middle, with above and shades below. In reality, each of the pure hues has a different value. For example, pure yellows are much lighter in value than pure violets. (See Value Comparison Charts.)

If you understand where each of the pure hues falls on the value scale, you can mentally move the color along the value scale as you tint and shade it.

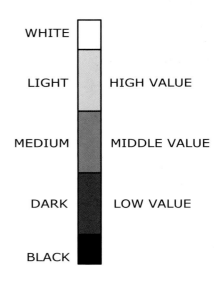

**VALUE SCALE**

Value is a measurement of how much light is reflected by a color. Value flows from light to dark, but just as the flow of the spectrum is divided into hues, values are divided into groups. We recommend thinking in terms of only five value families—black, dark, medium, light, and white.

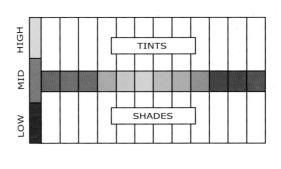

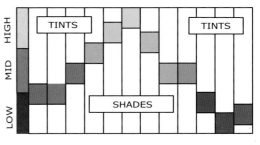

**VALUE COMPARISON CHARTS**

A common way to illustrate tints and shades is to place pure hues across the center of a grid and show tints above and shades below. This is misleading since the diagram implies that all pure hues are medium values. Squint your eyes and look at both diagrams above, and you will see that in reality the pure hues range from a light-value yellow to a deep, dark blue-violet.

Loretta Lam. *Deep Shade Necklace.* Longest bead 2¼ x 1 inches.
Polymer clay with oxidized sterling silver cable.
The choice of using only black and white, with very subtle neutrals, puts the emphasis on the simple forms of the beads.
Photo by Bob Barrett

# THE THIRD PROPERTY OF COLOR: Saturation

SATURATION IS DEFINED AS the degree of pure hue in a color. High-saturation (also known as full-saturation) colors are the most pure. Low-saturation colors are the least pure. Think of a fully saturated color as 100 percent pure and a neutral color as 10 percent pure.

Saturation is reduced when the color is mixed with anything that lowers the percentage of pure color. One way to reduce saturation without changing the value is to mix the color with a neutral that is similar in value. A color that is darkened with mud and then lightened with white is the same as a color shifted by adding a middle-value neutral. These colors are sometimes called "tones." We call them "muted." (See Saturation Scale.)

Tinting and shading, terms used mostly to describe changing a color's value, also change a color's saturation. For example, a pure color tinted half and half with white is 50 percent pure color and 50 percent white. Not only is the color's value shifted with the addition of white, but the saturation is also reduced. (See Saturation Zones.)

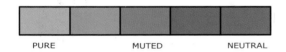

| PURE | | MUTED | | NEUTRAL |

**SATURATION SCALE**
One way to desaturate a color is to mix it with a neutral color in the same value range. Sometimes these colors are called "tones"; we call them "muted."

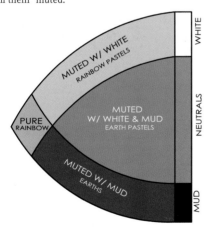

**SATURATION ZONES**
When you tint, mute, or shade a color with a neutral color, you are also desaturating it.

The value and saturation of a color are intimately associated with mood. A dark pure blue evokes a different feeling than a pale, muted gray-blue. Because value and saturation are linked to expressing mood, we like to think of color as divided into six saturation families, based on the feelings generated by each group. (See Saturation Families.) The words used to describe these feelings are very subjective and vary from person to person, but the overall intuitive reactions are usually the same.

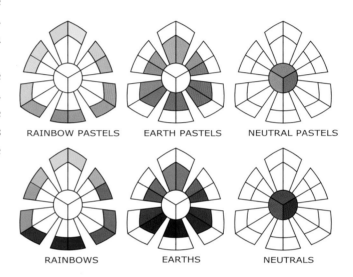

RAINBOW PASTELS    EARTH PASTELS    NEUTRAL PASTELS

RAINBOWS    EARTHS    NEUTRALS

**SATURATION FAMILIES**
We divide colors into six saturation families. Colors in the same saturation family have similar properties and evoke similar feelings.

## Rainbows
The pure colors fall into what we call the rainbow family. These colors feel dynamic, bright, and playful.

## Earths
These are rainbow colors that are muted or "shaded" with mud. Earths are darker than rainbow colors and do not have any white in them. They feel natural, rich, and deep.

## Pastels

When you tint the rainbow colors they become pastels, and so we call them rainbow pastels. These colors feel refreshing, soft, and clear.

## Earth Pastels

The tinted versions of earth colors are also soft, but not as clear as the rainbow pastels. They have a complexity that makes them more sophisticated, and they feel more restful than active.

## Neutrals

When the saturation of a pure color has been reduced so much that you can no longer tell which hue family it belongs to, the hue has been neutralized. Neutrals result from the combination of three primaries in close to the same amounts. They are dark colors, and they feel classic, quiet, and dignified.

## Neutral Pastels

Neutral pastels result from adding white to neutrals. They feel calm, delicate, and elegant.

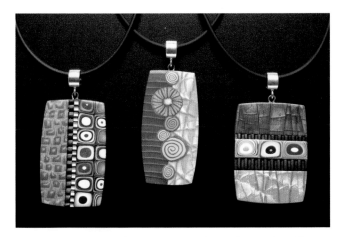

**MEISHA BARBEE.** *Three Low-Saturation Pendants.* 1¾ to 2 inches tall. Polymer clay, sterling silver bails, and rubber cords.
"Typically I sit down for a full day of color mixing and store the premixed sheets for later use. I can then pick from an array of colors sitting in front of me. This allows me to work very spontaneously when designing my cane, stripes, and final jewelry design."
Photo by Melinda Holden

## ABSOLUTE VS. RELATIVE PROPERTIES

THERE ARE TWO EQUALLY valid ways to think about the properties of color. Properties can be considered absolute characteristics of a single color—emerald-green is defined as a pure, medium-value, cool green. Or they can describe a color in relationship to another color—leaf-green is warmer, more muted, and darker than emerald-green. (See Absolute vs. Relative Properties.)

**ABSOLUTE VS. RELATIVE PROPERTIES**
Single colors have absolute properties that can be defined and measured. As soon as you put it next to a second color, the properties become relative to each other.

The absolute temperature of a hue is defined by wavelength. Colors that are between 380 and 530 nanometers are cool, and colors between 540 and 720 nanometers are warm. But the concept of relative temperature is more useful to us. The absolute temperature of yellow is warm, but we can take two yellows and put them together, and one will appear warmer and one cooler than the other. We'll refer to this concept of relativity over and over again as we discuss color.

Just as hues have both absolute and relative temperatures, value is also both an absolute and a relative property. A middle-value color next to a black will be the lighter color in the pair. The same color next to white will be the darker color in the pair.

Saturation is also both an absolute and a relative property. A muted color next to a pure color will be the muddier color in the pair. The same color next to a neutral will be the brighter color in the pair.

# COLOR VISUALIZATION

CHANGING THE SATURATION OF a color not only changes its value; it often results in changing its hue as well. This interconnectedness of the three properties is best understood by visualizing colors in a three-dimensional model, or color solid. (See 3-D Model of the Interrelationship of Color Properties.)

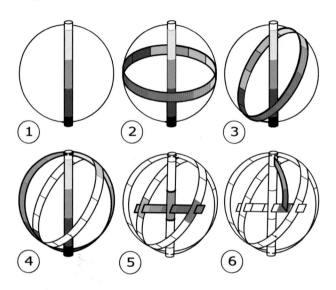

**3-D MODEL OF THE INTERRELATIONSHIP OF COLOR PROPERTIES**
The only way to show all three properties of color at the same time is a three-dimensional model. This version shows how color flows in many different directions—from hue to hue, from dark to light, from pure to neutral, and from muted to white.

Imagine a plain sphere with a vertical axis running through the center (1). Place black at the bottom and white at the top, and divide the axis into three more sections: Imagine a dark neutral in the lower third, a medium neutral in the middle, and a light neutral just under the white. This is a value scale.

Next, imagine a circle of pure hues around the equator (2). This is often the way hue circles are shown, but it is not accurate. Yellows are much lighter in value than violets. To make the hue circle more realistic, you need to imagine tilting the equator by sliding the yellow section up almost to the white and the violet section down almost to the black (3).

Now take one of the violets near the bottom and imagine it running along a path going up the outside surface of the sphere, all the way to white (4). Divide this flow of color into three steps, starting with the pure violet at the bottom as the darkest value, moving to a medium-value violet with some white in it, then to a light-value violet with lots of white. Take one of the yellows and imagine it running along the outside surface on its way to white. This is a very short distance compared to the violet. A pure yellow is much lighter in value than a pure violet. Now take the violet and yellow and run them to black. The violet will not have far to go compared to the yellow.

Imagine a pure turquoise-blue along the tilted equator (5). Visualize taking this blue underground toward the center of the earth, toward the vertical neutral axis. As it gets farther away from the outside of the sphere, it gets more and more muddy. We call the colors between the outside and the center "earth colors." As it hits the center, the blue becomes neutralized. Run the color through the vertical axis and out the other side, going through the brick-red earth color to the complementary tomato-red. This path illustrates mixing complements together.

The last thing to visualize is the brick-red earth color heading for white. Brick red is made up of tomato red and mud (6). The colors along this path are part tomato-red, part mud, and part white; we like to call them earth pastels.

Remember to think of moving a color in all these different directions when you are looking for just the right combination of hue, value, and saturation.

**MERRIE BUCHSBAUM.** *Garden Fence Bracelet.* 3½ x 4 inches. Translucent polymer clay with ground herbs, metallic powders, and silver leaf.
Photo by John Polak

# EXERCISE

## Package Color Testing

**MATERIALS**

- ¼-OUNCE PIECES OF PACKAGE CLAY—AN ASSORTMENT OF THE BRAND YOU WORK WITH MOST
- 2-OUNCE PACKAGE OF WHITE CLAY OF THE SAME BRAND
- ¾-INCH SQUARE CUTTER
- ½-INCH CIRCLE CUTTER
- INDEX CARD FOR BAKING
- EXTRA-FINE-POINT BLACK MARKER (SHARPIE BRAND)

EACH OF THE POLYMER clay colors that we buy in a package can be described by its three properties. The Polymer Primaries and Secondaries Chart on page 138 lists most of the primary and secondary colors currently available in Fimo Classic, Fimo Soft, Sculpey III, Premo Sculpey, Studio by Sculpey, and Kato brand clays and shows where they fall in hue, value, and saturation after they are baked. This information is the result of package color testing.

The best way to learn the properties of the package colors and also learn about pigment strength and darkening characteristics is to make test-mix samples of each color straight out of the package. A test mix is a color mixed with one-half white. We recommend that you make test mixes of at least five different package colors.

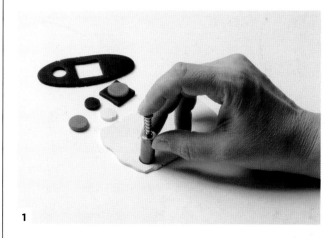

**1.** Sheet out a small piece of white clay and a piece of one of the colors at the thickest setting on your pasta machine. Cut out a square of the colored clay to use as a base for the sample. Cut out a circle of both the white and the colored clay, and mix them together to get a new color that is a half-and-half mix. Ball up the mixed color and flatten it onto the square of package color.

**2.** After mixing white into all the package colors, bake the test-mix samples according to the manufacturer's directions. Write the brand and name of the clay on the back of the samples. If you are using more than one brand of clay, you may want to mark the samples with the brand as well.

**3.** The photo shows unbaked colors on the left side and baked colors on the right. The fuchsia darkened considerably more than the other colors.

**4.** Compare the baked colors. Do some seem stronger than others?

## Value Sorting

- 1/4-OUNCE PIECES OF PACKAGE CLAY— AN ASSORTMENT IN YOUR FAVORITE BRAND
- 1/2 OUNCE EACH OF BLACK AND WHITE CLAY
- 1/2-INCH CIRCLE CUTTER
- 3/4-INCH SQUARE CUTTER

VALUE IS THE MOST difficult of the three properties of color to see correctly. Hue is very easy to see. Even with the switch from red to magenta, we are still comfortable putting colors into their hue family groups. Value is an easy concept to understand, but measuring it accurately by just looking at it is difficult. Value tends to stump us.

Books on color theory traditionally illustrate a value scale using a *gray scale*. The most common gray scales have between nine and eleven values running from black to white, with a middle gray somewhere in the center. We have found that it is easier to determine value by thinking of value as having only five families—black, dark, medium, light, and white.

This exercise includes making a value sorter for use in your studio and learning how to see the absolute value of a color.

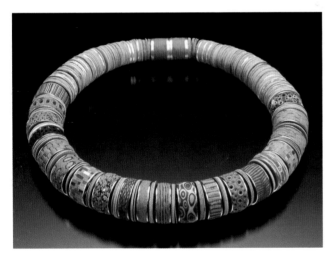

**CYNTHIA TOOPS.** *Untitled necklace.* 18½ inches long. Polymer clay, steel bobbins, and silver.
Each of the individual beads is textured. The textures Cynthia created include woven strips of clay, onlayed open-cut lattice, abutted edges, and small rectangular mosaic pieces. The end caps for the textured beads are steel sewing-machine bobbins. Between these beads are flat wafer beads made from polymer clay.
Photo by Doug Yaple

**1.** Sheet the clay at your pasta machine's medium setting. Using the square cutter, mix three grays of eight squares each according to the formulas on the Value Scale Chart on page 33.

**2.** Sheet white, black, and the three new grays at your pasta machine's medium setting. Cut out a 1 x 1½-inch piece from each color, and lay them side by side, running from black through white. Sheet the remaining black and white clay at the medium setting to use as a backing for the value scale. Lay the colors on the backing running from black at the bottom to white at the top.

**3.** Arrange your pieces of package colors alongside the value scale according to their value. It helps to squint so that you see just the value and not the hue. Compare the black-and-white photo of the package colors alongside the value scale with the photo showing the same clay in color.

**4.** Trim the scrap clay. Cut holes in the center of each value step with the 1/2-inch circle cutter. Bake the clay according to the manufacturer's directions. When your value sorter is cool, with the circle cutter, cut out 1/2-inch circles of your package colors and use them to determine the value of each of the package colors.

**5.** Sheet your package colors on your pasta machine's medium setting. Using the 1/2-inch circle cutter, cut one circle from each color. Place the colored circle of clay into the hole in the value sorter that you think most closely matches the value of that color.

Assess your scale and your determination of the value of package colors. How even are your steps from black to white? What value are most of the package colors? Did the value of any of the colors surprise you? How many of the colors are very similar in value?

## Value Scale Chart

| Brand | Premo Sculpey | Studio by Sculpey | Sculpey III | Fimo Classic | Fimo Soft | Kato |
|---|---|---|---|---|---|---|
| WHITE | 8W:0B | 8W:0B | 8W:0B | 8W:0B | 8W:0B | 8W:0B |
| LIGHT | 7W:1B | 7W:1B | 7W:1B | 7.5W:0.5B | 7.75W:0.25B | 7.75W:0.25B |
| MEDIUM | 4W:4B | 4W:4B | 4W:4B | 6W: 2B | 7W:1B | 7W:1B |
| DARK | 1W:7B | 1W:7B | 1W:7B | 2W:6B | 4W:4B | 4W:4B |
| BLACK | 0W:8B | 0W:8B | 0W:8B | 0W:8B | 0W:8B | 0W:8B |

The pigment strengths of black and white clays vary from manufacturer to manufacturer. This chart gives formulas for mixing a balanced value scale in each of the major brands of clay. The formulas are given in ratios; for example, 7W:1B indicates 7 parts white clay to 1 part black clay.

1

2

3

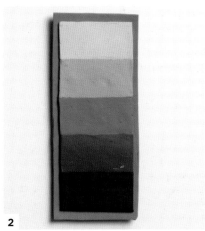

(continued)

4

5

## Mixing Pivot Tiles

**MATERIALS**

- 1 OUNCE EACH OF CLAY IN SIX PACKAGE COLORS (ONE FROM EACH HUE FAMILY; SEE PAGE 24)
- 1 OUNCE OF BLACK CLAY
- 1 OUNCE OF WHITE CLAY
- 2 OUNCES OF SCRAP CLAY
- ³/₄-INCH SQUARE CUTTER
- EXTRA-FINE-POINT BLACK MARKER (SHARPIE BRAND)

THE "PIVOT" COLOR IN these tiles is the starting color (magenta in the steps below) that is then mixed with other colors to make nine variations. This slight shifting of one color—with hue, value, and saturation changes—is a great way to explore the variety of colors that can be made based on one color. This exercise can be particularly valuable if you do it with a color you don't like; usually there is a variation you will like better than the pivot color.

You will mix three types of variations of each of six package colors:

- HUE VARIATIONS: THE ORIGINAL PACKAGE COLOR; THE ORIGINAL PACKAGE COLOR MIXED WITH ¼ OF A WARMER COLOR; THE ORIGINAL PACKAGE COLOR MIXED WITH ¼ OF A COOLER COLOR

- VALUE VARIATIONS: TINT EACH OF THE THREE HUE VARIATIONS WITH ¼ WHITE; SHADE EACH OF THE THREE HUE VARIATIONS WITH ¼ BLACK

- SATURATION VARIATIONS: MUTE EACH OF THE THREE HUE VARIATIONS WITH ¼ GRAY.

**1.** Select six package colors, one in each of the hue families, and add packages of black and white.

**2.** Sheet the black and white at the thickest setting on the pasta machine. Make some gray by mixing a square of white and a square of black together. Cut out one square each of white, gray, and black. Cut the squares into quarters.

**3.** Starting with magenta, cut out twelve squares, using the square cutter, and arrange them in four rows of three. Cut out one square of the violet-purple and mix it with the four squares on the left, then cut out one square of the orange and mix it with the four squares on the right. Once the mixing is complete, cut out four squares of the new colors and place them on either side of the four squares of the magenta.

**4.** Place one quarter of white on each of the three colors in the second row. Place one quarter of gray on each of the three colors in the third row. Place one quarter of black on each of the colors in the fourth row.

**5.** Once all the colors are mixed, sheet them at your pasta machine's medium setting. Cut out a square of each color and position it on the scrap clay in the same four rows of three colors. Trim the excess gray clay. Bake according to the manufacturer's directions.

**6.** Using the Sharpie marker, note the package colors used on the back of the tile. Repeat for each package color.

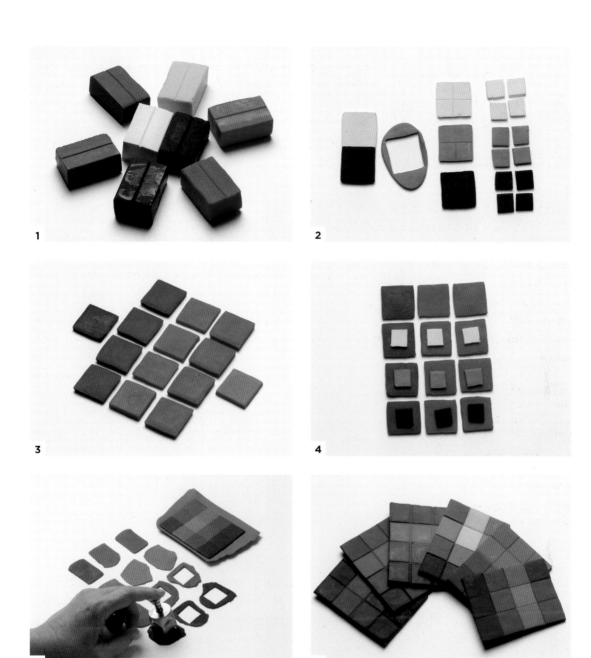

1

2

3

4

5

6

Examine all the pivot tiles. Did some colors shift more than others? The amount of variation will differ for each tile, depending on the comparative pigment strengths of the package colors used. Strong package colors do not show as much variation as weak colors. The pivot tiles show the full-saturation colors on the top row, tints (with one-fifth white) on the second row, tones (with one-fifth gray) on the third row, and shades (with one-fifth black) on the bottom row. The pivot tiles can be used for reference when you are mixing colors. They provide a benchmark for determining the proportions you need to get the colors you want.

# PROJECT

## Pivot Bead Strand

Project design by Maggie Maggio

**MATERIALS**

- YOUR GREEN PIVOT TILE
- 1 OUNCE OF THE GREEN PACKAGE COLOR USED IN THE PIVOT TILE YOU HAVE SELECTED
- PEA-SIZE PIECES OF BLUE AND YELLOW PACKAGE COLORS
- 2 OUNCES OF BLACK CLAY
- 2 OUNCES OF WHITE CLAY
- 2 OUNCES OF SCRAP CLAY
- ⅛-INCH-DIAMETER MANDREL OR ROD FOR MAKING TUBE BEADS

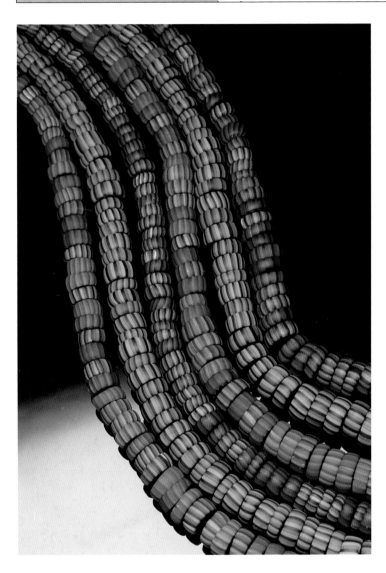

IN THE MIXING PIVOT TILES exercise (page 34), you took one color and made eight slight variations of it by changing the hue, value, and saturation. Using all these variations of color instead of just a single color allows you to enliven your work and create more exciting pieces. This project uses six slight variations of one color to make beads inspired by trade beads.

**MAGGIE MAGGIO.** *Pivot bead strands.* 20 inches long.
Polymer clay.
Maggie enlivens monochromatic strands of beads, inspired by trade beads, by using many slight variations of each of the colors.
Photo by Doug Barber

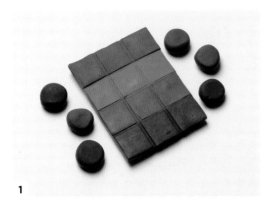

**1.** Use the pivot tile to help you decide the proportions for making six variations of the green package color. Add some blue to the green for one variation and some yellow to the green for another variation. Take a small piece of each of these three variations and add some black to them. It's best if the colors do not have much white. You need only ½-inch-diameter balls of each color.

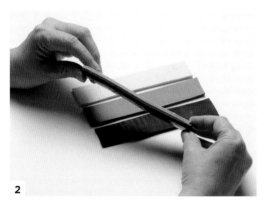

**2.** Mix approximately 2 ounces of a middle-value gray, using the formula for your clay on the value sorter you made in the Value Sorting exercise (page 32). Sheet the remaining black and white clay and the gray clay at the thickest setting on the pasta machine. Cut out sheets that are 1 inch wide x 6 inches long. Stack the sheets with the gray between the black and white.

**3.** Run the stack vertically through the pasta machine at the thickest setting to make a long piece of layered clay. Cut the long strip of clay into sixteen pieces, and stack them into a striped cane.

**4.** Sheet one of the six variations of green on the thinnest setting of the pasta machine so that it measures at least ³/₄ inch long x 2 inches wide. Cut a ¹/₈-inch slice off the black, gray, and white stripe cane, and run it through on the thickest setting of the pasta machine. Trim the striped piece, and lay it on top of the thin sheet of green clay.

*(continued)*

**5.** Run the striped piece with the green layer through at the thinnest setting of the pasta machine to make a long, thin, striped sheet.

**6.** Cut the sheet in half. Save half; fold the other half so that the color is on the outside, and run it through at the thinnest setting again. The stripes will stand out more, and the color will be lighter. You will now have two variations of striped sheets made from the one color.

**7.** Ball up about 1 ounce of scrap clay, and press out any air bubbles. Roll the ball into a ³/₄-inch-diameter cylinder. Carefully pierce through the center of both ends of the cylinder, and cover it with a piece of the thin, striped clay. Stretch the cylinder by rolling it on a rod until it is 2 inches long. Cut off a few beads of various thicknesses between ¹/₈ inch and ¹/₄ inch. Then roll the rest of the tube to a smaller diameter, and cut a few more beads. Do this one more time to get even smaller-diameter beads. Before baking, squish each bead slightly with your finger to round the edges. Bake according to the manufacturer's directions. Repeat with all the colors you mixed in step 1. You will end up with 12 variations of green beads. String the beads so that the largest-diameter beads are in the center and the smallest are on either end.

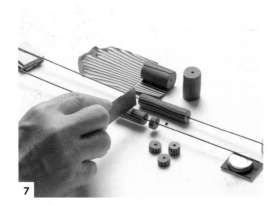

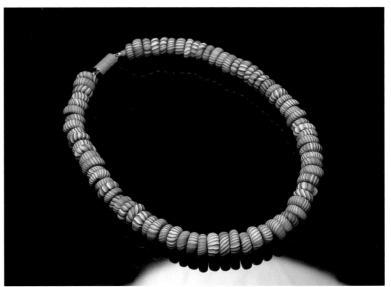

**LINDLY HAUNANI.** *Denim Pivot Bead Blues Necklace.* 17 inches long; largest bead ¹/₄ x ¹/₂ inch. Polymer clay.
Brighter, more saturated beads are interspersed between the more subtle desaturated blue beads. The blue beads were formed on a larger (1-inch-diameter) base tube that, when rolled and reduced, stretched the striped sheet more and resulted in a faded denim look to these beads.
Photo by Doug Barber

ELISE WINTERS DISCOVERED polymer clay in 1993 and was an early innovator in creating techniques for using polymer clay as a pliable canvas for paint. In 1999 Elise retired as a public school art teacher and launched a successful career as an art jeweler. As a college student she was trained in the intuitive Bauhaus tradition of studying color. As a teacher, she led her students through classes in color theory that allowed them to explore the reality of how colors mix and combine into color schemes. Now a full-time artist, she conducts color explorations that intentionally combine the depth of her knowledge with a refined awareness of her instincts to produce gorgeous works of wearable art.

*During the time between wakefulness and sleep, my mind's eye is filled with colors. I don't know where these colors come from any more than I understand the source of my dreams. But those colors invariably find their way into my work. Selecting and formulating color feels totally intuitive. Perhaps because I have integrated the rigorous theoretic training in color and light which I received in college, that thought process has become transparent to me. I always deal with color in combinations, and it is the dynamics of their interaction that thrills me. When I am fine-tuning a color scheme, my inner eye sees the exact color needed to make that group "sing." Theory doesn't dictate my choices. But invariably, at the conclusion, I could identify the principles that make the color scheme work.*

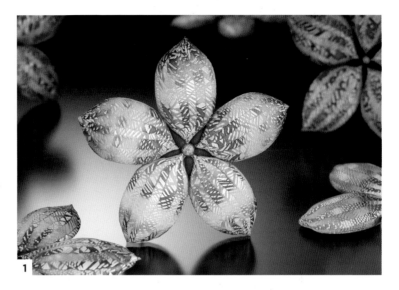

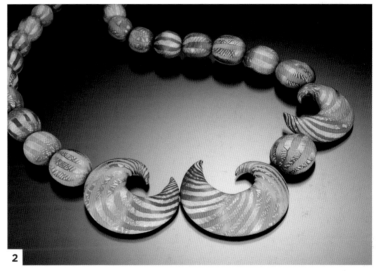

**1.** *Pentala Brooches.* Each 3 x 3 x 3 inches. Polymer clay and crazed acrylic.
The dark center and the lighter sections of color in the middle of the petals highlight the three-dimensional form of each of these beautifully designed flowers.

**2.** *Brio Necklace.* 20 inches long. Polymer clay and crazed acrylic.
Elise alternates violet to magenta to tomato-red blend stripes with gold stripes. The flared focal beads add playfulness to the necklace and provide counterpoint to the round beads.

**3.** *Ruffle Brooch.* 2½ x 2½ inches. Polymer clay and crazed acrylic.
Shape, stripes, and color flows all add to the dimensionality of this dynamic brooch.

Photos by Hap Sakwa

CHAPTER THREE

# Finding Your Inspirational Colors

YOUR PERSONAL REACTIONS TO COLOR are pivotal in finding your own inspirational colors. In this chapter, we guide you through the creation of a Color Inspiration Collage, which you will then use throughout the remainder of the book as a tool to guide you through learning how to mix the colors in your collage, develop a personal palette, and experiment with combining these colors. The instructions for mixing the colors for each of the projects in this book are based on using your collage as the color inspiration.

# HOW WE REACT TO COLOR

WHEN DESIGNING YOUR COLOR schemes and making decisions, an awareness of the three main sources of color reactions—personal, trend, and cultural—will be helpful to you. Personal reactions are based on individual tastes: You like blue and I don't. Trend reactions are based on the latest fashionable colors: This year green is in, next year it is out. Cultural reactions are based on the symbolic meaning of colors as handed down through the generations. Unlike personal reactions, which vary from person to person, and trend reactions, which vary over time, cultural reactions are fairly constant.

Cultural reactions connect color with emotion. Without the use of words or images, color generates emotion by using age-old mental associations. If I asked you, "What color is serenity?" you would probably say blue. Because of its association with water and sky, blue is considered a cool, passive color. Serenity is a cool, passive emotion. Therefore the color of serenity must be blue.

The pure hues generate the strongest emotions. Different cultures may have different interpretations, but each culture consistently develops the strongest associations for white, black, red, yellow, green, and blue. The same hue can have both positive and negative associations. Black is considered a negative color in Western culture, yet we still have many positive associations for black: It is elegant, sophisticated, and classic.

Changing the properties of a color changes the emotions produced by that color. Red is associated with fire, blood, excitement, drama, passion, and anger. Change the value of red by shading—adding black—and now we have a burgundy color. The feelings generated by burgundy are not as strong as those generated by pure red. If we change the value of red by tinting—adding white—we get pink. Do you associate the feelings of power and anger with pink?

So, in addition to hue associations, we have value associations. The lighter values of the six base hues are usually perceived as being delicate, romantic, and feminine. Visualize a pale turquoise, pale lime-green, and pale purple. Here it's not the hue that is generating your reaction; it's the value. The darker values are often seen as deep, rich, and masculine. Now visualize a dark teal, a dark moss-green, and a dark eggplant. The hues are the same, but your response to the darker versions of each color will be different because now the values are different.

There are also associations based on saturation. Hues at their highest saturation might be described as sharp, clear, bright, clean, and refreshing. The shaded low-saturation versions of each hue are the earth colors, and they can be called muddy, muted, dull, or even dirty. The feelings produced by bright lime-green, ultramarine-blue, and purple will be very different from the feelings produced by moss-green, indigo, and eggplant. Imagine a deep, dark Rembrandt painting executed in bright, almost neon primary colors. Conversely, imagine the clear pure primaries of Mondrian's paintings replaced with slate, wine, and ochre.

Each individual color has nuances of meaning. Be sure you are expressing what you want with the colors you are using. If you want to convey the message of light, lively, and playful, what colors would you select? Would they be the same as colors selected to reflect deep, dark, and serious?

Color can be used to create a sense of mood. "Feeling blue today," "seeing red," "green with envy," and "looking off-color" are oft-used expressions. In the West, black is the color worn at funerals, while in China white is worn. Japanese and Western brides wear white, and in China brides are expected to wear red.

Java, Peru, ancient Mexico, southern India, medieval Italy, Scandinavia, Japan, and Miami's South Beach are all evocative place names. Do these places suggest specific color schemes to you, or do you imagine the colors of more specific imagery? Would you be likely to find hot pink, vibrant orange, and gold in Scandinavia? The colors used in the art of a region have a tendency to reflect the climate, cuisine, and vegetation.

Color can be used to impart a sense of time. The colors that are used can be as important as the iconography in an image. The colors that are used to convey ancient, medieval, or futuristic would not all be of the same saturation.

**1. MAGGIE MAGGIO.** *Santa Fe Pendant.* 1 x 4 inches. Polymer clay and rubber cord.
The colors of the landscape surrounding Santa Fe were the inspiration for this "sense of place" pendant.
Photo by Bill Bachhuber

**2. ADAM VURAL.** *Beetle Blues.* 7¼ x 13 inches. Polymer clay. Adam mirrored and kaleidoscoped the cane slices to create the overall pattern. What makes these unique is that the Skinner color blends run crosswise throughout the millefiori canes and add variation to each of the subsequent slices. Notice how from top to bottom the blue changes from turquoise to faded denim.
Photo by Adam Vural

**3. JANA ROBERTS BENZON.** *Russian "Painted" Millefiori.* 3½ x 3½ inches. Polymer clay canework collage.
The colors in this cane are reminiscent of Russian folk-art paintings, slightly desaturated. The white background and white dots help unify the composition.
Photo by Jana Roberts Benzon

## Making Your Color Inspiration Collage

**MATERIALS**

- GOOD PAPER SCISSORS
- GLUE STICK
- 11 X 17-INCH PIECE OF POSTER BOARD
- MAGAZINES FOR CLIPPING
- TWO 1-GALLON PLASTIC STORAGE BAGS OR LARGE MAILING ENVELOPES FOR STORING YOUR CLIPPING LIBRARY
- FIVE OR SIX SANDWICH-SIZE PLASTIC BAGS
- PERMANENT MARKER (TO LABEL STORAGE BAGS)

HAVING A STARTING POINT, or touchstone, helps you make the decisions necessary for developing your personal palette via an informed selection of your mixing colors. While you could approach this process by using another artist's viewpoint—a painting, fabric design, or photograph—working from a collaged image of your own design is much more personal and magical.

The dimensions of your first collage are purposefully the maximum size of the platen of most color copiers, 11 x 17 inches, as this allows the most room for multiple clippings reflective of the color scheme. In selecting your clippings, you will need to make a series of decisions based on your instincts about what matches, works together, and makes for cohesion.

**1.** The first step in creating your collage is to put together a collection of magazine clippings. The easiest way to do this is to take five magazines, rip out all the pages that have color pictures (often one side is much more interesting than the other), then trim off any white edges, faces, and words. Larger images may be cut or ripped into pieces. Try not to spend too much time editing or musing over the color schemes at the beginning. Just keep cutting until you have about 100 trimmed clippings.

**2.** Gather all your clippings into one pile and begin your first sort into two piles. This part of the exercise should take no more than five minutes. Pick up each clipping and ask yourself the question: "Just for today, right now, do I like this color combination?" If your answer is yes, then place that clipping in your "keep" pile. If your answer is no, place the clipping in your "do not like" pile.

**3.** Once you have completed your sort into "I like this color combination" and "I don't like this color combination" piles, place the discarded clippings aside.

**4.** Spread out all your saved clippings so that you can see them. The number of piles in your next sort will depend on the variety of color combinations that appear in the clip-pings you have selected. Spend five minutes rearranging your clippings into subsets, relying on the color combinations rather than the images. While you are sorting, your criteria could include: vibrant vs. subdued; warm colors (sunshine-yellow, tomato-red, and caramel) vs. cool colors (ultramarine, grape, and teal); or organic colors vs. urbanized colors. Ultimately you are sorting the clippings into piles that "hang together."

**5.** Your next task is to select one of these piles of clippings to make a collage from. You may find making this selection instantaneous, as one of the piles is particularly attractive to you. But if you are hesitant, eliminate two piles at a time until you only need to pick from two, then make the decision.

**NOTE**

The collage you are making in this first exercise should include areas of yellow, red, and blue in their variations that you find pleasing. Having all three of these hue families present will aid in the development of your personalized palette in the next three chapters.

**6.** Lay out the clippings from the color combination that you have chosen to work with on your poster board. Do you have enough clippings to cover the entire board? Perhaps you need to find more clippings to coordinate with those you already have.

**7.** Once you have gathered enough clippings, use the glue stick to adhere them to your board in a pleasing arrangement. Allocate a maximum of fifteen minutes for assembling your collage. Try to rely on your intuition and instinct while you compose your collection of color images.

**8.** If one or more of your clippings makes you pause and you find yourself wondering whether that piece really matches, chances are that it really doesn't and you may have to find another clipping to fit into your collage. It is sometimes helpful

to tack your collage up on a wall so that you can stand back and get a fresh perspective.

**9.** Make a photocopy of your collage at your local copy shop. Compare the colors in your photocopy to your paper collage. If the colors aren't accurate, ask the color copier technician for help. Have this photocopy laminated so that when you place clay on top of it, the plasticizer won't leach into your collage.

You will use this Color Inspiration Collage as the basis for exercises and projects in the rest of the book. Over time you may find that your color preferences change, and you may want to redo this exercise or use it as a starting point for a new and different set of colors to work from.

| Lindly's Collage | Maggie's Collage |
| --- | --- |
| MY COLOR INSPIRATIONS ARE driven in part by my artistic fascinations—the succulent colors of food, my visceral reactions to a sense of place, and color balance with repetitive pattern. This translation is not always overtly obvious as I make the decisions to select my collage elements. For example, I didn't set out to find and use the colors of avocados, papayas, and lemon custard reflected in tropical sunlight and reminiscent of the textile artist Kaffe Fassett; instead I choose three related images and worked from there. However, perhaps in part because of my enthrallment with food and its colors, almost invariably the comments I receive from others about my color combinations are "Those colors look almost edible" or "That color reminds me of smoked gouda," . . . or Kaffir lime leaves, or saffron, or cinnamon bark. | I USUALLY WORK IN a much more subdued palette than Lindly, The colors I like are reminiscent of the beautiful russets, olives, and slates of the Pacific Northwest, where I live. I am particularly inspired by the colors found in landscapes—the colors of the forest floor and the canopy of trees on a mountain, and the verdant colors in my garden. But for this book, I wanted a collage that felt more playful and fun, so I was drawn to deep, rich primary colors. I started this collage by photocopying and cutting up one of the first color collages I ever made. I rearranged the clippings to help balance the composition and added some more vibrant blues. |
|  |  |

You may opt to continue to make all your collages the same size as your Color Inspiration Collage, 11 x 17 inches, or choose to work smaller and make more collages. Using 8½ x 11–inch paper allows you to store your collages in a standard binder in sheet protectors. An interesting variation, especially if you find you are drawn to incorporate the work of other artists in your collages, is to photocopy a collage, cut it into strips, then recollage the image into a strip collage. This rearranging will successfully capture the overall feel of the color combinations while decreasing your chances of being directly influenced by the work of another artist.

Some starting point ideas:

- YOUR FAVORITE COLOR
- YOUR LEAST FAVORITE COLOR
- A FAVORITE PIECE OF MUSIC OR A POEM
- A FAVORITE TRAVEL DESTINATION
- A MEMORABLE MEAL
- FEELINGS—CALM AND RESTFUL OR EXCITED AND PASSIONATE

Making a series of collages based upon one of your collages is an excellent way to practice discerning color differences within your clippings. Experiment by making a collage that:

- REITERATES A SPECIFIC SECTION OF YOUR COLLAGE
- CHANGES THE PROPORTION OF THE MOST DOMINANT COLOR TO SMALL ACCENTS
- IS A PASTEL VERSION OF YOUR COLLAGE
- INCLUDES MORE DARK VALUES

Another interesting avenue to explore is varying the compositional elements, the line, the amount of pattern, and the overall flow of your collage. For example:

- IF YOUR COLLAGE INCLUDES LOTS OF DENSE, FINE PATTERN, MAKE A COLLAGE THAT HAS THE SAME COLORS IN SWEEPS AND WASHES.
- IF YOU MOSTLY USED SQUARES AND RECTANGLES TO MAKE YOUR COLLAGE, MAKE ANOTHER WITH CURVES AND CIRCULAR SWATCHES.
- IF YOUR COLLAGE IS LARGELY MADE UP OF RELATIVELY LARGE CLIPPINGS, MAKE ANOTHER USING 1-INCH-WIDE STRIPS.

**EVALUATE**

How do these changes affect the colors present in these collages? Which types of arrangements do you find more natural and pleasing? Do you prefer lots of small-scale patterns or large washes of color?

**LAURIE MIKA.** *Tree of Life.* 24 x 21 x 1 inches. Polymer clay, jewelry parts, beads and collage images.
Photo by Colin Mika

# BUILDING YOUR COLLAGE COLLECTION

WE ENCOURAGE YOU TO make many more collages so that you will have a reference library of inspirational color combinations that please you. Each time you make a collage you increase your ability to discern the subtle differences between colors, while exploring the importance proportion and placement make when composing color combinations.

**PASTELS**
Four strip collages, each 6 x 6 inches.

**SATURATION**
Four strip collages, each 6 x 6 inches.

**PURPLES AND ORANGES**
Four strip collages, each 6 x 6 inches.

**ORANGES AND BLUES**
Four strip collages, each 6 x 6 inches.

**PROJECT**

## Ruffle Spiral Flower Brooch

Project design by Lindly Haunani

**MATERIALS**

- 1 OUNCE OF LIGHT-VALUE CLAY FROM YOUR COLLAGE
- 1 OUNCE PLUS ½ OUNCE OF DARK-VALUE CLAY FROM YOUR COLLAGE
- 1 OUNCE OF BLACK CLAY
- 1 OUNCE OF THOROUGHLY MIXED SCRAP CLAY OR GRAY CLAY (WON'T SHOW IN THE FINISHED PIECE)
- PIN BACK
- LIQUID POLYMER CLAY FOR ATTACHING THE PIN BACK

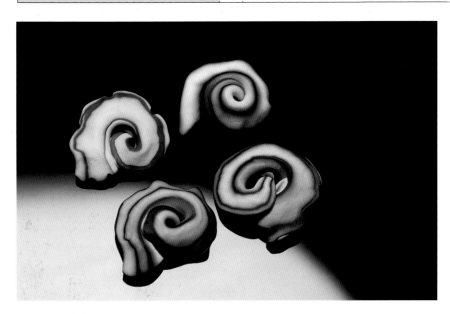

**LINDLY HAUNANI.** Lindly's four brooches. Each 2 x 2 x ½ inches. Polymer clay. Four different colorways are pictured here— grape, olive, eggplant, and purple. You may want to experiment with combining two different-colored canes in one piece.

Photo by Doug Barber

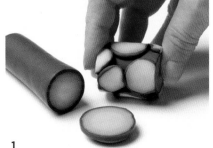

1

THIS IS A SIMPLE and direct way to experiment with the colors and value contrast in your collage by making a two-color Skinner blend log and wrapping it with a dark color (see Rolled Skinner Blend Log with Wrap, on page 18).

**1.** Using 1 ounce of the light-value clay and 1 ounce of the dark-value clay, and following the instructions for making a two-color rolled Skinner blend on page 18, make a two-color rolled log.

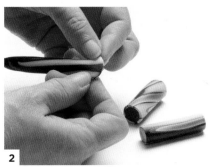

2

**2.** Mix ½ ounce of black with ½ ounce of dark-value clay. Sheet on the medium setting on your pasta machine to make a wrapped log cane following the instructions on page 18. Form the scrap clay into a round ball and then roll into log on your work surface until it is 1 inch in diameter. Cut ⅛-inch-thick slices from your cane, and apply to the outer surface. Roll this log firmly on your work surface until it has been reduced to ½ inch in diameter. Cut off a 4-inch piece. Using your fingers, pinch one end to a tapered point and fashion the other end to a flattened flange shape.

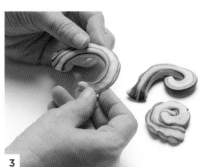

3

**3.** Grasp the pointed end in your fingers and begin spiraling and ruffling the piece together. Bake according to the manufacturer's directions. Allow to cool. Since the back side of your brooch is not flat, you will need to add a platform for mounting your pin back. Make a ½-inch-diameter ball of clay, pressing it firmly into the cavity and using your fingertips to flatten the top. Follow the instructions on page 20 to attach your pin pack with a drop of liquid polymer clay. Bake according to the manufacturer's directions.

TRAINED AS A plant ecologist, Carol Simmons has been exploring the possibilities of polymer clay since 1995. Her fascination with patterns in nature and her love of color are evident in her work. She recently opened her own studio in Fort Collins, Colorado, and is now a full-time polymer clay artist and teacher. She is a past president of the National Polymer Clay Guild.

*Over the past couple of years, I've derived most of my color schemes from collages. The collage pictured at right is one of the first I created. It grew out of my passion for tiles and tapestries created during the Arts and Crafts and Art Nouveau periods.*

*As a caner, I particularly like exploring symmetry and working with images from nature. After I mix my colors, I start making canes from different color combinations I see in the collage. Once I have a group of canes that reflects the colors in the collage, I arrange them in a way that pleases me and fill in the gaps with a background color. My goal is to produce a master cane that I respond to in the same way I respond to the collage. The colors in the cane may occur in different proportions or even differ somewhat from those in the collage—it is the overall response that I am aiming for. The final step in the process is to reduce the master cane, cut it into slices, and use different sections of the slices to create one-of-a-kind kaleidoscopic designs. The color combinations in the resulting designs differ depending upon the sections of cane I use, but as a group they echo the original collage.*

**1.** *Color inspiration collage.* 8 ½ x 11 inches. Polymer clay.
Carol used the colors in her collage, which range from lime-green to blue-violet and included the earth and rainbow colors and their pastel variations, to mix her colors in preparation for making the canes she used in this series. Notice the similarity of graphic motif between her canes and her collage.

**2.** *Eight pendants.* Each 2 inches in diameter x ⅜ inch long. Polymer clay.
In this series, Carol has combined her cane elements in eight different variations. Notice how the proportion and placement of the predominant color in each composition gives each pendant a unique feeling.

Photos by Carol Simmons

1

2

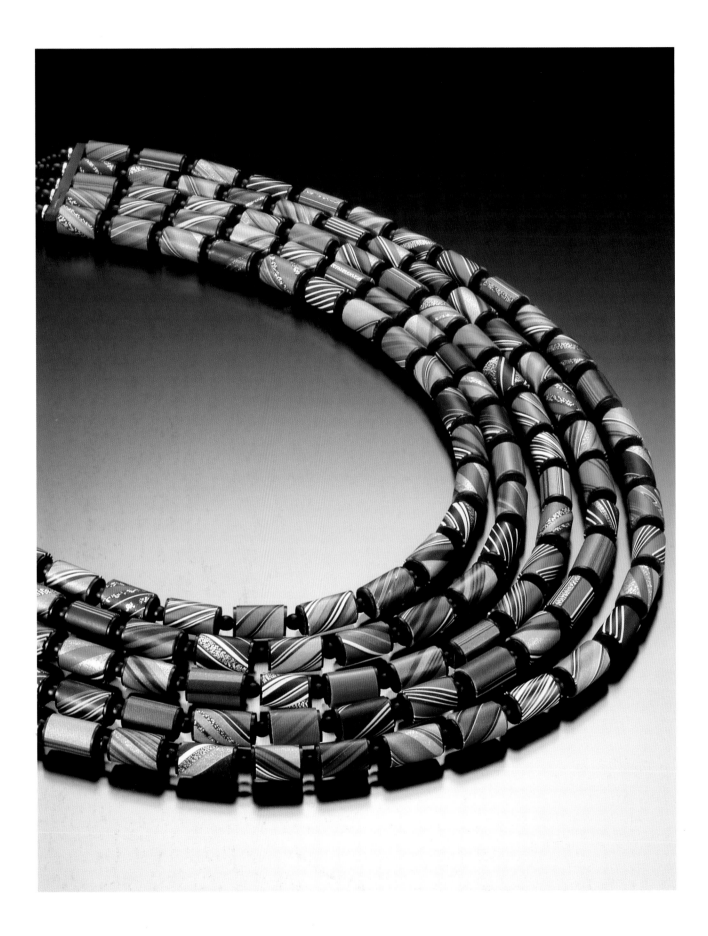

CHAPTER FOUR

# Choosing Your Colors for a Project Palette

WHEN YOU THINK OF A palette, the first image that may come to mind is the oval-shaped piece of wood with a thumbhole on which many painters arrange their paint colors for mixing. Your laminated color copy of the Classic Color Sorter can be used as a palette to help keep your polymer clay colors organized. It can also be used to sort any small pieces of clay you have mixed and not used in a project, in anticipation of auditioning the colors for future projects or using them as mixing components. *Palette* also refers to the selection of colors artists choose to best reflect their color preferences. One important consideration when designing a palette is the need to limit the number of colors to just those that work well, while eliminating colors that don't work well.

## DEVELOPING YOUR PERSONAL PALETTE

OIL PAINTERS HAVE MANY reds to choose from, including vermilion, alizarin crimson, carmine, Venetian red, cadmium, and Indian red. Fortunately or not, depending on how you look at it, there are not as many choices available to polymer clay artists. However, most of the color lines from clay manufacturers offer different variations of the primary colors yellow, magenta, and blue. (See, on page 138, the Polymer Primaries and Secondaries Chart, which shows the location on a color-mixing map of the different manufacturers' polymer clay primary colors.)

In this chapter, you will use the Color Inspiration Collage you created in Chapter Three (see page 44) to help you develop your personal palette of polymer clay colors. You will then use the colors you have selected to mix colors for the rest of the exercises and projects in this book. The basic palette, the colors you will mix with, should include:

- YELLOW
- MAGENTA
- BLACK
- SPOT COLOR(S)
- BLUE
- WHITE
- MUD

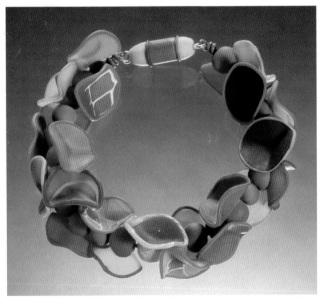

GLORIA ASKIN. *Fun Flowers Necklace.* 18 x 4 inches. Polymer clay, glass beads, and telephone wire.

"When I choose colors for my work I like to get more bling and often use fluorescent as accents. I love to surround bright colors with their opposites on the color wheel, sometimes choose colors that clash and sometimes juxtapose dark and light colors with strong contrasts. I want the colors to dance."

Photo by Norman Watkins

## PRINTING COLORS AND SPOT COLORS

MOST LIKELY YOUR HOME computer printer contains two cartridges. The black cartridge holds one color of ink. The color cartridge has three colors of ink: cyan, magenta, and yellow. It's the combination of these four ink colors and the white of the paper that makes it possible to print images in full color. This process is referred to as CMYK (in which K designates black).

The closest polymer clay primaries to this color palette are turquoise (cyan), fuchsia (magenta), and zinc- or lemon-yellow (yellow). Using this color palette for printing or mixing polymer clay colors has some inherent problems, including the inefficient reproduction of faint tints and the inability to capture a fully saturated blue-violet (the latter because the cyan-blue is such a warm blue with a yellow undertone bias).

Sometimes additional colors of ink—referred to as spot colors—are used to replicate an image. Commonly used spot ink colors in commercial printing include metallic, fluorescent, and custom, hand-mixed inks that provide an exact match to a specific color. Examples of spot colors that are available in polymer clay—and that may be important in developing your color palette—include metallic, fluorescent, and perhaps premixed package colors.

The two fluorescent primary colors available in polymer clay are fluorescent pink and fluorescent yellow. ("Fluorescent" and "neon" are used interchangeably as names for these colors.) On their own, fluorescent polymer clay colors can be very garish. On occasion, a relatively small amount of one of these colors might be used as an accent or spice note in a color scheme. As mixing colors, the fluorescents are particularly useful if you want to brighten a color. Lindly calls these bright colors "supra-saturated" and often uses them in her work.

Throughout this book, we encourage you to mix all your colors using three primaries. These primaries can be selected from the many package colors available or they can be customized by mixing package colors together. There are, of course, exceptions and instances when using a spot color or extra package color makes more sense. For example, Maggie uses a burnt umber color in her work, often to replicate the color of dark, bittersweet chocolate. She could mix umber and then add black to it, but since she uses the color frequently and there is a matching package color that is made with burnt umber pigment, it makes sense to use this package color as one of her spot colors.

# CHOOSING COLORS FOR YOUR PALETTE

SINCE PIGMENT PRIMARIES ARE not perfect representations of spectral colors, you can use their inherent temperature biases to advantage when selecting the primaries you'll use. (See Primaries and Secondaries.)

One approach to selecting your primaries is to look at the options available as package colors and pick the one you find most attractive. For example, for the blues, your choices in polymer clay are cobalt-blue, ultramarine-blue, and turquoise, or any combination of these that you choose to mix.

Another approach is to pick the package primaries that when mixed together result in the secondary colors—the violets, oranges, and greens—that most closely match the collage that inspires your palette. (See Mixing Secondaries.)

The tasting-tile studio tool that follows will help you make this decision. You will use your Color Inspiration Collage to help determine which of the primaries to use to mix colors that match your collage most closely.

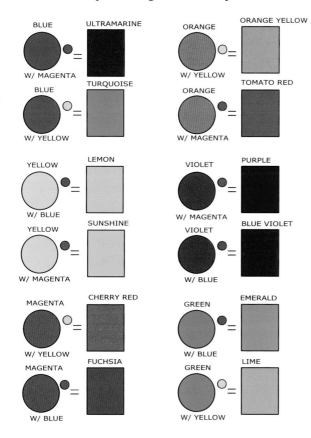

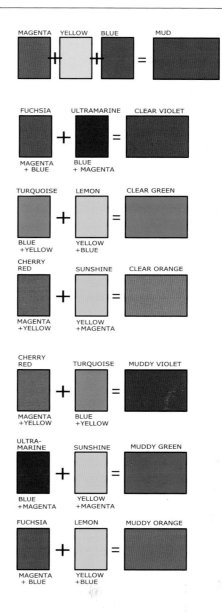

## MIXING SECONDARIES

Since any amount of magenta, yellow, and blue combine to make mud, the smallest amount of a third primary can desaturate a mixed color. The blues, yellows, and magentas we are using for each corner of the Classic Color Sorter (see page 26 and 133) all have a bias, which means they have a little bit of another primary in them. If you want to mix a clear secondary color that is not desaturated, you have to select two primaries that are not biased by the third primary.

## PRIMARIES AND SECONDARIES

Instead of searching for pure primaries and secondaries, we will use hues that are biased. The blues, yellows, and magentas all have a small amount of another primary.

| Lindly's Palette | Maggie's Palette |
|---|---|

**Lindly's Palette**

**Yellow** = cadmium-yellow

**Blue** = ultramarine-blue

**Magenta** = fuchsia

**White**

**Black**

**Mud** = equal parts of my three primaries mixed together

**Spot colors** = fluorescent yellow, fluorescent pink (magenta)

**Maggie's Palette**

**Yellow** = $^{31}/_{32}$ zinc-yellow, $^{1}/_{32}$ fuchsia

**Blue** = $^{7}/_{8}$ cobalt-blue, $^{1}/_{8}$ fuchsia

**Magenta** = $^{3}/_{4}$ fuchsia, $^{1}/_{4}$ cadmium-red

**White**

**Black**

**Mud** = $^{1}/_{2}$ burnt umber, $^{1}/_{2}$ black

**Spot colors** = cadmium-red, burnt umber

USING MY PALETTE AS a starting point and the four seasons as inspiration, I've designed four different color collections that I use in my work. Each such collection (designers refer to them as "colorways") has a different degree of saturation and corresponds roughly to one of the four different zones in the color sorters—for spring, rainbow pastels; for summer, earth pastels; for fall, earth colors; and for winter, rainbow colors. When I want a certain color to be more saturated and vibrant than my primaries allow, I use a fluorescent as a mixing component to create brighter colors. To provide balance and value contrast to each collection, I paid special attention to the lights and darks that represent each season.

THE PRIMARY COLORS I usually choose for my palette are a traditional red, yellow, and blue because I am drawn to the warmer and slightly muted colors that result from mixing with these primaries. When I use these primaries to mix my rainbow colors, they have a folk-art feel. When I want a palette with more earth colors, I skew my colors with a dark, almost purple, brown, adding it to each rainbow color. When I want a lighter palette, I add a cream-colored "white" to my earth colors. I rarely use a rainbow pastel palette.

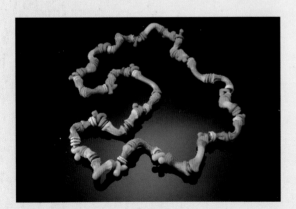

**LINDLY HAUNANI.** *Santa Fe Necklace.* 26 inches long.
Polymer clay.
Photo by David Terao

**MAGGIE MAGGIO.** *Log Cabin Brooch.* 2$^{1}/_{2}$ x 2$^{1}/_{2}$ inches.
Polymer clay.
The contrast of light and dark versions of Maggie's primary color palette energizes a variation of the log cabin design in this small brooch.
Photo by Doug Barber

# Studies in Gold and Blue

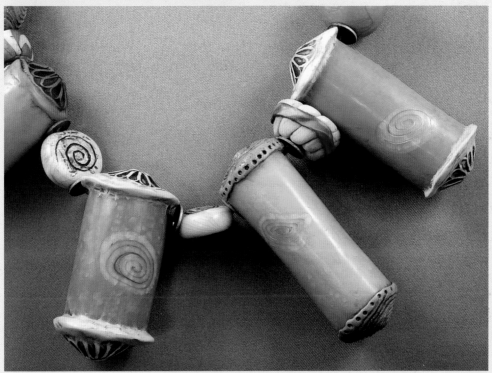

**1. RACHEL CARREN.** *Winslow Homer Two-Part Brooch.*
1¾ x 1¾ inches. Polymer and acrylic pigment.
This color scheme was inspired by the art of nineteenth-century American painter Winslow Homer. The gold pattern is metallic acrylic paint that is silk-screened onto the clay.
Photo by David Terao

**2. LOUISE FISCHER COZZI.** *Wholey Lifesaver Earrings.*
1⅝ x 3⅜ inches. Painted and etched polymer clay with 18k gold edges and niobium ear wires.

One simple geometric form, here a disk, is enhanced with subtle variations in the surface colors. The slightly irregular edges to the circles help make the composition more dynamic.
Photo by Robert Diamante

**3. DAYLE DOROSHOW.** *Rattle Beads.* 1 x 2 inches. Polymer clay and acrylic paint.
"My love of color is fueled by the artisans of faraway places and long-ago civilizations."
Photo by Dayle Doroshow

WE CALL COLOR-MIXING SAMPLES "tasting tiles." With this exercise, you will make a reference set of the different secondary colors you can obtain using polymer clay primaries. Think of this as "sampling" the clay colors, just as you would taste and compare flavors at a wine or cheese tasting. You will then use the tiles to identify the primaries that will mix into a palette that matches the colors in your collage.

There is much to be learned as you follow the instructional steps below, including answers to these questions:

- WHICH PRIMARIES, WHEN MIXED TOGETHER, TAKE YOU MOST DIRECTLY TO THE COLORS IN YOUR COLLAGE?

- HOW DOES THE UNDERTONE BIAS OF A COLOR AFFECT THE DEGREE OF SATURATION?

- WHICH OF THE PRIMARIES ARE MADE WITH THE STRONGEST PIGMENTS?

### Recipes for Color-Tasting Tiles

- VIOLETS: 1 PART BLUE PLUS 1 PART MAGENTA

- GREENS: 3 PARTS YELLOW PLUS 1 PART BLUE

- ORANGES: 15 PARTS YELLOW PLUS 1 PART MAGENTA

- MUDS: 1 PART YELLOW, 1 PART MAGENTA, AND 1 PART BLUE

These recipes, of course, are just general guidelines based on the relative pigment strength of the mixing primaries. We call these consensual recipes. (See Consensual Secondaries.) When we speak of a primary—magenta, for example—that doesn't necessarily mean it has to be a straight package color. You may find that your ideal magenta is actually 3 parts fuchsia to 1 part tomato-red, which is the red that Maggie uses to mix the color palette inspired by her collage.

We used Premo Sculpey brand polymer clay to mix the tasting tiles pictured with the steps that follow. You should mix your tiles using the brand of clay you prefer to use. The Polymer Primaries and Secondaries Chart (page 138) can aid you in making your selections.

Before you begin to mix your tasting tiles, please read all the instructions carefully. Be sure to place the correct mixing recipe on the back of each tile you make. In each of the following four photographs, three samples are pictured for each tasting tile. The square piece illustrates what a one-square recipe, cut with a 3/4-inch square cutter, looks like before mixing. The round, flattened button of clay, which is a tasting tile that has been mixed, includes an insert of that color that has been tinted with white. The smaller circle of clay is the pie-chart recipe that you will affix to the back of your tile prior to baking.

| MATERIALS |
| --- |
| • 1 OUNCE EACH OF TWO DIFFERENT YELLOW CLAYS— CADMIUM-YELLOW AND ZINC-YELLOW |
| • 1 OUNCE EACH OF TWO DIFFERENT BLUE CLAYS— ULTRAMARINE AND COBALT |
| • 1 OUNCE OF TWO DIFFERENT MAGENTA CLAYS— FUCHSIA AND CHERRY-RED (IN PREMO THIS IS 3 PARTS FUCHSIA AND 1 PART CADMIUM-RED MIXED) |
| • 1 OUNCE OF WHITE CLAY |
| • 3/4-INCH SQUARE CUTTER |
| • 1/2-INCH CIRCLE CUTTER |
| • 1/4-INCH CIRCLE CUTTER |

**CONSENSUAL SECONDARIES**
You can start mixing secondaries by using a formula that takes into account the different pigment strengths of the primary colors.

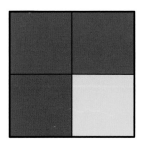

GREEN
3 BLUE : 1 YELLOW

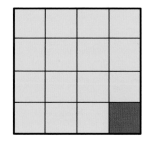

ORANGE
15 YELLOW : 1 MAGENTA

VIOLET
1 BLUE : 1 MAGENTA

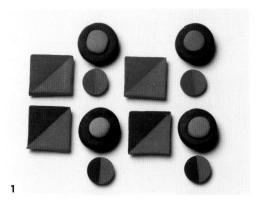

**1.**

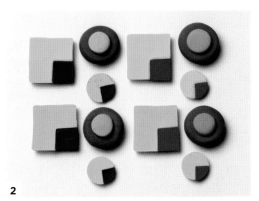

**2.**

**3.**

**4.**

**1.** Sheet the yellows, blues, and magentas using your pasta machine's thickest setting. With your square cutter, cut out seven squares of each color. Using the recipes above, cut and then assemble the twenty recipes. There are four combinations each for the violets, oranges, and greens. There are eight combinations of muds. To make the samples, you will mix together one cut square of each color combination. Before beginning to mix, cut and assemble the squares according to the recipes.

For the violets, the recipe is 1 part blue and 1 part magenta. Take one square each of the cobalt, ultramarine, fuchsia, and cherry-red, and cut these in half. Recombine so that there are four combinations:

- COBALT AND FUCHSIA
- COBALT AND CHERRY-RED
- ULTRAMARINE AND FUCHSIA
- ULTRAMARINE AND CHERRY-RED

**2.** For the greens, the recipe is 3 parts yellow to 1 part blue. Cut a quarter out of each yellow square and swap it with a quarter-square of blue:

- ZINC-YELLOW AND ULTRAMARINE
- ZINC-YELLOW AND COBALT
- CADMIUM-YELLOW AND ULTRAMARINE
- CADMIUM-YELLOW AND COBALT

**3.** For the oranges, the recipe is 15 parts yellow and 1 part magenta. Using a blade, score the yellow squares into 16 pieces, remove one square and swap it with magenta:

- ZINC-YELLOW AND FUCHSIA
- ZINC-YELLOW AND CHERRY-RED
- CADMIUM-YELLOW AND FUCHSIA
- CADMIUM-YELLOW AND CHERRY-RED

**4.** For the muds, since it is challenging to divide a square into three equal parts, you will make slightly larger samples by combining three half-square portions of the primaries:

- ZINC-YELLOW, COBALT, AND FUCHSIA
- ZINC-YELLOW, COBALT, AND CHERRY-RED
- ZINC-YELLOW, ULTRAMARINE, AND FUCHSIA
- ZINC-YELLOW, ULTRAMARINE, AND CHERRY-RED
- CADMIUM-YELLOW, COBALT, AND FUCHSIA
- CADMIUM-YELLOW, COBALT, AND CHERRY-RED
- CADMIUM-YELLOW, ULTRAMARINE, AND FUCHSIA
- CADMIUM-YELLOW, ULTRAMARINE, AND CHERRY-RED

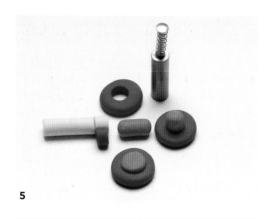

**5**

**1**

**2**

**3**

**5.** Before you begin mixing, make the pie-chart labels, as illustrated on page 16. Sheet each of the colors of clay at the thinnest setting on your pasta machine, and using the 1/2-inch circle cutter, assemble the recipes for each color sample. Place these directly next to each of your unmixed samples before you begin mixing. Mix all your samples one at a time, and place them on your work surface next to their pie-chart recipe circles. Bake according to the manufacturer's directions.

Using your 1/4-inch circle cutter, cut a circle of clay out of each of the samples. Make a 1/4-inch-diameter snake out of white clay and cut it into pieces the same size as the circles you cut out of the samples. Mix a piece of white with each of the circles to make the tinted version of your sample. Roll each of the tinted colors into a small cylinder, and place each of these on your work surface directly next to its corresponding sample. Now assemble each of the samples—push a cylinder of the tinted clay into the hole and attach the round recipe chart on the back.

If you have a favorite among the secondaries—the violets, greens, and oranges—you may want to customize the proportions of the consensual recipes or try using fluorescents in the mixes.

> **NOTE**
>
> If you follow these instructions, you will end up with twenty tiles. If you want to make a larger set with more variations, do the exercise using nine primaries, which could include a turquoise-blue, a fluorescent pink (magenta), and a fluorescent yellow.

**1. FLUORESCENT VIOLETS**
Four variations of violets mixed with fluorescent red. We made the samples on the right using 3 parts red and 1 part blue. Ultramarine and cobalt-blue are used here.

**2. FLUORESCENT GREENS**
Four variations of greens mixed with fluorescent yellow. We mixed the greens on the right using 3 parts yellow and 1 part blue. Ultramarine and cobalt are used here.

**3. FLUORESCENT ORANGES**
Four variations of oranges mixed with fluorescent yellow and fluorescent red. We mixed the top-left sample using half fluorescent yellow and half fluorescent red. We changed the proportions to 1 part magenta and 15 parts yellow—with, reading clockwise, fluorescent red, fuchsia, and cherry-red.

## Using the Tasting Tiles

You will now use your tasting tiles to help determine which of the polymer clay primary intermixes resulted in the colors that most accurately reflect those in your collage. The violets, oranges, and greens you were attracted to when composing your collage will help you choose the magenta, yellow, and blue to use as part of your personal palette.

Sort your tasting tiles into the muds and the three secondary hue families: the violets, oranges, and greens. For now, position these tiles recipe side down, so you won't be influenced by any preconceived notions about which primaries will work best to match your collage.

**TASTING TILES ON COLLAGE**

**1.** Place all your mud tiles directly onto your color collage. Do they all look like they belong in your collage? Do some seem to resonate with or match a color that appears in your collage? Remove the mud tiles that don't match and put them aside.

**2.** Place all your violet tasting tiles directly onto your color collage. Do they all match your collage? If so, then leave all of them on your collage and proceed to step 3. Or do some of the tiles look as if they belong, while others don't appear in your collage at all? Moving the tiles directly onto the violet areas of your collage will help you decide which violet tiles to keep and which to discard. Remove the mismatching tiles from the collage and set them aside.

**3.** Repeat this process with the green and the orange tasting tiles. You will now have sorted all your tasting tiles into two groups—those left on the collage because they match, and those set aside since they don't appear in your collage.

**4.** Examine each of the remaining tiles on your collage in turn, asking yourself: Does this color match appear only once or very rarely in my collage? If the answer is yes, put that tile aside also.

**5.** Place the tasting tiles you've selected on a plain white piece of paper and turn them over to reveal the pie-chart recipes on the back. Which primaries did you use to mix the matching tiles? Depending on your collage, perhaps all the violets, greens, oranges, and muds that match contain the same three primaries. In this case, your results are clear, and these primaries will become your mixing palette. Perhaps four or more primaries are represented in your mixes; in that case, proceed to the next three steps.

**6.** Examine all the tiles containing blues. If all the greens and the violets contain the same blue, that will be the blue you choose. At other times, there may be mixed results, and both blues will appear in the recipes. In that case, you will need to make a decision. Pick the blue you prefer. Or decide that your blue will be a custom-mixed double blue made from half cobalt and half ultramarine. Before committing to a custom-blended primary, you may want to repeat the tasting-tile exercises for, in the case of the double blue, both the violets and the greens.

**7.** Examine all the tiles containing the yellows and pick your yellow.

**8.** Examine all the tiles containing the magentas and pick your magenta.

> **EVALUATE**
>
> Are all three of the secondary hue families— the violets, greens, and oranges—equally represented in your collage? Or does one appear more frequently? If you are having trouble picking your primaries, give more weight to the tiles that match the greater proportion of the colors.

Make note of the primaries you've chosen. These will become the starting base for your palette.

These tasting tiles may be used to help analyze color combinations that you like and to help identify the polymer primaries that most directly result in matching colors. Suppose you have a favorite piece of fabric that you would like to replicate in polymer clay. You may use the chips to determine the primaries to use as a starting point to match the colors.

## Instinctual Color Mixing

**MATERIALS**

- 1 OUNCE OF YOUR PALETTE PRIMARIES—YOUR YELLOW, MAGENTA, AND BLUE INSPIRED BY YOUR COLLAGE
- 1 OUNCE OF WHITE
- 1 OUNCE OF BLACK
- 1 OUNCE OF YOUR MUD—EQUAL PARTS OF YOUR PRIMARIES
- 1 OUNCE OF YOUR SPOT COLORS (IF ANY)
- INDEX CARD
- CLASSIC COLOR SORTER (PAGE 133) AND YOUR OTHER STUDIO TOOLS

SO FAR YOU HAVE been mixing colors using recipes and exact proportions while making your tasting tiles, color scales, and color triangles. This has helped you understand the relative strength of the different polymer clay pigments. Now you can practice adjusting your mixes as you go. To get an exact match for a particular color in your collage, you might need to adjust the hue and/or the saturation and/or the value in several different steps.

One way to easily keep track of this is to make two small, identical piles of clay that include the combination of colors you plan to test-mix. Set one pile aside, then mix the other pile together; keeping the one reference pile unmixed will help you remember the colors you have added as you continue to make adjustments.

### Black

IF YOU HAVE STUDIED painting, you may have been warned to never use black paint. We both use black as a mixing component when we want to darken the value of a color mix to increase a value contrast. There are times when we will use a darkened (with black) version of a hue as our darkest-value color rather than black straight out of the package.

To mix many darker-value colors, especially colors without much yellow in them—navy-blue, dark teal, maroon—you have to use black.

### Mixing Mud

WHEN MIXING COLORS YOU should have some premixed mud on hand. The color we call "mud" is equal parts of your primaries mixed together. When added to white, mud makes a nice custom ecru. When added to black, it makes a rich, deep dark that harmonizes with the colors in your palette. You can mix in mud to desaturate the colors you are mixing. For example, if you add mud to an emerald-green, the yellow and blue in the mud becomes part of the emerald-green, and the remaining third primary in the mud, the magenta, moves the color toward gray.

### Your Spot Colors

WHEN YOU ARE TRYING to mix a particular color to match your collage, you may be unable to get a match using the colors in your palette. In such an instance, you may need to add another primary to your palette as a spot color.

If your Color Inspiration Collage contains a lot of very bright and vibrant colors, have neon yellow and neon pink (magenta), the two fluorescent primaries, on hand. They can be quite valuable as mixing components—for example, to make a lime-green or a magenta even brighter.

**1**

**3**

**2**

**4**

## Putting Your Knowledge To Work

START BY FINDING THE color that appears the most often in your Color Inspiration Collage. You will be mixing walnut-size bits of polymer clay to match it.

**1.** Cut a 1-inch-square hole in the middle of an index card to make a viewfinder and place it on your collage to isolate the first color you are planning to match.

**2.** Using your Classic Color Sorter (see page 133), determine the hue family of the color you are trying to match. For example, if you are mixing a green, is it an emerald or a lime? If you chose emerald, would you mix equal proportions of your yellow and your blue? After you have mixed your walnut-size sample, roll it into a round ball, then flatten it. Place your test mix directly on your collage. Is the hue correct? Or do you need to make an adjustment? If your green needs to be bluer, adjust this mix by adding a tiny amount of blue. (Before you mix it in, place the same amount of the blue you are mixing in on your reference pile.) Continue adding, mixing, checking, and documenting your test mix until it is the right hue.

**3.** Now that you have mixed the correct hue, examine your test mix in relation to the section on the color sorter that your color match belongs in. Is the color on the collage that you are matching bright and vibrant—that is, does it fit into the outer ring of your color sorter? Or is it slightly desaturated—say, matching spruce more closely? If your answer is spruce, you need to add mud to your mixture. Start by adding a small pinch of mixing mud to both your test sample and your reference pile. Mix the sample. Is the saturation right, or do you need to add more mud?

**4.** Is the color you are matching lighter in value or darker in value than your test sample? If it is lighter in value, you will tint the color you have mixed with white. If your match color is very light, you may want to start by adding a little of this color to a bigger piece of white. If your match color is darker in color, you need to add black. Do this in small increments, always remembering to put the corresponding portion on your reference pile. Once you have made the value adjustment, compare your color sample to the color on the collage that you are mixing to match.

NOW TRY TO MATCH a wide range of colors on your collage. Don't forget the lightest color, the accents, and—of course—your favorite color.

# Pinched-Petal Necklace

Project design by Lindly Haunani

**MATERIALS**

- 2 OUNCES OF YOUR YELLOW CLAY
- 1 OUNCE OF YOUR MAGENTA CLAY
- 1 OUNCE OF YOUR BLUE CLAY
- 2 OUNCES OF WHITE CLAY
- 3 OUNCES OF BLACK CLAY (FOR THE BLACK AND WHITE CANE AND WRAPPING THE TWO CANES)
- PIN TOOL
- ACRYLIC ROD OR BRAYER
- 36 INCHES OF BEAD-STRINGING CORD (HEAVY-DUTY UPHOLSTERY THREAD OR WAXED LINEN THREAD)
- CLASP
- FAST-DRYING SUPERGLUE
- BEAD TRAY MADE FROM FOLDED CARD STOCK

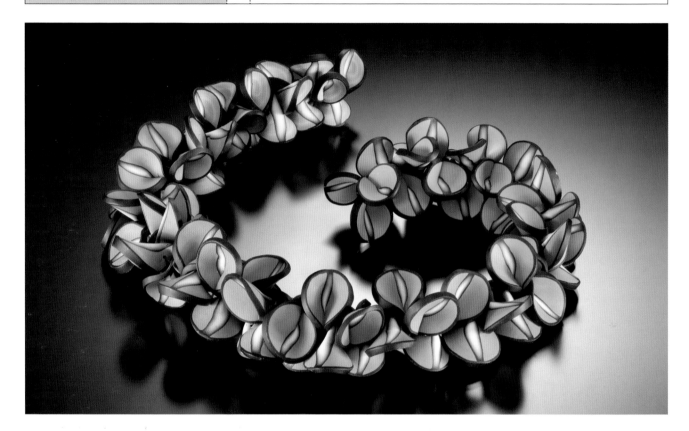

THIS NECKLACE IS MADE by combining two Skinner blend canes—a rainbow blend and a two-color blend made from black and white. You'll fashion the rainbow blend into a compact log and insert the black-and-white cane into the center, then wrap them with a medium-thick sheet of black clay. After reducing the cane by rolling it gently through the entire circumference, cut the cane into ⅟₁₆-inch slices and form individual petals. When strung together, the petals splay into an interesting array.

The necklace elements pictured in the photos with the steps below are made from Lindly's palette, and the rainbow blend has not been tinted. You may want to make your petal necklace from rainbow pastels, similar to one of the swatches you made while making your color-swatch fan deck. In that case, you would need to add more white to the materials list to tint your rainbow blend.

Lindly finished her necklace using a combination of base metal bead tips and a polymer-clay-covered barrel clasp; she secured the ends of the bead-stringing material and the bead tips with a fast-setting superglue.

**LINDLY HAUNANI.** *Rainbow Pinched-Petal Lei.* 22 inches long. Polymer clay.
Lindly used overlapping floral elements and a smooth flow of color from green to blue to magenta to evoke the soft feeling of a Hawaiian flower lei.
Photo by Hap Sakwa

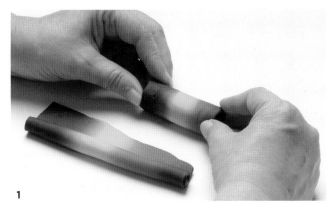

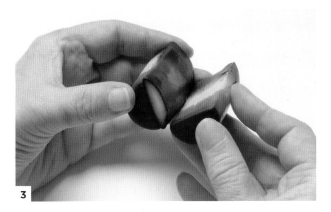

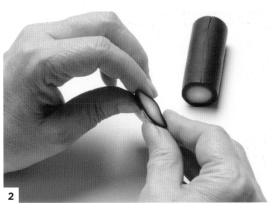

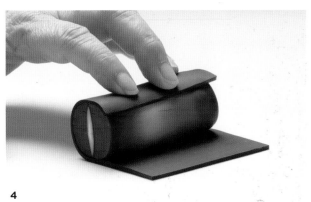

**1.** Following the instructions on page 19, make a rainbow Skinner blend using your primaries. Sheet your blend using your pasta machine's thickest setting, then fold the sheet in half across the blend and carefully roll the blend up into a large log. Squeeze across the cane to consolidate any air bubbles, then gently roll the cane to eliminate the seam. Instead of reducing the width of the cane, compress it in the opposite direction to make a thicker and shorter cane. Apply gentle pressure to both ends of the cane at the same time, until it is about 4 inches long. Set this cane aside and allow it to rest.

**2.** Using 2 ounces each of your black clay and your white clay, make a basic Skinner blend log (see page 18), with a black (medium thickness on your pasta machine) wrap (see page 18).

**3.** Continue rolling and reducing the black-and-white cane until it is about 1 inch in diameter. Cut the rainbow log in half lengthwise. Using your rainbow log as a measure, cut the black-and-white blend the length of the rainbow cane. Using your hands and your brayer, flatten the black-and-white cane into an elongated oval with sharp ends. When the black-and-white cane is the same length and height as the rainbow log, insert it into the log.

**4.** Gently consolidate the cane to eliminate any air bubbles, then roll gently to eliminate any seams. Using the remainder of the black sheet of clay that was rolled out on your pasta machine's medium setting, repeat the wrapping sequence, as explained on page 18, to wrap the bundled cane with a thin outline of black clay.

*(continued)*

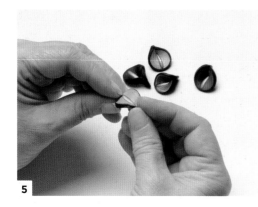

**5.** Reduce this cane until it is about ½ inch in diameter. For best results, allow the cane to rest several hours or overnight before slicing it into ⅟₁₆-inch rounds. To form the petals, take a slice of the cane and, using your dominant hand, press gently at the intersection of the black-and-white cane and the edge, fold, then gently pinch together. Using your pin tool, pierce a hole in the middle of the pinched end of each bead.

**6.** It is easier to assemble your necklace if you keep the color progression of the slices in order. After measuring the interior width of your baking oven, fold several sheets of card stock into 1-inch accordion folds in preparation for baking the petals of your necklace. Try to maintain the color progression as you form each bead and place it on a baking tray. Bake the beads according to the manufacturer's recommended baking temperature. Allow them to cool. String the beads in the order of your rainbow.

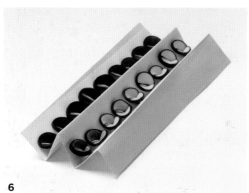

**EVALUATE**

Place your completed necklace on your collage. Does it look like it belongs? Does it include many of the colors in your collage? Starting with the right colors in a limited palette helps you get to where you want to go when mixing your colors.

**MAGGIE MAGGIO.** *Pinched-Petal Necklaces.* Each 16 inches long. Polymer clay. Two colorful necklaces twisted together reflect the traditional primary colors of Maggie's collage.

Photo by Doug Barber

**1**

AS A CHILD in Billings, Montana, Margaret Regan played near the sandstone bluffs that encircle the city, turning over rocks to search for bugs and stringing yucca-seed necklaces. She always loved making small-scale things and spent long summer afternoons constructing stone-and-stick fairy houses. These childhood interests resurface in her polymer work, which is playful, detailed, and occasionally insect-inspired. An early pioneer in polymer clay, Margaret travels extensively to sell her signature line of jewelry and vessels at fine-art and craft shows around the country.

*Pure color shouts at me. I'd prefer a conversation, so I subdue the colors to a speaking level and begin the chat. Sometimes I do this by mixing my yellow to ochre, having lots on hand so I can add bits in easily, like making a favorite spice mix ahead of time. Premo gold is also good for this seasoning approach to shifting package colors.*

*My main color pursuit is what I call my terra series—the warm neutrals of stone and plains and earth. I'm doing my native Montana environment via polymer—the ruddy sandstone cliffs and sage-green hills of eastern Montana. I will occasionally assign myself color homework, an exploration of colors I wouldn't otherwise pursue. I stretch myself with a foray into pink or by dabbling in pure yellow. Afterward, I return with relief to what I consider my home colors, my comfortable habitat of rust and olive-green, salmon and caramel, and black and cream. Polymer color: so thick and rich, you can roll it into a ball. If I could eat it, I would, that's how delicious the whole thing is to me.*

**2**

**1.** *Green Disc Necklace.* 18 inches long; largest bead ¾ inch in diameter. Polymer clay with silver.
Subtle variations of muted spruce and olive greens are combined with silver in this elegant necklace.

**2.** *Terra Stickpins.* Each 1 x 5 x 3 inches. Polymer clay and sterling silver, with a nickel-steel stickpin.
Shape and proportion provide balance to these two dynamic color combinations. The yellow top on the tomato-red bead at right serves as a well-placed accent to the two large beads in the pin.

Photos by Hap Sakwa

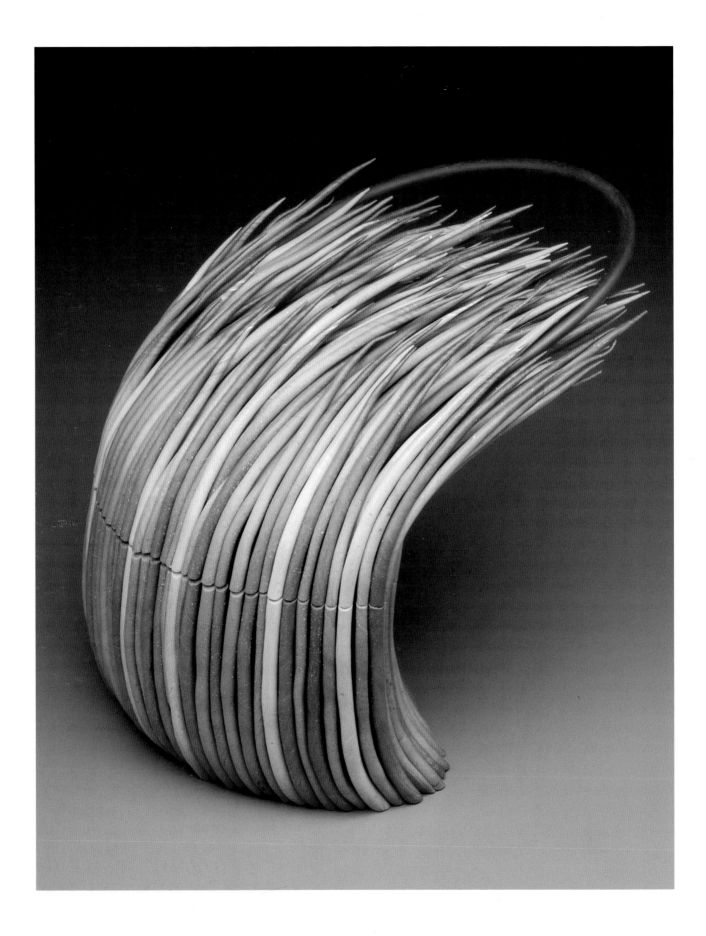

CHAPTER FIVE

# Mixing Colors That Flow

*LOCAL COLOR* IS THE TERM for an object's true color as seen at noon on a clear, sunny day. *Apparent color* and *perceived color* describe the same color as it appears when it is highlighted, shadowed, or in shade; when other colors are reflected on it; or when it is seen in a color of light that is different from natural light at noon. The color of the object does not change, but its appearance does. Colors can appear to move in many directions: they can shift from hue to hue along the color wheel; they can shift from dark to light along the value scale; and colors can change from pure to neutral as they move along the saturation scale. This natural flow of colors helps to give depth and interest to everything we see.

# COLOR SCALES

THE REASON SKINNER BLENDS are so appealing is that they mimic nature's way of creating depth by shifting colors in a very smooth and orderly fashion. Another way to duplicate a natural flow of color in polymer clay is with color scales.

Color scales break down the movement of one color to the next into a series of steps. There are two kinds of color scales—arithmetical and geometrical. The color scales we recommend are geometrical because they replicate the way our eyes naturally perceive color flow. (See Color Scales Worksheet.) The basis for the formulas used in the color scales shown on the worksheet is the Weber-Fechner law: "The visual perception of an arithmetical progression depends upon a physical geometrical progression." In other words, in order for a progression of colors to appear to be evenly spaced, the amount of difference between each color cannot be equal. The steps appear to be evenly spaced when the amount of difference between one color and the next increases or decreases by a factor of two. (See Geometrical and Arithmetical Scales on page 70.)

Polymer clay is an ideal medium to use for color scales because the clay can be accurately measured. All the colors in a color scale can be reproduced easily using the set formulas for each position along the scale.

## COLOR SCALES FOR POLYMER CLAY

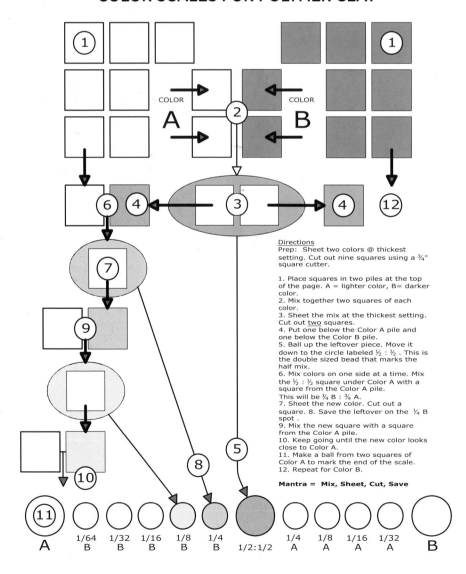

**Directions**
Prep: Sheet two colors @ thickest setting. Cut out nine squares using a ¾" square cutter.

1. Place squares in two piles at the top of the page. A = lighter color, B= darker color.
2. Mix together two squares of each color.
3. Sheet the mix at the thickest setting. Cut out two squares.
4. Put one below the Color A pile and one below the Color B pile.
5. Ball up the leftover piece. Move it down to the circle labeled ½ : ½ . This is the double sized bead that marks the half mix.
6. Mix colors on one side at a time. Mix the ½ : ½ square under Color A with a square from the Color A pile. This will be ¼ B : ¾ A.
7. Sheet the new color. Cut out a square. 8. Save the leftover on the ¼ B spot .
9. Mix the new square with a square from the Color A pile.
10. Keep going until the new color looks close to Color A.
11. Make a ball from two squares of Color A to mark the end of the scale.
12. Repeat for Color B.

**Mantra = Mix, Sheet, Cut, Save**

**COLOR SCALES WORKSHEET**

The color scales are important both theoretically and practically. The full-size Color Scales Worksheet appears on page 136; in order to best use this diagram as a working tool, copy it at full size and have it laminated.

# Studies in Color Flow

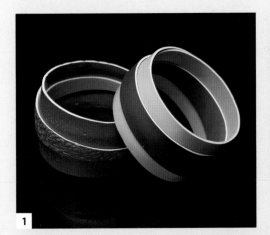

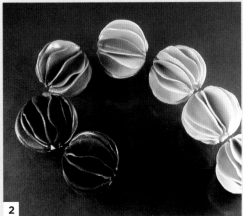

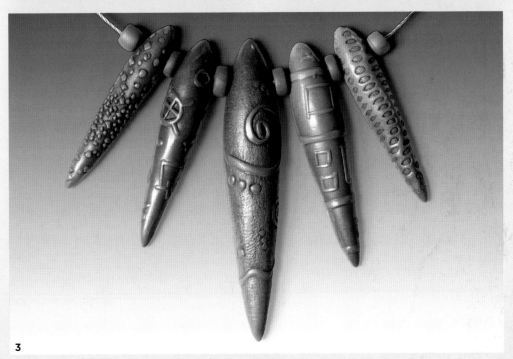

**1. MAGGIE MAGGIO.** *Rainbow Bracelets.*
1½ x 1 inches high x 3 inches diameter. Polymer clay.
The colors of the rainbow flow from the inside to the outside
on these simple bangle bracelets.
Photo by Doug Barber

**2. CHRISTELLE VAN LINGEN.** *Earth Ruffle Beads.*
Each bead 1¼ x 1 inches. Polymer clay.
Here the color flow is from lighter in value with more
translucent clay in the mix to darker in value with less
translucent clay in the mix.
Photo by Christelle van Lingen

**3. LAURA TABAKMAN.** *Five Pods—Green/Yellow Necklace.*
3 x ⅝ x ⅜ inches. Polymer clay on steel cable.
The use of different greens helps establish a color flow throughout
the necklace.
Photo by Laura Tabakman

# EXERCISE

## Mixing Color Scales

**MATERIALS**

- 2 OUNCES OF YOUR YELLOW—COLOR A ON THE COLOR SCALES WORKSHEET
- 2 OUNCES OF YOUR BLUE—COLOR B ON THE COLOR SCALES WORKSHEET
- ³⁄₄-INCH SQUARE CUTTER
- PIERCING TOOL
- STRINGING SUPPLIES
- COLOR SCALES WORKSHEET (PAGE 136), COPIED AND LAMINATED
- EXTRA-FINE-POINT BLACK MARKER (SHARPIE BRAND)

MIXING ONE COLOR TO another color in a series of steps is a standard color exercise. The most commonly used method starts with 10 units of one color on one side and 10 units of a second color on the other side. The steps in between are then mixed in an arithmetical progression. The first step is 9:1, then 8:2, 7:3, etc. (See Geometrical and Arithmetical Scales.)

Maggie was not happy with the results of this kind of scale because there were many steps that seemed to be missing near the ends of the scale. To be able to see these missing colors, she developed a method for mixing colors about fifteen years ago that she still uses in her studio and teaches in all her workshops.

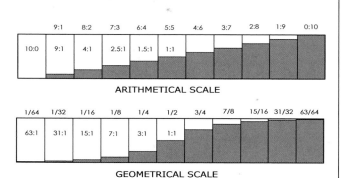

**GEOMETRICAL AND ARITHMETICAL SCALES**
The Weber-Fechner law states, "The visual perception of an arithmetical progression depends upon a physical geometrical progression."

Maggie's version of a color scale is geometrical and starts by mixing two colors half and half. The scale then runs in both directions from the half-and-half mix back to the original two colors in a series of steps. Each step reduces the amount of one of the colors by half. It sounds difficult, but it is actually very easy once you get the hang of it. Warning: Mixing color scales can become addictive.

**1.** Sheet the yellow and blue clay at your pasta machine's thickest setting. Using the ³⁄₄-inch square cutter, cut out nine squares of each color. Put the squares at the top of the Color Scales Worksheet, with yellow on the left side and blue on the right.

**2.** Pick up two squares of each color and mix them together. Sheet the mixed color at the thickest setting and cut out two squares. Place one of the squares on the left side and one on the right. Leave the remaining piece in the center of the worksheet.

**3.** Pick up the square of mixed color on the left and mix it with a square of yellow. The new color will be ¹⁄₄ blue and ³⁄₄ yellow. Sheet this new color at the thickest setting and cut out one square. Leave the remaining piece on the worksheet. Mix the new square with a square of yellow. The mixed color will be ¹⁄₈ blue and ⁷⁄₈ yellow. Sheet this color at the thickest setting and cut out one square. Leave the remaining piece on the worksheet. Follow this process of mixing squares, cutting out a square and saving the remaining piece until you can't see any difference between the new color you have mixed and the yellow clay.

**4.** Repeat the process for the blue side. Pick up the mixed square on the right, and mix it with a square of blue. Sheet the mix at the thickest setting, and cut out one square. Leave the remaining piece on the worksheet. Follow this process of mixing squares, cutting out a square, and saving the remaining piece until you can't see any difference between the new color and the blue clay.

**5.** Roll up the leftover pieces, and place them at the bottom of the worksheet. Flatten them into disk shapes. Pierce each bead (or drill after baking), and bake according to the manufacturer's directions. Label the yellow and blue beads at the ends of the scale with the marker to indicate the colors you started with. String the beads.

**1**

**2**

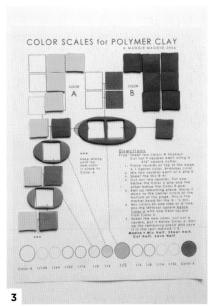

**3**

**4**

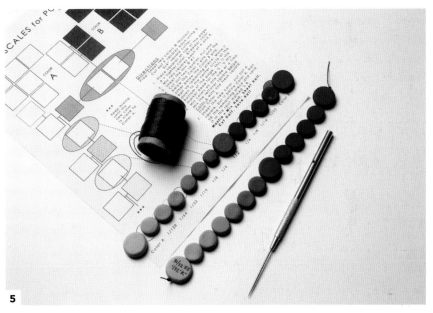

**5**

**MAGGIE'S COLOR SCALE IN FLUORESCENTS**
This scale is made between fluorescent red and a mixed green (3 parts fluorescent yellow and one part ultramarine). The resulting intermixes are brighter.

If you want to explore further, you can make value scales by taking each of your colors to your white and to your black. Another alternative is to mix scales between two colors that have fluorescents in their mixes.

**EVALUATE**

Take some time to examine the scale. Do the colors flow naturally from one to the next? Are there the same number of steps from the halfway point to the ends on both sides? Usually there are more steps on the lighter side. Were you surprised by the number of steps it took to get from the halfway mix back to yellow?

## Making Color-Scale Triangles

**MATERIALS**

- 2 OUNCES OF YOUR BLUE
- 2 OUNCES OF YOUR MAGENTA
- 4 OUNCES OF YOUR YELLOW
- 2 OUNCES OF YOUR WHITE
- ³/₄-INCH SQUARE CUTTER
- ¹/₄-INCH CIRCLE CUTTER
- PIERCING TOOL
- WAXED LINEN FOR STRINGING
- COLOR TRIANGLE WORKSHEET (PAGE 137), COPIED AND LAMINATED
- EXTRA-FINE-POINT BLACK MARKER (SHARPIE BRAND)

THE COLOR SCALES SHOW colors that are mixed using two colors. If you use a three-primary mixing system, you'll make many of the colors using some proportion of all three primaries. Over the years, Maggie tried to work out a simple way to show these beautiful tertiary colors that are mixed using three primaries. Starting with a triangle that had yellow at the top, and base colors running from blue on the bottom left to magenta on the bottom right, she experimented with various systems to mix the colors on the inside of the triangle. After lots of trial and error, she realized that if she ran a series of color scales that started with each of the base colors at the bottom of the triangle and ended with the same yellow at the top, she would get a beautiful collection of colors from inside the triangle. The Flow Triangle (see illustration) shows the zones of color that these color scales go through on the way from each base color to yellow.

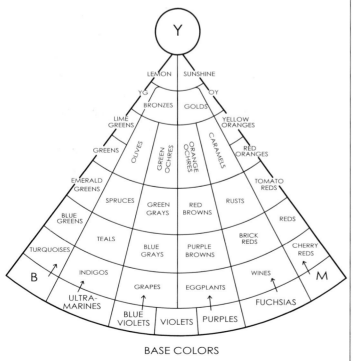

BASE COLORS

## COLOR TRIANGLES WORKSHEET

Yellow

| | | | | | | |
|---|---|---|---|---|---|---|
| 63/64 Y | | | | | | 63/64 Y |
| 31/32Y | | | | | | 31/32Y |
| 15/16 Y | | | | | | 15/16 Y |
| 7/8 Y | | | | | | 7/8 Y |
| 3/4 Y | | | | | | 3/4 Y |
| 1/2 2B:2Y | | | | | | 1/2 2M:2Y |
| 1/4 Y | | | | | | 1/4 Y |
| 1/8 Y | | | | | | 1/8 Y |
| 1/16 Y | | | | | | 1/16 Y |

Blue — ULTRA-MARINE — BLUE VIOLET — VIOLET — PURPLE — FUCHSIA — Magenta

BASE COLORS

### COLOR TRIANGLE WORKSHEET

The full-size Color Triangle Worksheet appears on page 137. Copy it at full size and laminate it, then use it to lay out each of the color scales while making a color triangle.

### FLOW TRIANGLE

This triangle is based on observing the results of hundreds of color scale triangles and attempting to document the relationships of the colors.

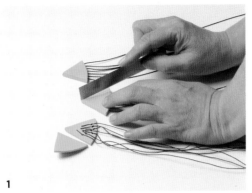

**1.** Sheet your yellow at your pasta machine's thickest setting, and cut out two triangles using the pattern at the top of the Color Triangle Worksheet. Cut seven 12-inch-long strings of waxed linen. Tie a knot at the end of each string. Press all the knots at one end of the strings into one side of one yellow triangle, then cover the knots with the other yellow triangle. Press the two yellow triangles together, and trim the edges. Bake the yellow triangle with strings according to the manufacturer's directions. Use the Sharpie to label the back of the triangle with your three primaries.

**2.** Mix a color scale (see Color Scales Worksheet, pages 68 and 136) from your blue (color A) to your magenta (color B). Select five steps between blue and magenta that you will use as base colors. These steps should include a violet-blue, blue-violet, violet, red-violet, and violet-red that are visually balanced between blue and magenta. Determine the proportion of each of your base colors, and mix enough clay to get eight ³/₄-inch squares of each color.

**3.** Mix the five colors, and sheet them out at your pasta machine's thickest setting so that they are long and narrow. Cut eight squares of your blue and magenta, and sheet them the same way. You'll use each of these colors to make a color scale to yellow. Sheet your yellow at the thickest setting, and mix seven color scales—one from each of the base colors to yellow. Using the ¹/₄-inch circle cutter, cut a hole out of the middle of each bead to mix with white for a tinted center. Pierce the beads, and bake according to the manufacturer's directions. String the scales onto the yellow triangle, starting with the blue on the left and running through each of the base colors to the magenta on the right.

**EVALUATE**

Along which color scale did you find gray? Brown? Ochre? The color scales show that the colors that flow from the blue-violet usually go through the grays, and the colors that flow from a red-violet usually flow through the browns. Note that the colors that fall at the same level have a horizontal relationship based on sharing the same percentage of yellow. Ochres have a high percentage of yellow and usually appear near the top of the color scales that flow from the blue-violet, violet, and red-violet base colors. (See Flow Triangle on page 72.)

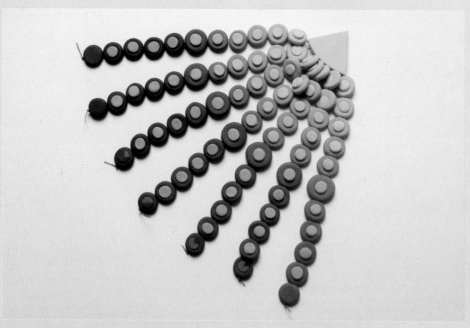

**LINDLY'S TRIANGLE**

Lindly made this color scales triangle using fuchsia, ultramarine-blue, and cadmium-yellow.

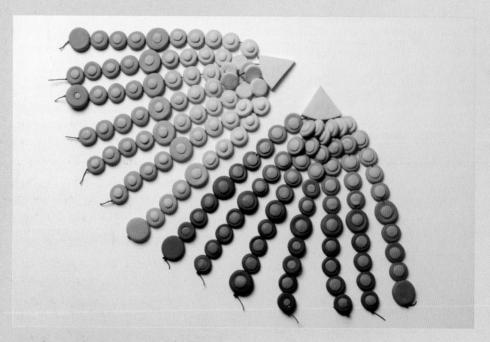

**MAGGIE'S TINTED AND SHADED TRIANGLES**

You can make tinted and shaded variations of your triangle by adding your white or your mud to your primaries before you mix the base colors and then make the color scales.

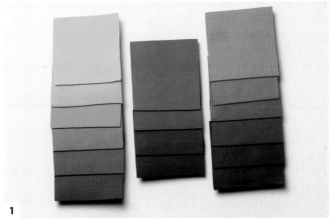

**1**

**2**

MAGGIE MAGGIO. *Bargello Focal Bead.* 1½ inches in diameter.
Polymer clay.
Inspired by Laura Liska's bargello series.
Photo by Doug Barber

THE BEST WAY TO create the illusion of depth is to use colors that flow naturally from a darker, bluer, and desaturated version of a color to a lighter, yellower, and brighter version of the same color.

When Laura Liska was working in polymer clay in the 1990s, she created gorgeous beads based on this principle. Laura is no longer working in polymer and has graciously agreed to share her technique.

**1.** Mix mud into each of the three bright colors in a series of six steps going from pure to muted. You can use color scales to determine the proportion of mud in each step, or you can just "wing it." Sheet at your pasta machine's medium setting. Cut a 2 x 2-inch square of each color. Stack the squares, starting with the first color and going from bright to dark, followed by the second and third colors.

**2.** Cut the stack into three equal pieces. Connect the three pieces to make a wide cane with the three sets of the stripes next to each other. Push them together to get rid of any air bubbles. Cut a 1/8-inch piece off the end of the cane and run it through the pasta machine at the thickest setting with the stripes going vertically. Then run through again at the medium setting. Squeeze the edges of the clay sheet as it goes into the pasta machine to be sure the stripes don't spread. The cooler and firmer the striped sheet, the easier it will be to use.

*(continued)*

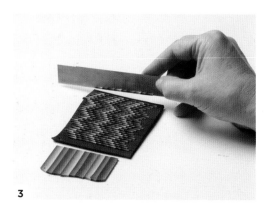

**3.** Prepare the base for the beads by sheeting out your mud at a medium setting. The warmer and stickier the base, the better. Cut thin strips from the striped sheet. Keeping the strip attached to the blade, place it carefully on the base sheet. It helps to gently rock the blade forward, then pull it gently to the side to release the strip from the blade onto the base. Depending on the pattern you want, place the next strip in a position slightly shifted from the first strip. Continue adding strips until the base is covered.

**4.** Using the 1 ½-inch circle cutter, cut two circles from the base for the back and front of the bead. Sheet some scrap clay at the pasta machine's thickest setting. Using the ¾-inch square cutter, cut out a square of clay. Ball it up and flatten it. Place the flattened ball in the center of the "wrong" side of one of the circles. Place the other circle on top (check to be sure the strips are running the same way on the front and back) and gently pinch the edges together.

**5.** Using the ³⁄₁₆-inch circle cutter, cut two circles of the base clay. Push them onto the top and bottom of the bead to define the location of the holes. Pierce a hole through the bead by first going through one end, then the other (or drill a hole through the top and bottom after baking). Bake according to the manufacturer's directions.

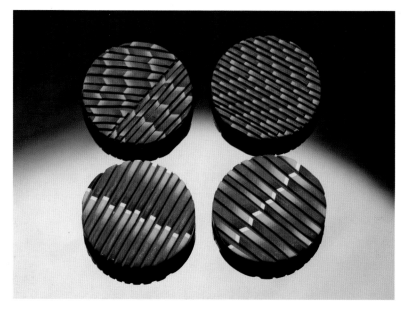

**LINDLY HAUNANI.** *Diagonal Bargello Brooches.* Each 2 inches in diameter. Polymer clay. Laura's bargello technique can be used to make more than beads. In this collection of circle brooches, Lindly cut the stripe canes at two different widths and arranged them in four different patterns.
Photo by Doug Barber

CERAMIC ARTIST KATHLEEN DUSTIN, MFA, has been working with polymer clay since the early 1980s and has developed many of her own techniques. A member of the League of New Hampshire Craftsmen, she has been a juror for numerous national shows. She maintains a busy schedule of juried shows throughout the year and teaches workshops around the United States and in Europe. Many of her luscious color combinations come directly from observing nature.

*Having a pretty good grounding in color theory from my formal art training, I feel I have the ability to organize colors to express what I want or to make a good composition. What is more intuitive, however, and continually changing in my work is color mixing and color choice. I almost never use a color straight from the package. I'll mix an interesting green, then cut that into eight pieces and add a small amount of different colors to each portion—maybe white to one, ecru to another, a teeny bit of red to another, yellow to another, and "mud" to another. The pieces work well together because they have the same base green, yet all are different. The resulting richness of color enables me to achieve a successful organic quality.*

*For my Blowing Grass Purse [see page 66], I first mixed a large Skinner blend made with four colors arranged into five segments—purple, ecru, green, ecru, and peachy-orange. I then cut this blend into six pieces crosswise to include the entire blend in each piece. I added small amounts of other colors to each blend and mixed each in. I ended up with six variations of one Skinner blend and rolled pieces of grass out of each blend, then assembled them into one clump of grass. These variations, called color shifting, can become extremely powerful when used together in the same piece of art.*

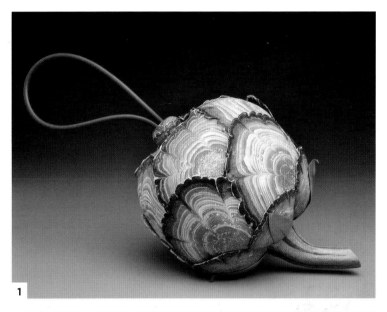

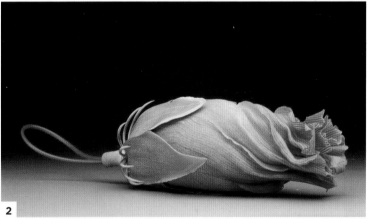

**1.** *Zinnia Bud Purse.* 6 x 5 x 5 inches. Polymer clay and rubber cord.
Hollow; constructed over a form, then cut into a top and bottom piece; a rubber-cord strap holds the two parts together. The light caramel outline along the pod petals accentuates the edge by contrasting with the dark spruce. The color flows in the interior of the pod petals have been alternated and realigned just as they might appear in nature.

**2.** *Hibiscus Purse.* 11 x 4 x 4 inches. Polymer clay and rubber cord.
Hollow-form construction. The color flows from the base to the tip of the purse and accentuates the overlapping and fluting of the petals while adding definition to the form.
Photos by Charley Freiberg

CHAPTER SIX

# Orchestrating Color Combinations

ALL COLOR COMBINATIONS ARE NOT equal. Some are more successful than others. One of the most important factors that determine whether or not a color combination will be successful is the appropriate use of contrast. When you combine two or more colors, their relationship can always be described in terms of contrast. The contrast—differences between colors—helps us, when viewing objects, to distinguish between the background and foreground. The more alike the two are, the less contrast there is. The more dissimilar they are, the more contrast there is.

# COLOR SCHEMES

THE FARTHER APART TWO colors are on the three-dimensional color model (see page 30) the more contrast there is. As Johannes Itten wrote in *The Elements of Color* (first published, in 1963, as *The Art of Color*), "We speak of contrasts when distinct differences can be perceived between two compared effects. . . . Our sense organs can function only by means of comparison."

When you made your collage in Chapter Three (see page 44), you were asked to choose clippings that appealed to you instinctively. You probably included many different color combinations. As you considered each new clipping, one of the decisions you made—perhaps intuitively—was whether the contrasts of hue, value, and saturation related to the rest of your collage.

Orchestrating a successful color scheme includes making choices to emphasize or de-emphasize contrasts. High contrasts of hue, value, and saturation make for bright, bold, emphatic color combinations, while low contrasts make for softer, calmer combinations. Depending on what you are designing, too little or too much contrast within a color scheme can be disastrous.

Value contrasts are most important, as they help to differentiate images and define patterns, especially when colors are used on a small scale, as is often the case when canes are reduced.

Contrast of saturation can help establish the mood of a color combination. Color schemes with low saturation contrast are often more subdued, moody, and elegant. Color combinations with high saturation contrast are often more lively, energetic, and jazzy.

There are many ideas about what makes a successful color scheme. Traditional color theories are based on analogies to music, with color schemes equivalent to musical chords. Just as chords in Western music are based upon the intervals between eight notes in an octave, color chords are based upon the intervals between colors on a color wheel. As in music, certain combinations produce harmony and others dissonance, depending on the context and the viewer.

### ORANGE AND BLUE TWISTS
Selecting colors based on a hue harmony is just the first step in designing a color scheme. These nine variations of an orange and blue complementary color scheme are very different due to changes in the value and saturation.

# HUE CONTRASTS

THE SIX HUE HARMONIES, as illustrated on the color triangles shown on the illustration Hue Harmonies and Contrasts, may be used as a starting point to help you select colors for a project based on the degree of contrast you are seeking. You may feel more comfortable with the low hue contrast combinations—achromatic, monochromatic, or analogous. Or you may have a preference for the hue harmonies with the highest degree of contrast—triadic, polychromatic (the scheme you used when designing your Color Inspiration Collage in Chapter Three, on page 44), or complementary.

## Achromatic/Low Hue Contrast

*Achromatic*, which literally means "without color or hue," is used to describe color combinations that feature the neutrals—umbers, grays, and browns, which are low saturation and therefore have a low degree of hue. Black-and-white color schemes are also considered to be achromatic; in this case, the degree of value contrast is high, but there is no hue contrast.

## Monochromatic/Low Hue Contrast

This type of color scheme features variations of a single hue. Unless you carefully consider the contrast of value and saturation, this can become a boring scheme—great for background wallpaper in a small room, but perhaps not so great for making canes, where legibility is desired when the cane is reduced in size.

## Analogous/Low Hue Contrast

This scheme incorporates between two and six hues that are adjacent on the color triangle. Analogous color schemes can be safe, quiet, and visually pleasing without the risk of discordant hue contrasts. Visual blending of adjacent hues can help create the illusion of graded washes of color. Hues with values that offer more contrast—for example, yellow to blue or yellow to red—can add excitement and dimensionality to your color scheme.

## Triadic/High Hue Contrast

This scheme is based on three hues. One example of a triadic color scheme is magenta, yellow, and blue. Another is the three secondary hues—orange, violet, and green. Groupings of threes are pleasing to the eye and are considered to be harmonious.

## Complementaries/High Hue Contrast

This high-contrast scheme features two hues directly opposite one another on the hue triangle. When complementary hues are mixed together, either physically or visually, the result is a muddy brown or a near gray. When the same colors are juxtaposed, they seem to vibrate.

## Polychromatic/High Hue Contrast

These color schemes include many colors from all sections of the hue triangle. These rich, complex color schemes could be every other color on the triangle or one from each of the hue families. Since the value contrasts are already high, your saturation choices become crucial in conveying your intended message.

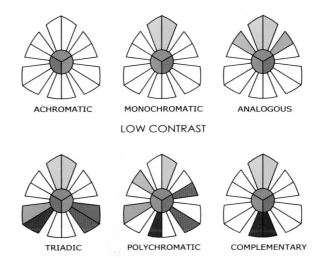

ACHROMATIC     MONOCHROMATIC     ANALOGOUS

LOW CONTRAST

TRIADIC     POLYCHROMATIC     COMPLEMENTARY

HIGH CONTRAST

**HUE HARMONIES AND CONTRASTS**
Limiting the predominant hues used in a project to a color scheme based on the standard hue harmonies can give you a foundation on which to build your projects.

# VALUE KEYS

A MUSICAL ANALOGY IS useful in describing value contrasts. Think of the various schemes as keys. There are five basic value keys that can be used to describe value contrasts within a color scheme. (See Value Keys.)

## High Key/Low Value Contrast

This color scheme includes white and light-value colors. An example of a high-key value scheme: the pastels of Easter, yellow, sky-blue, and mint-green combined with white. High-key value schemes can be soothing, calming, serene, and uplifting—or lacking in definition, insipid, and boring.

## Mid-Key/Low Value Contrast

A mid-key value scheme includes hues that fall into the light, medium, and dark range. An example: the combination of cherry-red, emerald-green, and turquoise-blue, three hues that are close in value. If you made a cane using these colors and reduced it to a small size, the detail in the cane would disappear, because there is not enough value contrast.

## Low Key/Low Value Contrast

Blacks and darks in combination are low-key color schemes. Black, purple, and indigo in combination are an example. Low key value schemes can be elegant, serious, and somber—or dark, murky, and depressing.

## Full Key/High Value Contrast

This value scheme includes a full range of values, from dark to light and including medium-value colors. A Skinner blend roll cane made from violet to white with a darkened violet (black added) is an example of a full-key color scheme. Canes made using a full-key value scheme will usually remain readable even when they are reduced to a very small scale.

## Black and White/High Value Contrast

This scheme provides the highest degree of contrast—very light (white) juxtaposed with very dark (black). When used on a small scale, as in thin stripes or a dense pattern, this scheme may appear to include gray and may read as being full key.

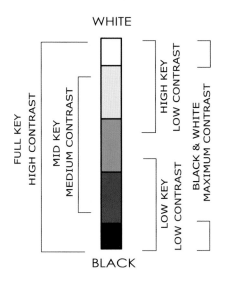

**VALUE KEYS**

Understanding the differences in the feelings produced by the different value keys can help you communicate the message you want to convey in your projects.

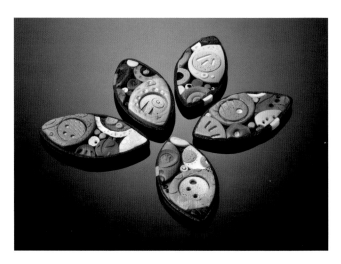

**DOROTHY GREYNOLDS.** *Dimensional Pendant Beads #2.*
Each 1¹/₂ x 2³/₄ x ³/₄ inches. Polymer clay.
"The 'exchange' bead concept gives me a variety of colors and designs—*mokume-gane*, mosaic, textured bright colors, and swirls of chocolate—to experiment with."
Photo by Eric Smith

# SATURATION CONTRASTS

THE THIRD PROPERTY OF color—saturation—also comes into play when we analyze contrasts. There are five basic saturation contrasts, ranging from low to high. The closer a color is to another on the three-dimensional model of color (see page 30), the less saturation contrast there is. (See illustration Saturation Contrasts.)

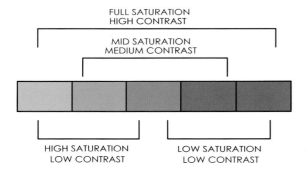

**SATURATION CONTRASTS**
Selecting most of your colors from just one of the saturation families can give your projects a unified look.

### High Hue Saturation/Low Saturation Contrast
The pure hues are high in saturation; when they are used together, there is a low degree of saturation contrast. Lime-green in combination with tomato-red is a high hue contrast combination, but it has both low saturation and low value contrast.

### Low Hue Saturation/Low Saturation Contrast
Neutral and muted hues are low in saturation; when used together, they exhibit a low degree of saturation contrast. An example of this contrast: using caramel, umber, and brick together.

### Medium Hue Saturation/Medium Saturation Contrast
A color scheme that uses pure, muted, and neutral colors has a medium degree of saturation contrast. An example of this contrast: using purple, eggplant, and brown together.

### Full Saturation Range/High Saturation Contrast
Ranging through all degrees of saturation—pure, muted, and neutral—this color scheme is a high saturation contrast. An example of this contrast: using lime-green, spruce-green, and gray together.

### High Hue Saturation with Neutral/High Saturation Contrast
Combining a fully saturated hue with a neutral hue makes for a high contrast saturation scheme. Neon yellow with neutral gray is an example.

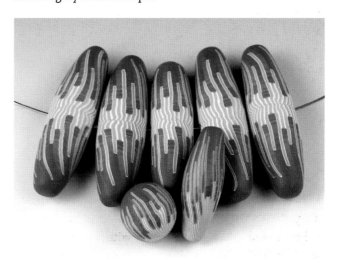

**MELANIE WEST.** *Wonky Pod Beads.* Largest bead 1 x 1½ inches. Polymer clay.
"I approach color the way I approach most of my life. I start with intuition and inspiration, and fine-tune with training and experience."
Photo by Melanie West

# YOUR COLLAGE: Contrast Analysis

EXAMINE YOUR COLLAGE AND describe the three contrasts—hue, value, and saturation. Are they all high contrast? Or all low contrast? Or does your collage contain differing degrees of the three different contrasts?

---

**STUDIO TOOL** | ## Contrast Table

---

A CONTRAST TABLE IS a baked record of the colors you plan to use in a color scheme. Making a contrast table prior to embarking on a project is extremely helpful, as it allows you to:

- PRACTICE YOUR COLOR MIXING (AND MATCHING) SKILLS
- SEE JUST HOW (AND WHETHER) THE COLORS CHANGE DURING BAKING
- ARCHIVE (FOR FUTURE REFERENCE) A SPECIFIC COLOR COMBINATION

Using your collage as a reference, choose the seven most predominant colors in your collage. You may opt to use the seven colors you mixed in the Instinctual Color-Mixing exercise in Chapter Four (see page 60).

**LINDLY'S CONTRAST TABLE**
Contrast table with clay stripes of the predominant colors of Lindly's collage before and after trimming.

### MATERIALS

- ¼-OUNCE PORTIONS OF EACH OF YOUR SEVEN COLORS
- 1 OUNCE OF DARK MUD (5 PARTS BLACK, 1 PART RED, 1 PART BLUE, AND 1 PART YELLOW; TO BE USED AS YOUR BASE FOR YOUR CONTRAST TABLE)
- 1-INCH CIRCLE CUTTER
- CONTRAST TABLE TEMPLATE: A 4 X 2½-INCH RECTANGLE MADE FROM CARD STOCK

**EVALUATE**

Did any of your colors become significantly darker during baking? How would this affect your choices when mixing these colors for another project? Would you change any colors that you were planning to use next to each other?

**1.** Sheet your color mixes on your pasta machine's medium setting and cut them into strips about 2¾ inch long x ½ inch wide. Set aside the leftover trimmings so you can compare these unbaked samples to the baked color samples in the completed contrast table.

**2.** Prepare the base for your contrast table by sheeting your dark mud on the machine's medium setting. Using the contrast table template, trim the dark mud sheet into a rectangle 4 x 2½ inches.

**3.** Arrange the ½-inch-wide strips of each color ⅛ inch apart on your template.

**4.** Place a base sheet of clay on top of your strip array on the template and press gently to adhere. Trim the edges of your strips, then turn the piece right side up. Remove the card.

**5.** Label the back with pie-chart labels (see page 16) of the primaries you used to mix the colors. Bake according to the manufacturer's directions.

# Studies in Red and Green

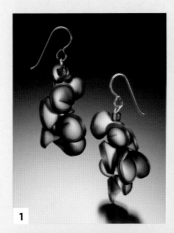

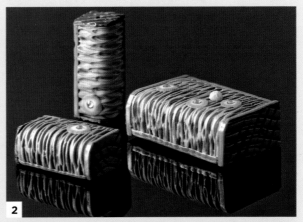

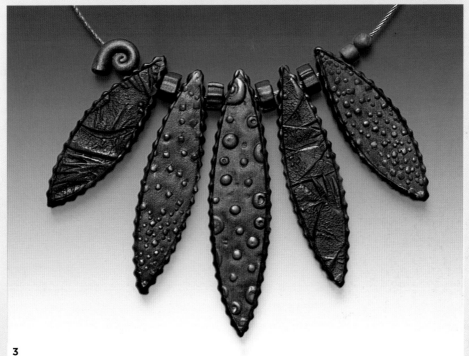

**1. LINDLY HAUNANI.** *Green Pinched-Petal Earrings.* 2 x ½ inches. Polymer clay and niobium ear wires.
The lime-green to dark emerald-green cane used to make these earrings provides a striking value contrast and helps add drama to the simple petal shapes.
Photo by Hap Sakwa

**2. CRISTINA ALMEIDA.** *Wavy Rock Series—Coralic Bead Set.* Largest bead 1 x 1⅞ inches. Polymer clay and Swarovski crystals.
The moss to brick-red Skinner blends have been latticed over the spruce-green base beads. Cristina maximized the deep texture in these beads by using a darker-value green underneath.
Photo by Paulo Almeida

**3. LAURA TABAKMAN.** *Five Pods—Fuchsia/Yellow Necklace.* Center pod 2¾ x 3½ x 7/32 inches. Polymer clay on steel cable.
Texturing the edges on the pods adds detail and interest to the shape. The small moss-green bead on the upper right provides accent to the analogous color combination.
Photo by Laura Tabakman

## Stripe Blends

- 2 OUNCES OF YOUR MAGENTA
- 2 OUNCES PLUS $1/2$ OUNCE OF YOUR BLUE
- 4 OUNCES PLUS $1/8$ OUNCE OF YOUR YELLOW
- 2 OUNCES OF WHITE
- 1 $1/2$ OUNCES OF BLACK
- 2 OUNCES OF TRANSLUCENT CLAY
- *OPTIONAL:* 6 OUNCES OF SCRAP CLAY, WELL CONDITIONED—TO USE AS A BACKING SHEET FOR THE STRIPES AT YOUR PASTA MACHINE'S THICKEST SETTING; WHEN RUN THROUGH THE MACHINE AT A MEDIUM SETTING, IT WILL DOUBLE THE AMOUNT OF YOUR STRIPE BLEND.
- RAINBOW SKINNER BLEND TEMPLATE (SEE PAGE 19)
- FAN DECK TEMPLATE (1 X $5^1/2$-INCH RECTANGLE MADE FROM CARD STOCK)
- STRIPE SETUP TEMPLATE (3 X 5 $1/2$-INCH RECTANGLE MADE FROM CARD STOCK). YOU WILL COMBINE STRIPS FROM TWO DIFFERENT SHEETS OF CLAY TO MAKE A STRIPE BLEND THAT FITS INTO YOUR PASTA MACHINE.

THE AMOUNT OF CLAY called for in this exercise allows you to make eight stripe blend sheets with different degrees of hue, value, and saturation contrasts. Using your fan deck template, you will archive a portion of each of these sheets for your fan deck; you'll use the remaining blends to make the log cabin pin project later in the chapter.

**1.** Using the rainbow Skinner blend instructions (see page 19), make a rainbow Skinner blend using 4 ounces of your yellow, 2 ounces of your magenta, and 2 ounces of your blue. Sheet this clay on your pasta machine's thickest setting. Align the stripe setup template across the rainbow and cut two 3 x $5^1/2$–inch rectangles that include all the colors. Mix the clay left over from making the rectangles to make a mud that is 2 parts yellow, 1 part red, and 1 part blue.

**2.** Cut one of the rainbow blend rectangles into vertical strips about $1/4$ inch wide, to make a total of twenty-two strips of different colors. Repeat with the other rainbow blend rectangle.

**3.** Mix four colors for the in-between stripes:

- SUNLIGHT: 1 OUNCE WHITE PLUS $1/8$ OUNCE YELLOW
- ECRU: 1 OUNCE WHITE PLUS 1/16 OUNCE OF MUD
- COOL SHADOW: 1 OUNCE BLACK PLUS $1/2$ OUNCE BLUE
- DARK MUD: $1/2$ OUNCE BLACK PLUS $1/2$ OUNCE MUD

Sheet each of the colors on your pasta machine's thickest setting, folding and rolling until you have a square that's 3 x 3 inches. Cut each of these four pieces into $1/4$-inch strips. Start with the sunlight blend and alternate eleven $1/4$-inch strips cut from your rainbow blend with eleven strips cut from the sunlight mixture, pushing the edges together as you go. You can arrange your rainbow blend colors sequentially, in accordance with a hue harmony, or randomly. Another option is to use portions of your collage for inspiration. Repeat this to make three more sets of strips with your ecru, cool shadow, and dark mud.

**4.** Roll out the translucent clay on your pasta machine's thinnest setting, and cut the sheet into four pieces. Across each set of strips, place one sheet, which will hold the strips together initially as they are blended in the machine.

**5.** Once all four sets of strips are ready, remove the templates. Starting on your pasta machine's thickest setting, and with the stripes perpendicular to your work surface, all colors touching the rollers, begin blending and folding as you would for a Skinner blend, twenty times, ending by sheeting the clay on a medium setting.

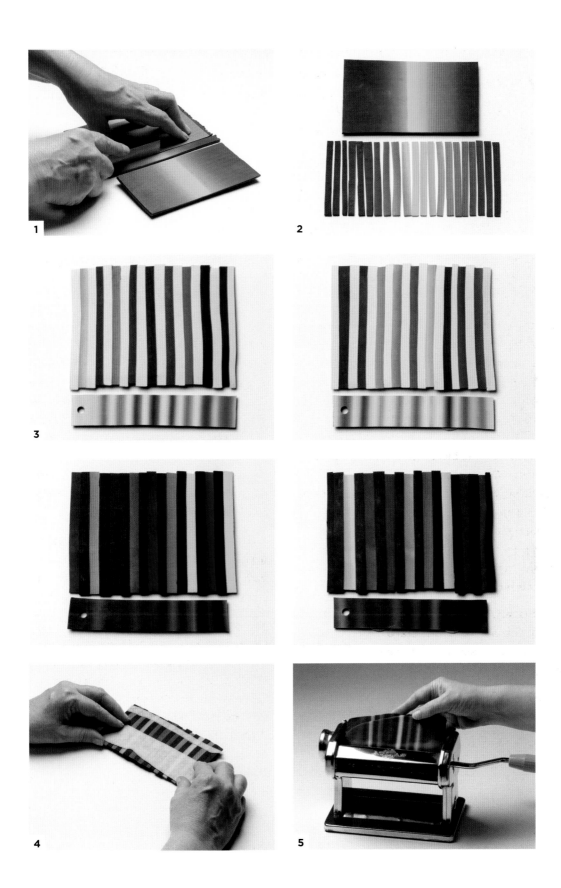

## Log Cabin Pin

Project design by Lindly Haunani

**MATERIALS**

- TWO SHEETS, BOTH 2 1/2 INCHES WIDE AND 5 1/2 INCHES LONG, OF YOUR STRIPE BLENDS, ROLLED OUT TO MEDIUM THICKNESS. VALUE CONTRAST IS KEY TO MAKING THIS DESIGN WORK: USE ONE LIGHT-VALUE SHEET AND ONE DARK-VALUE SHEET.

- 1 OUNCE OF DARK MUD OR BLACK CLAY ROLLED OUT ON YOUR PASTA MACHINE'S NEXT-TO-THICKEST SETTING. THIS WILL BE USED TO BACK YOUR PIN.

- SMALL RULER

- TWO 4 X 6-INCH INDEX CARDS

- 4 X 4-INCH SQUARE OF 50-GRIT SANDPAPER

- 1- TO 2-INCH PIN BACK

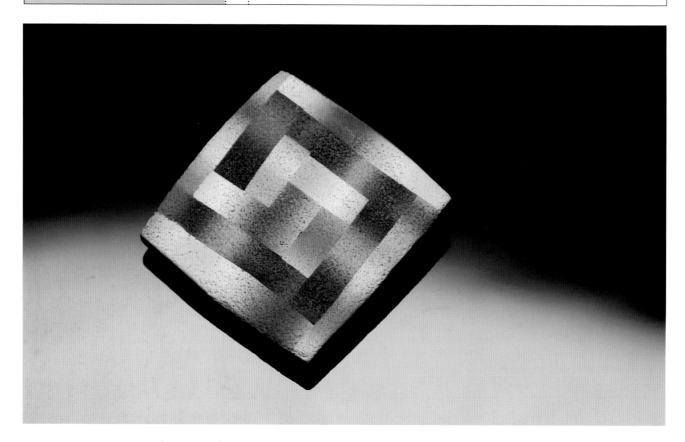

TEXTILE PATTERNS ARE A rich source of inspiration; of the many variations of piecing fabric strips together, dozens are easily adaptable to polymer clay. The log cabin is a popular quilting block pattern that is made using strips of fabric in a "spiraling" pattern.

In 2005, when our Color Explorers group first met in Santa Fe, we arrived with several inspiring pieces—three from Karen Sexton and two from Dorothy Greynolds—that featured their unique variations of stripe blends and two sets of generously provided notes on just how they made their blends. While brainstorming for ideas on how to put these laminate sheets of stripes together, Carol Simmons made a log cabin pin, and soon we were all trying our own variations with our own color palettes.

Further refinements ensued, and as more artists experimented with their own variations of adapting textile patterns using these stripe-blend sheets, it became evident that having several different stripe blends on hand is an excellent way to explore combining colors.

**LINDLY HAUNANI.** *Log Cabin Pin.* 1 3/4 x 1 3/4 x 1/4 inches. Polymer clay. To create the pattern, Lindly combines two stripe blends, one with tinted muds and one with shaded muds.
Photo by Doug Barber

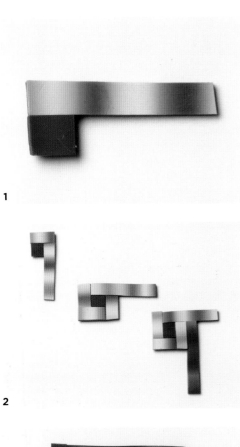

**1**

**2**

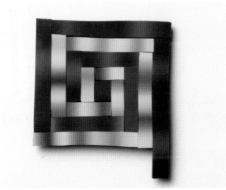

**3**

**4**

**1.** Cut each of the clay sheets into ¼-inch-wide strips across the stripes, using an index card as a cutting guide for your blade. Cut off a ¼-inch square of a dark stripe and place it on the center of the index card. Align one of the light-value strips to one edge of this square.

**2.** Rotate the index card a quarter turn, and align your second strip on the next side of the center square. Trim the first strip to the edge of where the strips meet, and repeat for the next two sides.

**3.** Switch to the darker strips, repeating this four times, then switch back to the lighter strips. Continue alternating sets of four dark and light strips until the design is slightly larger than your desired finished piece. Feel free to trim your strips, before placing them so that the same colors are not abutting on adjacent sides. (See Log Cabin Construction.)

**4.** Apply a backing sheet of dark mud or black. Gently press the sandpaper into the front of your design to impart a fabriclike texture and smooth out any of the seams, then press. Trim the edges to the desired shape. Cut three ½-inch-long strips of your stripes, abut them, and gently press to connect them, and use these to attach your pin back. Bake according to the manufacturer's directions.

**LOG CABIN CONSTRUCTION**
Start with a dark square, then follow the numbers on the pattern to lay out the stripes of color.

WHEN A FLEDGLING polymer clay community was developing in the San Francisco Bay Area in the early 1990s, Sarah Shriver gained recognition for her intricate millefiori beads. Today she continues to make her distinctive beads and teach her techniques around the world. She has taught all over the United States, and has traveled and taught in England, France, Israel, and Germany. Originally she did all her work in high-contrast ivory and black, with an occasional touch of deep red. Once she decided to add more color, she applied everything she knew about using contrasts to develop her new color schemes. Her current work is distinguished by a masterful use of the Skinner blend in beautiful colorways inspired by famous paintings.

*I began making beads in 1987, inspired by a polymer clay necklace made by Martha Breen of Urban Tribe in the early eighties. I used a lot of bold graphic patterns, often in black and ivory, because I liked the way they mimicked the look and feel of scrimshaw. I was also influenced by African, Asian, and European textile patterns. In 1997, when Judith Skinner shared her color-blending techniques, I was able to achieve a more painterly look in my canes and discovered a whole new language of color.*

**1.** *Orange and green necklace with earrings.* Necklace 21 inches long; beads in necklace and earrings 1 and 1½ inches long. Polymer clay, gold-filled ear wires, carnelian, and brass beads. The dark ochre edges of the lime-green beads help to add definition and cohesion to the necklace.

**2.** *Poppy Board.* 8 x 14 inches. Polymer clay.
When Sarah makes her large canes, she cuts slices off the components as she works in order to archive the cane's evolution. She intentionally exaggerates all the color contrasts, especially value contrasts, in anticipation of reducing the completed series of canes to a very small size. On the right side of the board Sarah has auditioned a Skinner blend as a possible background for the poppy petals.

Photos by George Post (top) and Sarah Shriver (bottom)

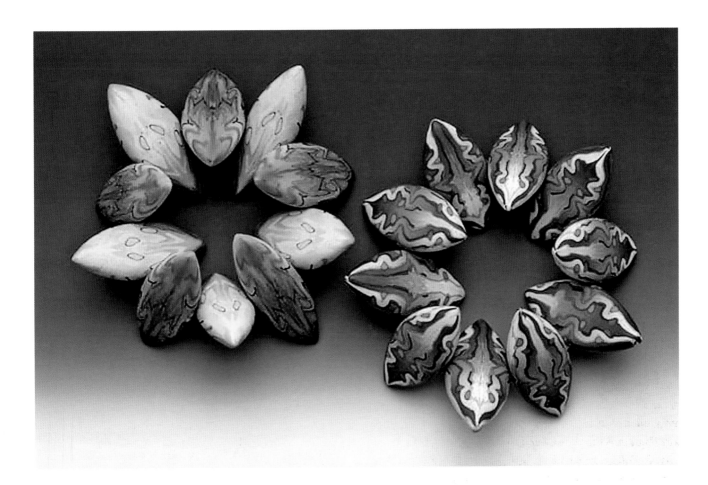

In addition to studying paintings, I am constantly looking at the infinite combinations of colors in the natural world—the richest and most direct source of dynamic color. I drag bits and pieces of my garden into the studio to sit right next to my clay while I attempt to mix an approximation of the hue and luminosity of the found objects.

I usually build my canes to a very large size—6 to 8 pounds and 4 to 5 inches in diameter. Before I begin to build, I do a series of detailed drawings to figure out both the color schemes and the placement of the visual elements, sometimes taking a very long time to mix and remix sheets of color blends. I compose the cane from blocks of color I've prepared, and think of them as pieces of a three-dimensional puzzle. After constructing the cane, I generally cut it apart into many smaller canes that use different parts of the image and modify each one by "kaleidoscoping" or mirroring them until I have a series of different but related canes. I love knowing that I can generate a virtually infinite array of intricate patterns through this process.

I would be remiss if I didn't credit polymer clay itself as my teacher, because it alone has enabled me to combine construction techniques, which seems to be my natural language of expression, with the highly emotional world of color.

**SARAH SHRIVER.** *Two petal bracelets.* Each bracelet 8½ inches long; individual beads range from ½ to ¾ inch wide and are 2 inches long. Polymer clay and rubber Buna cord. While the shapes of each of the individual beads are the same, the different color flows animate the surfaces and add dimension to these elegant bracelets.

Photo by George Post

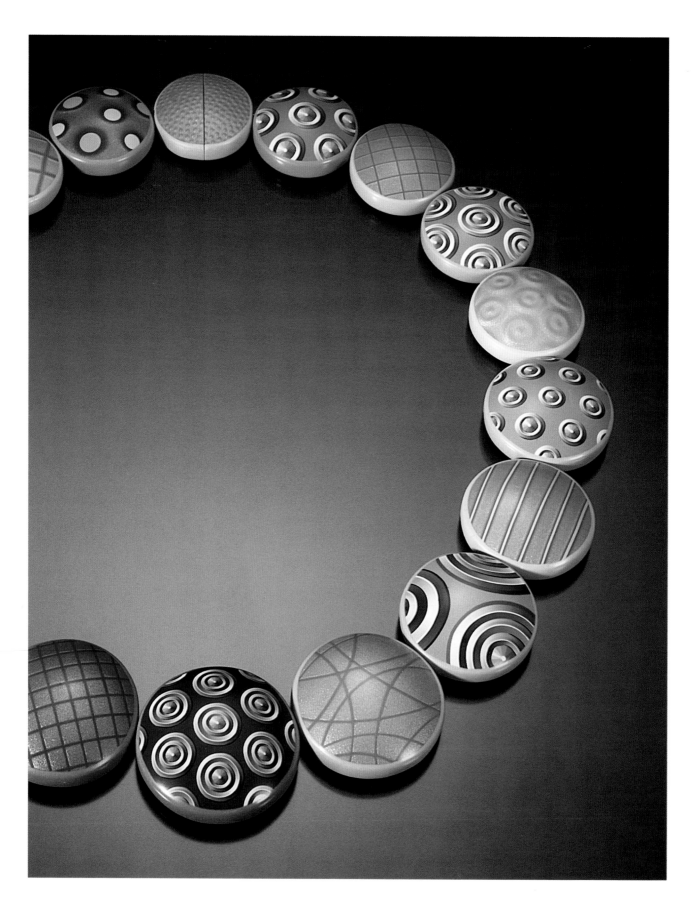

CHAPTER SEVEN

# Playing Games with Color

ARTIST AND TEACHER OF color Josef Albers said, "All color is relative." No color is ever seen alone. At a minimum, there is always a background. More often, colors are surrounded by many other colors and seen in relationship to all of them. Because colors are always seen in the context of other colors, they can affect the appearance of each other in a variety of ways.

# OPTICAL SHIFTING

WE SAW IN CHAPTER TWO that the temperature of a color can be relative—that its apparent temperature shifts depending on what it is compared to. A color need not physically change; it can change optically. Our eyes make adjustments to colors all the time. Optical shifts have to do with the way the cones in our eyes receive red, green, and blue stimulation. In very simplistic terms, when one set of cones is over-stimulated, it becomes fatigued and other cones take up the slack. The result is what is called an *afterimage*. (See Afterimages.)

Colors can shift in two ways: to appear to be more different or to appear to be more similar. Simultaneous contrast is the term used to describe the optical effect that occurs when colors shift to appear more different. We can also think of simultaneous contrast as the "pushing away" effect of one color on an adjacent color. In this case, the colors' properties appear changed to create more contrast between the colors. The typical illustration for this is one color surrounded by two different colors. (See One Color Appears to Be Two.)

### ONE COLOR APPEARS TO BE TWO
Color shifting pushes the inside color away from the surrounding color by optically adding the opposite properties. Using two colors that are opposite in all three properties creates maximum optical shifting.

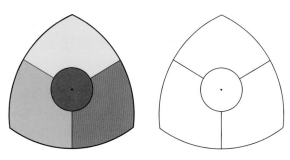

### AFTERIMAGES
Optical shifting is often caused by afterimages. Focus your eyes on the spot in the center of the colored triangle above for 30 seconds. Blink once, then focus on the spot in the center of the blank triangle. Let your eyes relax. You should see colors that are the visual opposite of the colors in the triangle. These are afterimages.

### SIMULTANEOUS CONTRAST—HUE
Colors shift in hue to only a small degree, depending on what they are surrounded by.

### SIMULTANEOUS CONTRAST—VALUE
The greatest degree of color shift occurs in value.

### SIMULTANEOUS CONTRAST—SATURATION
Saturation is the property least affected by color shifting.

**NAAMA ZAMIR.** *Spring Vase.* 10 inches tall. Polymer clay on glass. Bright canework flowers work their way through half the color circle—from yellow to violet—in a progression of colors.
Photo by Naama Zamir

*Optical mixing* is the term used to describe the optical effect that occurs when the eye blends adjacent colors. *Assimilation* describes the optical effect that occurs when colors shift and appear visually connected to adjacent colors in a pattern. Both phenomena can be thought of as the "pulling together" effect of one color on another. (See Optical Mixing and Assimilation.)

**OPTICAL MIXING**
When colors are repeated close together, the eye blends them by averaging the hue, value, and saturation of all the colors. Notice that the orange with blue stripes looks dark and muddy in comparison to that same orange with yellow stripes.

**ASSIMILATION**
The eye connects adjacent colors into a pattern and shifts them closer together in appearance. The squares of green on the left are optically connected into a line pattern with the yellow and so the green appears yellower. On the right, the same color of green squares connect with the blue and therefore appear bluer.

Which version of optical shifting takes place is dependent on two interconnecting variables—the colors' visual weight, and the distance from which they are viewed.

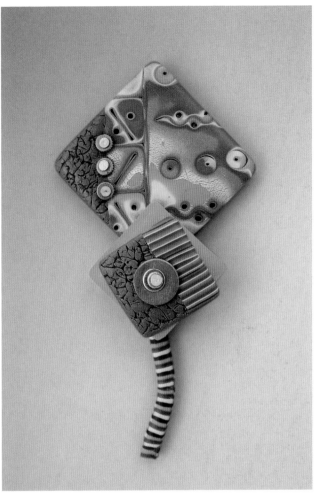

**JULIE PICARELLO.** *Flying Kite.* 1½ x 3 x ½ inches. Polymer clay, aluminum leaf, and brass and copper washers.
In this blue-and-orange color scheme, the pastel indigo provides contrast to the bright oranges.
Photo by Julie Picarello

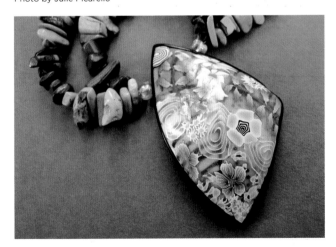

**RITA SHARON.** *Necklace.* 18 inches long. Polymer clay, silk-screened and painted with acrylic paint.
Flower canes are a fun way to play with optical shifting and outlining.
Photo by Rita Sharon

## Push and Pull Stripes

MATERIALS

- 2 OUNCES EACH OF THREE COLORS FROM YOUR PALETTE—DARK, MEDIUM, AND LIGHT VALUES

**MAKING A SET OF** stripe canes is a great way to see the effects of optical mixing and assimilation using colors.

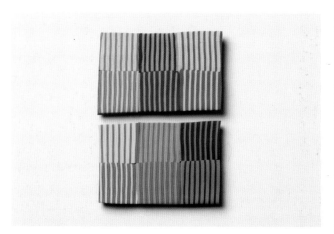

**PUSH AND PULL: LINDLY'S STRIPES**
The photo shows six different color combinations of stripes. The colors appear to change when their relative thickness is changed from thin to thick in the canes.

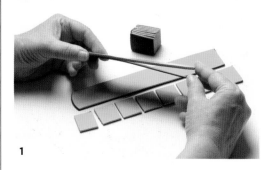

**1.** Select three colors from your palette. If you are using soft clay, leach it overnight (see page 13). Sheet two-thirds of each color at your pasta machine's thickest setting and one-third at the medium setting. Cut out a 1 x 5-inch strip from two different colors—one from a thick sheet and one from a thin sheet—and combine. Run the combined sheets lengthwise through the machine at the thickest setting to get rid of air bubbles to reduce the thickness of the stripes. Cut each two-colored strip into eight equal pieces and stack.

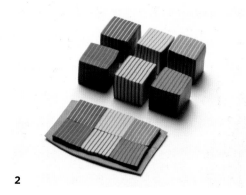

**2.** Make six different colored stacks, alternating the thick and thin sheets of each color to make six stripe canes. Cut ¹/₁₆-inch slices as samples from each stack, and lay them out on a sheet of scrap clay.

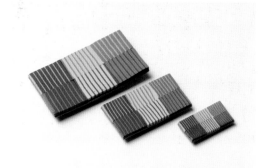

**3.** Reduce each of the stacked canes to ¹/₂ inch square. Cut ¹/₁₆-inch slices as samples from each cane and lay them out on a sheet of scrap clay. Reduce the remaining canes to ¹/₄-inch square; cut samples from each stack and lay them out on a sheet of scrap clay. Trim the edges. Bake according to the manufacturer's directions.

**EVALUATE**

Which colors are pushing away and which are pulling together? At what point in the reduction of a cane is one optical effect replaced by the other? Notice that the closer together the properties, the sooner the colors start to pull together.

## PROJECT

### Leaves and Berries Collar

*Project inspired by Pier Voulkos*

**MATERIALS**

- 2 OUNCES EACH OF FIVE COLORS FROM YOUR PALETTE (FOR THE LEAVES AND BERRIES)
- 2 OUNCES EACH OF TWO DARK NEUTRAL COLORS FROM YOUR PALETTE (FOR WRAPS)
- 2 OUNCES EACH OF TWO MIDDLE-VALUE NEUTRAL COLORS FROM YOUR PALETTE (FOR WRAPS)
- FOUR TOOTHPICKS OR BEAD MANDRELS OF A SIMILAR SIZE
- STRINGING SUPPLIES
- CLASP

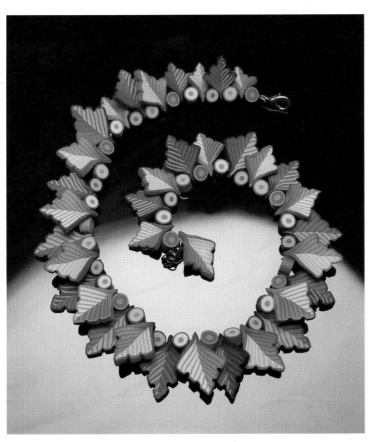

**MAGGIE MAGGIO.** *Leaves and Berries Necklace.* 16 inches long. Polymer clay. The variety in the colors is multiplied by the use of optical effects, which play one color off another in the simple design of the leaves and berries.

Photo by Doug Barber

**1.** Following instructions for the Push and Pull Stripes exercise, make at least six combinations of striped canes using colors from your collage. Once you have the colors stacked, cut the stacks in half diagonally from the top layer to the bottom layer.

THIS PROJECT WILL ALLOW you to experience the principles of assimilation and simultaneity at work, while you make two different canes, a stripe and a bull's-eye, in several different color combinations.

The striped leaves illustrate various stages of visual blending that depend on the amount of contrast between the stripes and the amount of reduction in the cane. The berries (described last in the steps below) illustrate simultaneous contrast—one center color wrapped in four different colors appears to be four different colors.

**2.** Flip half of each stack upside down and combine different stacks into leaves. Make half the stacks darker combinations and half the stacks brighter. After making the leaves, wrap the darker leaves in the dark neutrals and the brighter leaves in the middle-value neutral colors with a sheet of medium thick clay.

**3.** Reduce each leaf cane to ¹/₂-inch square. Reshape the cane to make it more of a diamond shape. Then reduce one end of the cane so that it tapers from ¹/₂ inch to ¹/₄ inch. When you slice it, later on, you will have a variety of leaf sizes to use in your necklace. Lay four toothpicks along the two top edges of the leaves, making sure the stripes in the cane are pointing downward, and press them into the length of the cane to make indentations in the leaves. Remove the toothpicks. Cut the canes into slices that are ¹/₁₆ inch thick.

**4.** To finish forming your leaves, take a slice of your leaf cane and press firmly at the bottom to warm your clay and slightly flatten it. Slowly, fold the bottom ¹/₄ inch of the cane together and gently pinch it together to form the stem of your leaf. Make a hole using your pin tool (or drill later). Bake according to the manufacturer's directions.

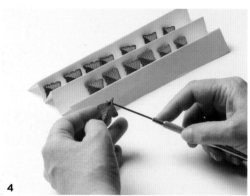

**5.** To make the berries, select one color to be in the center of each cane. Snake that color to between ¹/₈ and ¹/₄ inch in diameter and 10 inches long. Cut it into five pieces. Select five inner wrapping colors and sheet them at a thin setting. Cut 2 x 6–inch sheets of each of these. Attach the 2-inch-long edge of each of these thin sheets to a 2-inch piece of the snake, then roll these sheets around to wrap your five canes.

**6.** Sheet the neutral colors at a medium-thin setting, and wrap once around the logs and butt join. Reduce each log to between ¹/₈ and ¹/₄ inch in diameter. Cut these canes into ¹/₄-inch thick slices and pierce (or drill after baking). Bake according to the manufacturer's directions.

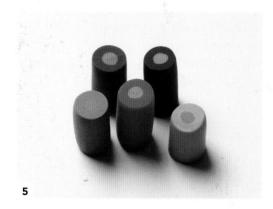

Before stringing the collar, lay out 16 inches of beads. Graduate the sizes by putting the larger leaves in the middle and the smaller leaves on the ends. Alternate the darker and brighter leaves, then put a berry between each leaf as you string beads and berries on your preferred stringing material. Add a clasp to one end and a chain with a slice of a leaf cane as a toggle to the other end.

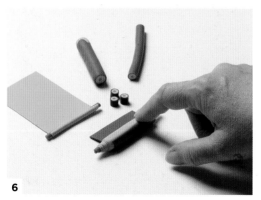

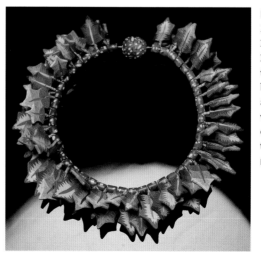

**PIER VOULKOS.**
*Leaf Necklace.* 20 inches long.
Polymer clay.
Notice how the tube beads that alternate with the leaf beads range in color from a brilliant tomato-red to a violet, ending with a polymer clay–covered barrel clasp in those two colors.
Photo by Doug Barber

DAN CORMIER HAS BEEN a full-time artist, innovator, and teacher in polymer clay since a serendipitous encounter with the medium in 1992. He earned recognition in the North American polymer clay community when he taught his innovative "perfect fit" vessel construction techniques at the first international polymer clay conference at Ravensdale, Washington, in 1996. His precision and meticulous attention to detail is reflected in his caning technique, which he calls "matrix caning." Much sought-after teachers, Dan and his partner, Tracy Holmes, have taught widely across the United States, Europe, and Asia.

*Color and polymer clay are so intrinsically connected that color comes to life in three dimensions in this material. It is color made physical, and that's one of the reasons I find this medium so seductive.*

*Most of my work first takes shape in my sketchbook, but when I begin to get hands-on in the studio, color becomes the most important consideration. I'll first develop a palette through playful experimentation, mixing and matching colors until I get something that feels right. When I've decided on a scheme, I'll document my color formulas so that I can mix large enough batches to do a small series of pieces. When it's time to do the actual physical process of preparing the colors, I will often spend a couple of days just mixing and sheeting my clay through my pasta machine. This immersion in pure color is for me one of the most satisfying aspects of working in this medium.*

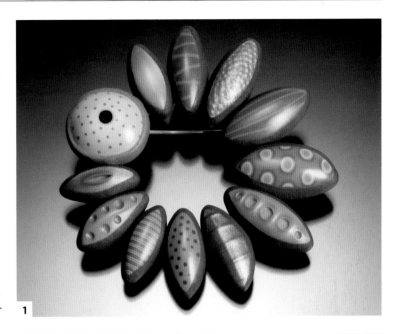

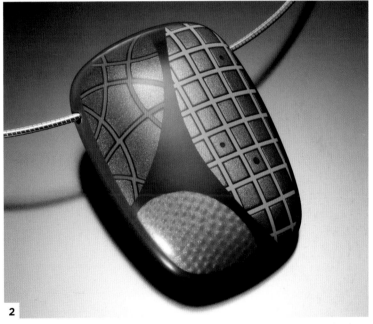

**1.** *Botanical Pin.* 2½ x 2½ inches. Polymer clay, aluminum armature, silver wire, "cutting edge" veneers, and die-formed constructions.
Hallmarks of Dan's pieces are precision of form and the sleekness of the surfaces. His attention to detail helps showcase the contrasts of color within his pieces. The lime-green focal bead in conjunction with the magenta beads creates the tension of maximized hue contrast. The repetition of the dots is a unifying graphical element.

**2.** *Thong Choker.* 1½ x 2 inches. "Cutting edge" polymer clay veneers with die-formed construction.
The small dots of magenta in the turquoise grid provide balance to the composition.
Photos by Robert Diamante

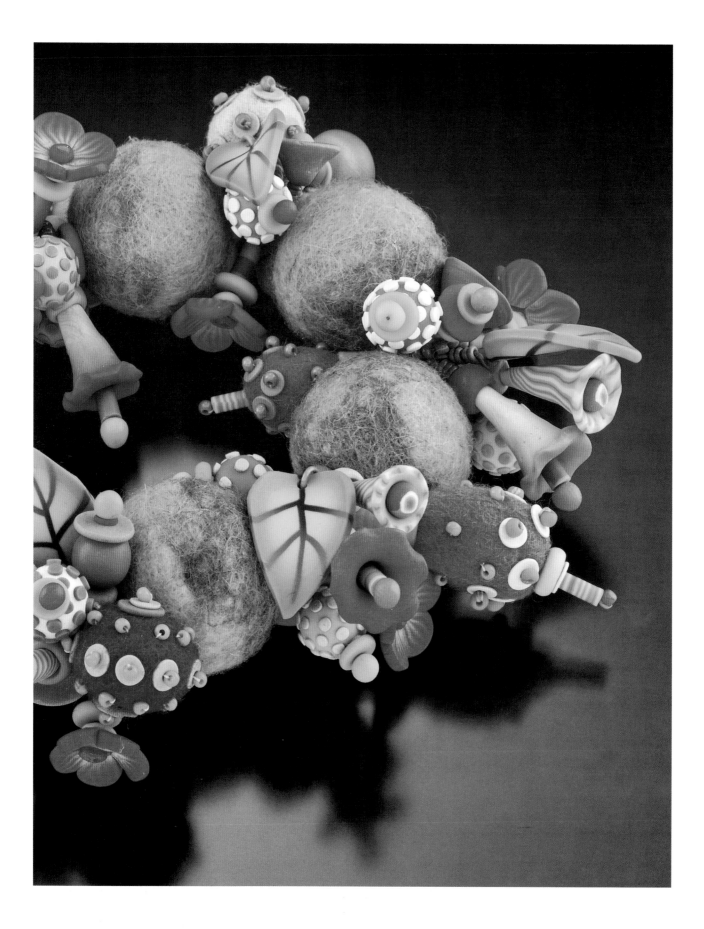

# Exploring Color Composition: Placement and Proportion

**IN THIS CHAPTER YOU WILL** continue combining knowledge and instinct as you examine the critical importance of placement and proportion to the effectiveness of a color scheme. Consider the orchestration involved in making the Mediterranean fish stew called bouillabaisse. The placement and proportion of the components are both important in making this dish successful. Perhaps you don't enjoy cooking or are not familiar with making a bouillabaisse. In that case, as you read you may want to think of a different analogy—dancing, composing music, directing a play, or designing software, something that you feel very comfortable doing.

## WORKING TOWARD A DYNAMIC BALANCE

AT ITS BEST, A bouillabaisse is an exquisite marriage of flavors, aromas, textures, and colors, intensified by a careful balance of melded flavors, distinctive elements, and surprising accents and spice notes, within the framework of the split-second timing required for adding the ingredients. Too much saffron or garlic tends to make the stew bitter and, in the extreme, inedible. If the fish is overcooked, the stew turns into an insipid mush. A dark and murky broth—rather than one that is brilliantly clear—will overpower the briny delicacy of the seafood. But just enough of everything, in the right proportions, results in ambrosia.

In *Interaction of Color* (1963), Josef Albers also used an analogy, but instead of ingredients in a recipe, he referred to colors as actors in a play. Not every actor has a starring role. Some play the leads, others are the supporting actors, and still others are walk-ons. All are needed for the play to be successful.

Cooking a wonderful dish and producing a successful play are nearly as subjective as working with colors. When you are designing color schemes, stay away from overpowering darks and overly insistent spice notes, and avoid creating murky areas that may occur with insufficient value contrast. If a piece you are designing doesn't feel right, you may need to remove colors or add an accent color. Or increasing a value contrast may be just the spark that is needed.

The next time you see a color scheme you don't like—a room design, carpet, painting, piece of fabric—consider why. Perhaps you simply don't care for the predominant color, or you sense an imbalance. Is it because the design lacks contrasts? Identifying why a color scheme doesn't work can be just as valuable as identifying the aspects of designs that please you. When designing your color schemes, remember that the colors should work together to enhance intentions. Such orchestration can play an important role as you make color choices, examine and redefine contrast, and ultimately make decisions about the proportional relationships of the colors.

Interior designers often use the 60–30–10 "rule" to help keep the colors they are using in proportional balance. This rule determines the ratio of three colors, including their variations that are used in a design. Sixty percent is the portion devoted to the main color, a 30 percent portion is the contrasting "interest" color, and a 10 percent portion is the accent color. You may adapt this strategy as a starting point when designing your projects.

When you design a color scheme, decide early on which color will be dominant. You may want to include it in several variations, and perhaps assign a deep dark or a light tint of the same color a role as a supporting color. Accent colors should be in keeping with the degree of contrast you are seeking in the overall scheme. Take the time to experiment with proportions and placement in a piece before committing to a final design.

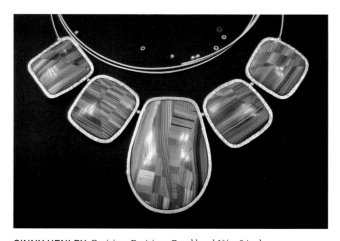

**GINNY HENLEY.** *Decisions Decisions.* Focal bead 1⅞ x 2 inches. Polymer clay, fabricated brass, and glass beads.
"When I am working with colors, often another shade will yell at me from the sidelines. Hey! What about me? Sometimes I prefer to go for minimalism, and other times I prefer to go over the top."
Photo by Ginny Henley

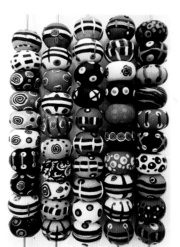

**PONSAWAN SILA.** *Fifty Beads.* 1 x ½ inches. Polymer clay. "In making these beads I challenged myself to come up with fifty different designs using only four colors—black, white, grey, and brown with a hint of gold."
Photo by Ponsawan Sila

# PROPORTION

IN ORDER TO BALANCE the visual weights of colors in a composition, it is often necessary to adjust their relative sizes. This concept is usually illustrated via the image of a balancing scale or a child's seesaw. If we take the same amount of each of the six pure colors and compare the complements with each other, we see that the yellow is visually much stronger/heavier than its complement (violet), that orange has more visual weight than blue, and that magenta and green are similar in visual weight. (See illustration Proportional Seesaws.) In order to make the complements appear balanced, the amount of yellow in relation to violet must be reduced so that it is much smaller in proportion to the violet. The orange must also be reduced in size, but not by as much.

Goethe devised a proportional chart to diagram the relationship of visual weight to size. He assigned each color a number from 1 to 10, with 10 as the greatest weight. (See Goethe's Weighting System.) Goethe considered balance to be aesthetically pleasing and recommended using the numbers to mathematically determine the proportion of each color to include for visual balance.

How do the numbers in Goethe's weighting system work in the attempt to find balance? The numbers can be used in ratios. For example, the yellow to violet ratio is 3:9, which is the same as 1:3. If you are using yellow and violet, use three times as much violet as yellow for a visually balanced color scheme.

Although this idea is useful, we think it's better to rely on your instincts rather than on a numbering system to determine proportions in a composition. What is important to understand is that colors that are strong affect the colors around them to a greater degree than colors that are weak, and that you can reduce their effect by reducing their size in relation to the weaker colors.

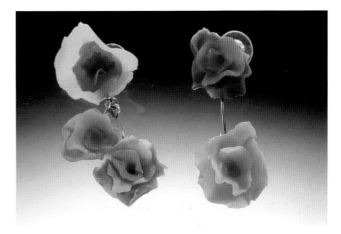

**GLORIA ASKIN.** *Sweet Flowered Earrings.* 2¹/₂ x 1¹/₄ inches. Polymer clay and silver wire.
The asymmetrical arrangement of these organic shapes makes for a lively design. The three sets of purple petals function as anchors to the composition.
Photo by Norman Watkins

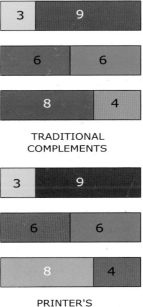

TRADITIONAL
COMPLEMENTS

PRINTER'S
COMPLEMENTS

**GOETHE'S WEIGHTING SYSTEM**
Recognizing that each of the pure hues has a different visual weight, Goethe gave each a number on a scale of 1 to 10, with 10 as the greatest weight.

HEAVYWEIGHT COLOR     LIGHTWEIGHT COLOR

**PROPORTIONAL SEESAWS**
If you want to balance the visual weight of colors, it helps to imagine them on a seesaw.

## PLACEMENT

NINETEENTH-CENTURY SCIENTIST Wilhelm von Bezold discovered that he could change the entire appearance of a design by changing just one color in the design. This is called the Bezold effect. There are two variations of this effect. In one, changing a large field of color, such as the background, to another color changes the appearance of the colors in the overall design. The second, called the "spreading effect," involves changing the color of the outline, or key line; if an outline surrounding a design is dark, the overall design appears to be darker, while a design with a light outline appears to be lighter. Both variations show how important placement of color is to the overall design. (See Bezold Effect.)

### BEZOLD EFFECT
In one variation of the Bezold effect, changing just one color in a design—in this example, the background color—changes the design's appearance. You can observe the "spreading effect" in the small, square central elements in the designs above.

Placement choices are influenced by your compositional preferences. Just as the properties of color are interconnected, your preferences for color, contrast, and composition are also interconnected. We have found that collages, such as the one you created in Chapter Three (see page 44), provide excellent clues to an artist's personal preferences.

## USING YOUR COLLAGES

OVER THE YEARS WE have amassed a collection of more than one hundred color collages. Many are from group sharing during our color workshops. In addition to adding students' collages to our collection, we have made several in response to specific color challenges we gave ourselves. For example, we have a dozen yellow-and-blue collages, some of which feature proportionally much more yellow than blue, and vice versa. Others feature emphatic saturation contrasts, such as one that uses bright, vibrant ultramarine-blue as an accent for a mostly umber-based composition.

Sometimes we hang this collage collection on several walls in a classroom setting. Aside from being an impressive array, it provides valuable clues to compositional preferences. For example, Maggie's collages tend to feature more clippings, a lot of straight lines and rectangles, and architectural features. Her colors tend to include more earth colors with dramatic value contrasts. Lindly's collages are much more curvilinear, include fewer clippings, and often employ triangles, diagonals, and areas of overlap. Her colors tend to include more rainbow pastels and earth pastels with dark neutrals. These respective color and compositional preferences are often evidenced in our polymer clay work.

Take a moment to examine your collage, which provides valuable clues to your compositional and color preferences. Are there lots of straight lines or more curves? Have you included repeated motifs? What hue and what proportional size are the accent colors you used to help move your eyes throughout the composition? Are there areas of dense pattern or large washes of color? How can you translate this knowledge to your polymer clay projects?

MAGGIE MAGGIO. *Folk Art Box.* 3 inches diameter x 1 inch high. Polymer clay. This small openwork box was made after doing a quick audition of color placement for the flower petals.
Photo by Roger Schreiber

# EXERCISE:

## Proportional Contrast Table

**MATERIALS**

- ¼-OUNCE PORTIONS OF EACH OF YOUR SEVEN COLORS

- 1 OUNCE DARK MUD—5 PARTS BLACK, 1 PART RED, 1 PART BLUE, AND 1 PART YELLOW (TO BE USED FOR THE BASE OF YOUR CONTRAST TABLE)

- 1-INCH CIRCLE CUTTER

- CONTRAST TABLE TEMPLATE: A 4 X 2½-INCH RECTANGLE, MADE FROM CARD STOCK

THIS CONTRAST TABLE IS a variation of the one you made in Chapter Six (see page 84). Rather than making each of the color strips even in dimension, you will now vary their widths to reflect the proportion of that color that appears in your collage. You will then lay thin strips of each of these colors across the width of the table and indicate the simultaneous contrast between each of the colors.

Choose the seven most predominant colors in your collage. Remember to include any neutrals, darks, and lights that may appear. You may opt to use the seven colors you mixed in the Instinctual Color Mixing Exercise in Chapter Four (see page 60), and adjust these mixes using what you learned about darkening while baking when you mixed the colors for your first contrast table in Chapter Six.

**1.** Sheet your color mixes on your pasta machine's medium setting, and cut them into strips 2¾ inches long and with a width that reflects the amount of that color in your collage. Set these strips aside.

**2.** Prepare the base for your contrast table by sheeting your dark mud on your pasta machine's medium setting. Trim the dark mud sheet into a rectangle 4 x 2½ inches, using the contrast table template. Arrange the strips ⅛ inch apart on your template.

**3.** Place the base sheet of clay on top of your strip array on the template, and press gently to adhere. Trim the edges of your strips, then turn the piece right side up. Remove the card.

**4.** Cut thin strips (⅛ x 4¼ inch) of each of your colors, and arrange them in a horizontal grid across the table. Press gently to adhere.

**5.** On the back of your contrast table, attach pie-chart recipes for the primaries you have used according to the instructions on page 16. Archiving the primaries is especially important if you are using customized primaries. Bake according to the manufacturer's directions.

**PROPORTIONAL CONTRAST TABLE**
Proportional contrast table in Lindly's palette, before and after adding the horizontal strips.

**EVALUATE**

Would you change any colors you were planning to use next to each other to compensate for the simultaneous contrast? Look closely at one of the horizontal color strips as it runs across the color bands—which colors effect the most change? How would this affect your choices when mixing these colors for another project?

## Mosaic Leaf Brooch

Project design by Lindly Haunani

### MATERIALS

- ½ OUNCE OF YOUR MAGENTA
- ½ OUNCE OF YOUR BLUE
- 1 OUNCE OF YOUR YELLOW
- 1 OUNCE OF YOUR MUD
  (THE AMOUNT YOU USE DETERMINED
  BY THE LEVEL OF SATURATION IN
  YOUR COLLAGE; USE THE REST FOR
  BACKING THE MOSAIC)
- WALNUT-SIZE PIECES OF PREMIXED
  "GROUT" COLORS
- ½ OUNCE OF A CONTRASTING
  COLOR CLAY (THIS WILL BE USED TO
  OUTLINE THE EDGES YOUR BROOCH)
- LIQUID POLYMER CLAY
  (FOR ATTACHING EDGING AND PIN
  BACK TO THE BAKED AND GROUTED
  MOSAIC)
- SMALL, STIFF PIECE OF PLASTIC
  (A PERFECT USE FOR EXPIRED
  CREDIT CARDS)
- ISOPROPYL ALCOHOL WIPES
- PIN TOOL
- PIN BACK(S)

THIS PROJECT EXAMINES THE importance of placement and proportion while making a mosaic leaf brooch. We encourage you to make more than one so that you can see how just how different a color combination is when there is a change in even only one color—in this case, the "grout" for the mosaic in its supporting role. Because of their shapes, all the leaf brooches pictured in this part of the chapter read as leaves, whether the bodies of the leaves are greens or magentas.

Lindly used grout colors that were inspired by her collage, including a dark blue-green, a blue-violet, a cream-yellow, a light mud (with white), a dark mud (with black), and a yellow-green.

**LINDLY HAUNANI.** *Mosaic Leaf Pin.* 1½ x 3 x ¼ inches. Polymer clay.
Lindly chose the outline color at the edge of the brooch to match the olive-green near the center of the leaf vein. The "grout" color is a dark indigo-blue, which offers value contrast.
Photo by Doug Barber

Because of the placement of the grout (throughout the entire piece) and its relative dominance, the use of different colors of grout in the leaf mosaic brooch is a good illustration of the Bezold effect (see page 104).

For your leaf brooches, you will once again use your collage as inspiration. You may need to adjust the proportion of mud used in your blend—anywhere from none at all to as much as three times the mud pictured in the photo that appears with step 1 below.

Instead of making individual mosaic tiles, for this project you will lay down strips of a Skinner blend one at a time. Before adding another strip, you will use your pin tool to make indentations in the strip to create the illusion of spacing between mosaic tiles. You will then lay down each succeeding strip of clay a pin tool's width from the previous strip. After completing this first step, you'll bake the piece, then press polymer clay into these impressions, just as mosaic tiles are grouted.

**1.** Condition and sheet your three primary colors on your pasta machine's thickest setting. Cut out triangular pieces as shown in the photo, then assemble them to make a three-color blend measuring 4 x 5½ inches. The blend pictured here includes a cadmium yellow mixed with half white and triangles of mud to slightly desaturate the oranges and greens.

**2.** Sheet your remaining mud on your pasta machine's medium setting; you will use it for the backing of the mosaic. Using your slicing blade, cut an arced section of your leaf vein color, and set this onto the middle of your backing clay sheet. Using your pin tool, held sideways, make indentations into the clay to accommodate the polymer clay grout that you'll add in the next step. Continue by laying another strip of the leaf-colored clay on your base, with a space equal to the width of your pin tool apart from the first strip, and impress the grout lines. Continue adding strips of the leaf color until you have all the leaf parts in place. Cut out your leaf shape by curving your blade and cutting straight down. Bake this piece according to the manufacturer's directions, and allow it to cool.

**3.** Warm the polymer clay you are using for your grout color by rolling it between your hands for a couple of minutes. Form this piece into a ball, then press it very firmly into your baked mosaic surface. Use the piece of stiff plastic to scrape the excess polymer clay off the top of your mosaic. Once you have removed most of the grouting clay, use an alcohol wipe to eliminate any remaining excess grout. Bake your brooch again to cure the grout color.

**4.** Once the brooch has cooled, sheet ½ ounce of clay on your pasta machine's medium setting. Use a thin strip of this to add an outline border to the piece. Cut a thin strip of the clay slightly longer than the length of one side of the leaf, with a ¼-inch seam allowance—slightly wider than the depth of the leaf. Apply a few drops of liquid polymer clay (see page 10) to the sides of the piece, spreading it with the tip of your finger. Lay the brooch, mosaic side down, on your work surface, and align the edging strip to the edge touching the table. Press gently in place. Turn the piece over, grasp it in your hand, and use your blade to trim the excess clay that overhangs the back, so the edging is flush. Bake and when your brooch has cooled, turn it over and apply the pin back according to the directions on page 20. Bake your brooch again, back side up, according to the manufacturer's directions.

1

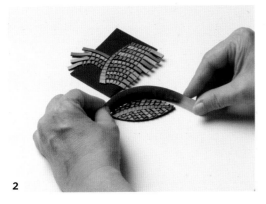

2

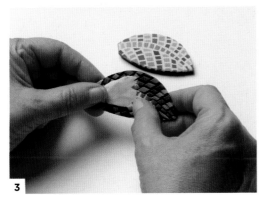

3

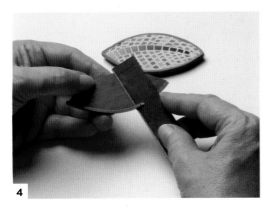

4

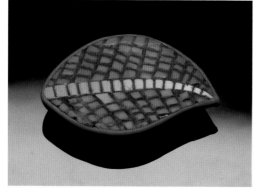

**MAGGIE MAGGIO.** *Mosaic Leaf Pin.* 1½ x 2½ inches.
Polymer clay.
The dark grout blends with the deep colors of the leaf and
highlights the center mosaic stripe.
Photo by Doug Barber

EVALUATE

Once your brooches have cooled, place them on top of your
color collage. Do they all look as if they belong? Which com-
bination do you like the best? Which one the least? How can
you incorporate what you have learned here when designing
color schemes in the future?

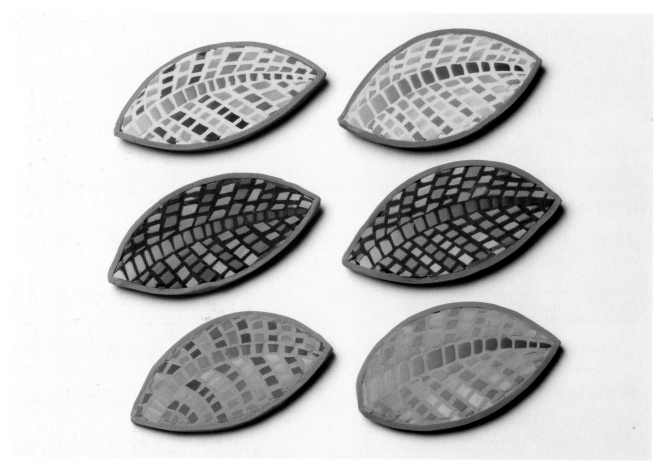

## LEAF BROOCHES

All six of these leaf brooches include the same set of colors. What has changed is their placement
and proportion, along with the color of the clay that was used as grout.

MIXED-MEDIA ARTIST DEBRA DEWOLFF'S first love was fiber art. While raising her three daughters, she quilted for fun and won prizes for her art quilts at shows around the country. It wasn't until her youngest daughter brought polymer clay beads home from summer camp in the early 1990s that Debra started to play with clay. As a quilter, it was natural for her to include fiber in her polymer clay pieces. She later learned metalsmithing so that she could include metal with her fiber and polymer clay work. Now Debra's chosen career is making and selling jewelry that beautifully combines her skills in many media.

*I've studied some color theory, but my color choices are made more by instinct than anything else, as I'm sure is the case with most artists. I tend to gravitate toward bright, saturated colors in my work, but I don't know why. It's just a personal preference, I guess. I love lots of color. Maybe it's the kid in me. Don't we all remember fondly that first big box of perfect unused crayons—the one with the sharpener built in on the back? I've heard the human eye can discern about two million different and distinct colors. That's a lot, but I wish there were even more.*

**1.** *Necklace.* Pendant 2½ x 2¾ x ¼ inches. Beaded necklace cord 16 inches long. Polymer clay, sterling silver, and peridot seed beads.
The stripes, with their subtle value differences, help add interest and dimension to the central flower's spiral.

**2.** *Untitled brooch with stand.* 2¼ x 3¾ x 1½ inches. Polymer clay, acrylic, sterling silver and 24k gold leaf.
The small red beads of color in the center of the flower repeat the dot motif while providing accent to the color combination.

**3.** *Leaf brooch.* 1¼ x 3½ x 1 ½ inches. Polymer clay and sterling silver.
The artist used two color flows. Lime-green to emerald-green and blue-violet to magenta undulate in almost equal proportions throughout this leaf-shaped brooch.

Photos by Larry Sanders

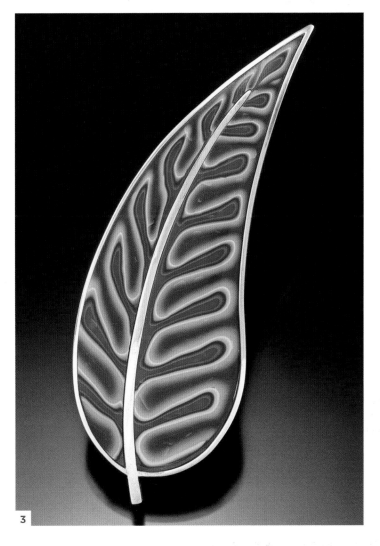

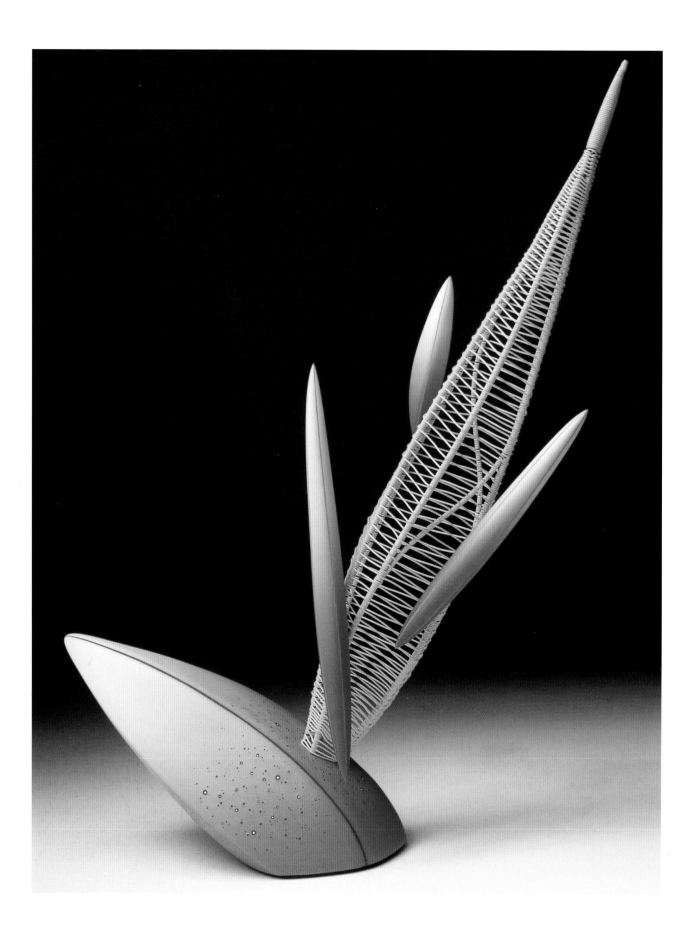

CHAPTER NINE

# Exploring Pattern and Texture in Your Colors

**IT'S TIME TO PUT ALL** the information you have learned from the previous chapters to use. In this chapter you will make patterned and textured elements inspired by your collage. You will have the chance to put into practice everything you have learned about mixing colors that flow, matching colors with exactitude, orchestrating color combinations, the games colors play, and placement and proportion. But don't think about it too much! Making small samples is a quick and fun way to explore how colors interact with each other. Think of it as brainstorming with clay. Do them fast. Play!

# PLAYFUL PATTERNS

PATTERN IS A TWO-DIMENSIONAL, decorative composition of elements repeated in an intentional arrangement. Patterns can be categorized in many ways. We like to think of patterns in four major types:

- POWDERED PATTERNS: SMALL ELEMENTS ARE REGULARLY SPACED AND ORGANIZED BY EITHER VISIBLE OR HIDDEN GRID LINES.
- STRIPED PATTERNS: THE ELEMENTS ARE LINEAR.
- FIGURE-GROUND PATTERNS: THE ELEMENTS AND BACKGROUND ARE INTERCONNECTED.
- RANDOM PATTERNS: THE ELEMENTS ARE IRREGULARLY SPACED.

As you put together patterned sheets of clay for the Pattern Sampler Bracelet project in this chapter (see page 116) and for the final project in Chapter Ten (see page 127), you will instinctively lean toward making the kinds of patterns you love the most.

Pattern preferences can be very personal. You may prefer:

- CURVED LINES OR STRAIGHT LINES
- LARGE FIELDS OF COLOR OR FINELY TEXTURED FIELDS OF COLOR
- LINEAR ELEMENTS OR ROUNDED ELEMENTS
- SYMMETRICAL OR SCATTERED ARRANGEMENTS
- REALISTIC OR ABSTRACT IMAGERY

Look at your collage. Can you identify your pattern preferences? Do the clippings that make up your collage have several elements in common? Maybe there are lots of rounded images: dots, spots, rolling hills, curved shapes, and puffy clouds. Or maybe there are more stripes than spots. Is there a lot of visual texture, or are there many large, smooth, fields of color? While most collages utilize all of the above, often one or two types of patterns dominate.

Just as you can find samples of all types of hue, value, and saturation in your collage, you can probably also find a variety of patterns. Look for examples of each of the four types of patterns noted above to reproduce in clay. In clay, some patterns do not work out as well as others, but the process of trying many variations teaches you a lot about how colors come together to make pattern.

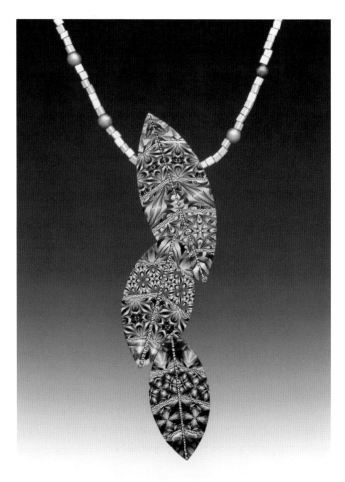

**SANDRA MCCAW.** *Falling Leaves Necklace.* Necklace 16 inches long; each leaf 3¾ x 1⅛ inches. Polymer clay, 23-karat gold leaf, and glass beads. This necklace incorporates thirteen different patterns. The differentiation in scale and the gold-leaf veining help to unify the composition.
Photo by George Post

## Making Pattern Samples

MATERIALS

- 3 X 3-INCH TEMPLATE MADE FROM CARD STOCK
- SELECTION OF WELL-CONDITIONED COLORS IN YOUR PALETTE
- X-ACTO KNIFE
- SHEET OF PAPER
- SPOON FOR BURNISHING
- ½-INCH CIRCLE CUTTER

THERE ARE MANY TECHNIQUES for making patterns in polymer clay. Making samples allows you to try out some of these pattern techniques in a short amount of time. In this exercise, you will make a collection of 3 x 3–inch pattern samples and then, in the project that follows, use some of them to make a sampler bracelet.

In the examples below, you will use color-washing to make samples of the powdered, striped, and random patterns. *Color-washing* involves stretching a thin layer of colored clay over a thick layer of white clay until the white underneath begins to show through and illuminate, or brighten, the color. Once you are familiar with the technique, you can use color-washed sheets for appliquéing designs in all kinds of different patterns. The example of a figure-ground pattern will be a checkerboard cane.

### Striped Pattern Using Color-Washed Stripes

Striped patterns are created when you repeat lines of colors in a design. The lines can vary from thick to thin and from straight to wavy. (See Striped Patterns.) Lines can be made using many different polymer clay techniques. The leaves in Chapter Seven (see page 97) are striped using canework, and the leaves in Chapter Eight (see page 106) are striped using a mosaic technique. For this sample, you will appliqué stripes cut from sheets of color-washed clay.

**STRIPED PATTERNS**

**1.** Make some color-washed sheets by covering a 2 x 2–inch sheet of white at the thickest setting with a sheet of color at the thinnest setting. Run the layered sheets, one at a time, through the pasta machine on the thickest setting; then turn the sheet 90 degrees, and run it through on the medium setting. Turn the sheet one more time at 90 degrees, and run it through on the thinnest setting.

**2.** Decide on a background color, and cut a 3 x 4–inch piece from a sheet run at the thickest setting. Cut skinny strips of clay from the different colors of watercolor sheets, and place them on the background color. Run the sheet through the pasta machine at the medium setting in the direction of the stripes. Cut out a sample using the template.

## Powdered Pattern with Color-Washed Cane Slices

Thin slices of cane, in this case a bull's eye, may be color-washed and then cut with a shape cutter and arranged to create a pattern.

**POWDERED PATTERNS**

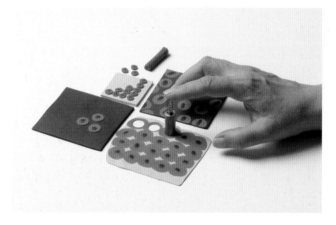

Sheet white clay at your pasta machine's thickest setting to make a 2 x 2-inch square. Cut thin slices of a bull's-eye cane (see page 98), and cover the white clay in a regular pattern. Run the white sheet with slices through the pasta machine on the thickest setting; then turn the sheet 90 degrees and run it through on the medium setting. Turn the sheet 90 degrees and run it through on the thinnest setting. Sheet a 4 x 4-inch piece of a contrasting color on the medium setting to use as the background. Use a circle cutter to cut out pieces of the bull's-eye pattern, and lay them on the background. Run it through the pasta machine or burnish with a spoon. Using the template, cut out a 3 x 3-inch sample.

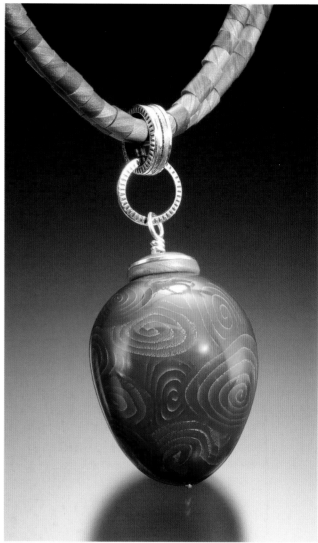

**MARGARET REGAN.** *Red Egg Pendant.* 1 x 1 x 1¹/₂ inches. Polymer clay, sterling silver, 23k gold, quail egg armature, 2-strand polymer cord.
Photo by Hap Sakwa

## Figure-Ground Pattern

The checkerboard is the simplest example of a figure-ground pattern in which all the elements interconnect. Tessellations (as seen on the right side of the Figure-Ground Patterns illustration) are examples of more complicated figure-ground patterns.

**FIGURE-GROUND PATTERNS**

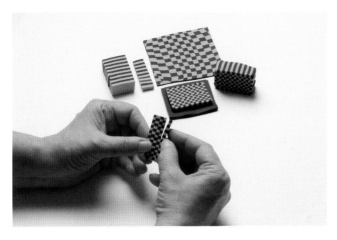

Make a stripe cane using two colors sheeted at your pasta machine's thickest setting. Cut slices from the cane in the same thickness as the machine's thickest setting. Flip every other slice to make a checkerboard pattern. Cut thin slices, and cover a 3 x 3–inch sheet of scrap clay. To smooth the slices into the background, lay a thin sheet of paper over the slices and burnish them with the back of a spoon. Cut out a sample using the template.

## Random Pattern: Color-Washed Appliqué

The elements in random patterns are placed without following a grid or other simple geometric scheme. Random patterns often use conversational or abstract elements. *Conversational elements* are recognizable objects or imagery used in the design. *Abstract elements* are non-recognizable motifs.

**RANDOM PATTERNS**

Make color-washed sheets in different colors. Use an X-acto knife to cut out leaves. Roll a thin snake to use for branches. Apply the leaves and branches to a thick 3 x 3–inch sheet of background. Smooth the appliqué by running it through the pasta machine at the thickest setting or burnishing it with a spoon.

## Pattern Sampler Bracelet

Project design by Maggie Maggio

**MATERIALS**

- SIX 3 X 3-INCH SHEETS OF PATTERN FROM YOUR SAMPLER SHEETS— TWO POWDERED PATTERNS, ONE STRIPED PATTERN, A FIGURE-GROUND PATTERN, AND A RANDOM PATTERN

- 2 OUNCES OF CLAY IN A DARK, COORDINATING COLOR FOR THE INNER LAYER OF THE BEADS

- PIERCING TOOL

- 14 RUBBER O RINGS OR SPACER BEADS WITH LARGE HOLES

- 12-INCH-LONG PIECE OF RUBBER BUNA CORD

- SUPERGLUE GEL

COMBINING COLORS INTO PATTERNS can be difficult. Often a successful pattern is the result of trial and error. Just as weavers often create a "sampler" to test the colors they think they want to use in a piece, it's a good idea to test your patterns with small amounts of clay before committing a large amount to a project.

**MAGGIE MAGGIO.** *Pattern Bracelet.* Twelve leaf beads, each 1½ inches long. Polymer clay.
This colorful bracelet captures the playful feeling of the slightly muted primary colors in Maggie's collage.
Photo by Doug Barber

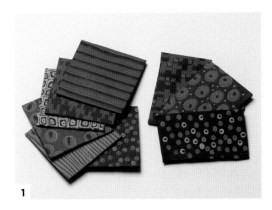

**1.** Select six pattern samples and embellish a few of them with extra pattern by adding dots or other design elements that are inspired by your collage. Cut them to 2 x 3 inches.

**2.** Layer a sample on a piece of mud sheeted at your pasta machine's thickest setting. Trim the extra mud, and cut the piece in half. Sandwich the mud between the pattern samples. Cut out three leaf shapes from the stack. Do this for all six pattern samples.

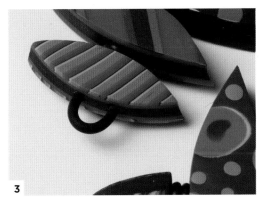

**3.** Pierce all the beads except the end bead through the middle. Pierce the end bead all the way through at an angle, then make another hole partway into the bead. Making a loop with the rubber cord at the end of the bracelet, glue the cord into the short hole to finish the closure. (See Bracelet Ends.)

**4.** Cut a small triangle bead from one of the leftover stacks to use as the toggle. Pierce this end bead halfway from the base to the point. Bake the beads according to the manufacturer's directions. Select four patterns that look the best together to use in a bracelet. String the beads on rubber Buna cord with the O rings or spacer beads placed between each bead. Use glue to attach the toggle and last bead as shown.

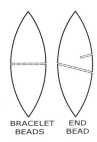

BRACELET    END
BEADS       BEAD

**BRACELET ENDS**
Pierce all but one bead horizontally through the center (or drill after baking). Pierce or drill one bead as shown.

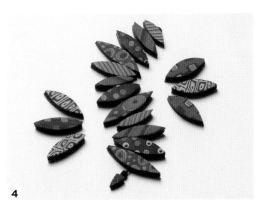

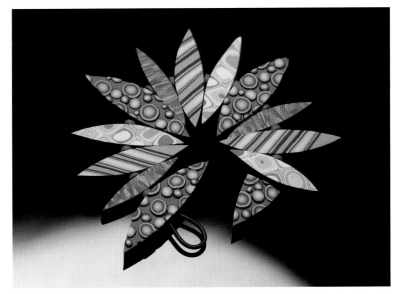

**LINDLY HAUNANI.** *Coffee Shop Pattern Bracelet.* Bracelet 9 inches long; largest bead 2 inches long x ³⁄₈ inch thick. Polymer clay, strung on rubber cord.
Lindly achieved compositional balance by including beads from each of the different patterns. The color scheme is reminiscent of the colors one might find in a breakfast café.
Photo by Doug Barber

# TANTALIZING TEXTURES

TEXTURE INFLUENCES THE PLAY of light off a piece—in both bright light and shadow—and can range from the very subtle, as in the imprint of a piece of chiffon on the surface of clay, to distinctive differences in the surface, as in onlayed, twisted pieces that rise several inches from the background. You can accentuate the perceived depth of textured areas by choosing a lighter-value color to form highlighted areas and a darker-value color to form the areas that are the lowlights or the base of a piece. You can also use variations in saturation and hue to accentuate implied or actual texture.

When working with textures, it's useful to incorporate several different scales. Combining something very small, something of medium size, and something obviously larger can add interest and balance. Depending on the size of the piece, you may choose to repeat a motif several times in different scales; for example, in the texture sample "peas" (see opposite), the peas have been made in several different sizes.

Working with texture gives you an opportunity to experiment with animating surfaces. The play of light, whether created from enhanced surface reflectivity (highlights) or deep shadows (lowlights) has an effect on the color contrasts.

The hundreds of products designed to add texture to polymer clay include roller tools, hard plastic pattern plates, and deeply cut rubber stamps. Our caveat is that many of these texturing tools produce "commercial" patterns that are easily recognizable, and they might not be the right scale and proportion for your work. We encourage you to make your own texture plates and tools from polymer clay.

You can create textures using such found objects as pieces of tree bark, seashells, onion bags, pot scrubbers, and plastic shelf liner. And you can experiment with implements designed for cooking and crafts. One of Lindly's texturing favorites is a meat tenderizer. It's heavy, which gives it heft when making impressions, and when pressed repeatedly into the clay, it makes an interesting overall design. Be creative. For example, rather than pressing a leather-embossing tool into the clay in a predictable pattern, try overlapping the impressions.

Some of the ways you can add texture to clay include:

- IMPRESSING THE CLAY
- ADDING SURFACE ELEMENTS
- CUTTING INTO THE CLAY TO CREATE SLITS OR SHAPED OPENINGS
- USING A THREE-DIMENSIONAL MOLD
- USING A CUT AND PREBAKED PATTERN SHEET THAT YOU CREATE FROM POLYMER CLAY

**TEXTURING TOOLS**
Pictured are, clockwise from upper left: (1) brass brush for cleaning barbeque grill grate, (2) meat-tenderizer mallet, (3) dog comb, (4) wire ceramic tool, (5) ravioli cutter, (6) fine-grit sandpaper, (7) plastic mesh onion bag, (8) coarse-grit sandpaper, (9) needles mounted in polymer clay, (10) round brass brush, (11) blunt-end plastic shaping tool, (12) texture roller, (13) leather stamp, (14) ball burnisher, (15) leather stamp, and (16) tapered-end shaping tool.

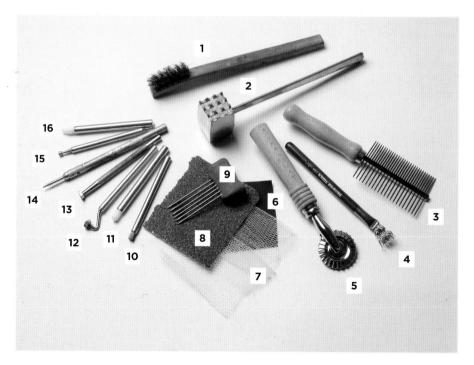

# Playing with Textures

PICTURED HERE ARE SOME ideas from Lindly's texture-sample library, to help you brainstorm your own unique texture-sample variations using polymer clay. Play and have fun doing this: If a particular texture inspires you, try several different colors, experiment with different pattern arrangements, exaggerate the textural elements, or make them more subtle.

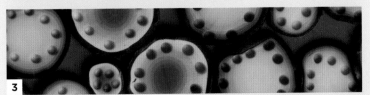

### 1. LEAF CANE SLICES IN RANDOM PATTERN

Giving each layer of clay a different texture can add visual interest. Impress your base layer with a plastic mesh onion bag. Arrange cane slices randomly. Here leaf cane slices were used, on a base sheet of clay, and then textured using a piece of chiffon fabric.

### 2. LATTICE

Make a two-color stripe cane and cut slices from it. Arrange the slices in a lattice pattern, as pictured here. Next time around, you may want to experiment with laying the stripes down randomly rather than in a grid.

### 3. DOTS IN A RANDOM PATTERN

Reduce two round two-color wrapped Skinner blend canes to several different sizes and arrange them on your base sheet of clay. A knitting needle or another tool with a rounded point may be used to impress dots into the cane slices.

### 4. STRIPS CUT WITH A RIPPLE BLADE ON A SKINNER BLEND BASE

Use a ripple blade, designed to cut waffle-cut french fries, to cut strips of rickrack from a sheet of clay. Here the strips are curved when applied to the base sheet; you may want to try a lattice or random pattern.

### 5. PEAS

After rolling small balls of clay of differing sizes and colors, apply them in a random pattern by gently pressing them onto a base sheet of clay.

### 6. LEMON CANE SLICES WITH SEEDS

Create an array of cane slices on your base sheet (pictured here are slices from a lemon cane), then impress texture using medium-grit sandpaper. You can onlay ovoid dots of polymer clay (here in the shape of lemon seeds) between the cane slices. You can make the circular dot impressions using a ball burnisher, a tool with a round ball at the end that makes rounded impressions when pressed into the clay.

### 7. REVERSED SKINNER BLEND STRIPES

To create this texture, cut ⅛-inch-wide strips out of a two-color Skinner blend sheet (see page 16). Reassemble these strips on a base sheet of clay, alternating the orientation of every other strip so that the dark and light sides of the blend start on opposite sides of your base sheet. Lightly pound the sheet with a meat-tenderizer mallet to create the overall texture.

### 8. DIMENSIONAL OVAL CUTOUTS

Texture a sheet of clay with 50-grit sandpaper, and cut out holes using an oval cutter. Lay this sheet on top of another sheet of clay. Turn the sandwich over to the back side and add small balls of clay to push up the surface of the base sheet.

## Texture Collage Pendant

Project design by Lindly Haunani

**MATERIALS**

- 2 OUNCES OF ULTRALIGHT POLYMER CLAY OR SCRAP CLAY TO MAKE PENDANT BASE
- LIQUID POLYMER CLAY
- AT LEAST FIVE PREMIXED COLORS, 1 OUNCE EACH
- ACRYLIC ROD OR BRAYER
- SELECTION OF TEXTURE TOOLS
- *OPTIONAL:* SMALL PAINTBRUSH AND BURNT-UMBER ACRYLIC PAINT

- 26 INCHES OF RUBBER BUNA CORD OR SOFT GLASS CORD, HOLLOW PLASTIC AQUARIUM TUBING THAT COMES IN COLORS
- DRILL BIT IN SAME THICKNESS AS YOUR CORD
- PIN VISE TO HOLD THE DRILL BIT WHILE DRILLING STARTER HOLES
- SUPERGLUE

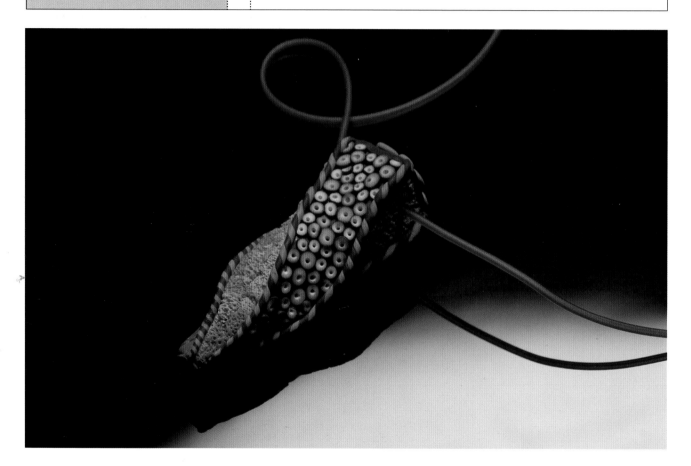

THIS PENDANT FEATURES A core of ultralight polymer clay, a specialty polymer clay made by Polyform. This clay has the consistency of marshmallows and offers two distinct advantages—it is lighter in weight than all other polymer clays, and when baked there is a surface tooth that makes attaching sheets of unbaked polymer clay to it easier. Lightening the weight of a piece by using this clay can make it more comfortable to wear. You may opt to use scrap clay instead. You will prebake the core, then add textures as sheets in three different bakings, to allow for neat seams and to avoid disturbing the textures as you apply them. The final touch is the application of a twisted cord of clay to the edges.

**LINDLY HAUNANI.**
*Guava Pendant.* 1 x 1 x 4 inches. Polymer clay with Soft Glass cord (hollow, colored plastic tubing). Strung on translucent, hollow plastic tubing, this pendant draws color inspiration from tropical fruit juices. Photo by Doug Barber

**1.** To form the base of the pendant, fashion the ultralight clay into a log, 1 x 1 inch square. Using the acrylic rod or brayer, gently roll toward one end of the log to form a point. After each roll, give the log a quarter-turn so the shape remains even. Trim both ends square, to make a pyramid 3½ inches long. Using both hands, gently grasp the shape on opposing sides, and twist the end clockwise a half-turn. Recheck the ends to see if they need retrimming to make them square. Bake according to the manufacturer's directions and allow to cool.

You will use a base sheet of colored clay that has been sheeted on your pasta machine's medium setting to create five textured sheets of clay (see page 122 for Five Textures). It will be easier if you have a "seam" allowance so you can trim the pieces after you have applied them to the pendant base. You need four pieces 1½ inches wide x 4 inches long and a top piece that is 1½ x 1½ inches square.

**2.** Pressing firmly, attach one of your texture sheets to a side section of the pendant base. Using a blade, trim the edges flush to the form. Repeat on the opposite side of the pendant base. Using a pin tool, mark a starter hole in the clay, centered and ½ inch from the pendant's top. Later on you will drill a hole here for the hanging cord. Bake according to the manufacturer's directions, and allow to cool completely before attaching the next two sides. Attach the remaining two textured sheets to the uncovered sides of the pendant base. Trim the edges flush, then cover the top of the pendant. Bake according to the manufacturer's directions, and allow to cool completely.

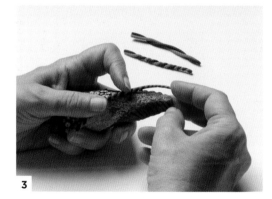

**3.** Fashion edge piping for each side using two ⅟₁₆-inch-diameter x 4-inch-long snakes of clay that have been twisted together. The piping is designed to help hide the seams between the sides and accentuate the form. Use a small bead of liquid polymer clay to attach the piping to the pendant (you are applying unbaked polymer clay to a baked polymer clay surface). Bake according to the manufacturer's directions and allow to cool. Using the starter holes you made in step 2, drill two ¼-inch-deep holes to accommodate the cord you've chosen. Apply a drop of glue to each end of the cord and glue them in place.

> **OPTIONAL**
>
> You can antique the textures by brushing the surfaces with burnt umber acrylic paint. To antique a piece of baked polymer clay, use a stiff brush to apply a liberal coating of acrylic paint, making sure that all the crevices are filled with the paint. Before the paint dries, use a paper towel to wipe off most of the paint. Allow the paint in the crevices to remain, while removing all the paint from the top surfaces.

WHEN YOU SELECTED THE patterns to use in your finished Pattern Sampler Bracelet, most likely you selected more than one kind of pattern—perhaps one with stripes, one with a scattered pattern, and one with a powdered pattern. Using a variety of patterns in one piece creates visual interest.

When making your texture pendant, use different kinds of textures in repeating colors to create a similar compositional effect. You may opt to use pieces of the texture samples you made in the exercises or to make several more to choose from when putting your piece together.

Here are instructions for five textures you might want to add to your repertoire: straight lines, a fine texture, a scattered texture, an overall texture, and a spiraled texture. These were inspired by Cynthia Toops and her *Flora 11 Necklace* (see page 21).

### Free-Form Layered Lace and Indented Stripes

The texture shown at the left is made by poking hundreds of small holes in five different versions of cherry-red clay sheeted on a pasta machine's thinnest setting. A tool designed to hold onions steady while they are cut—with six sharp, pointed metal pins mounted in a straight line in polymer clay—works well, but you can also use a pin tool. As you make more and more holes in each piece, stretch the clay with your hands and form irregular edges by tearing the edges of the pieces. Overlap these small pieces on a medium-thick sheet of pastel cherry-red.

You can make the texture shown at the right by impressing the clay with the tip and edge of a pin tool held with the full length close to the surface of the clay on a diagonal.

### Indented Dots

For this texture, reduce three wrapped Skinner blend log canes to ⅛ inch in diameter. (The canes are easier to cut if you allow them to rest for several hours or overnight before cutting.) Cut the canes into ⅛-inch-thick slices, apply them to a medium-thick sheet of base clay, then use the tip of a small knitting needle to indent the center of each slice. Pictured here are two different base colors—yellow-orange and maroon. Notice how the texture looks different on the two backgrounds.

### "Coral" Surface and Onlayed Spirals

Make the overall texture on the left by repeatedly pressing a dog comb into the clay. After applying this sheet to your pendant base, apply added texture using the comb. To get the texture on the right, roll a pea-size piece of polymer clay into a compact ball. Place it on your work surface and begin rolling it into a log, placing more pressure on the right side until it forms a pointed end. Using your fingertip, continue rolling that end until it is a snake of 1/32 inch in diameter. Cut the snake into pieces ¾ inch long. Roll the snakes gently to taper one of the ends. Starting with the tapered end, form the snakes into spirals, then attach the spirals to a sheet of medium-thick polymer clay.

JEFFREY LLOYD DEVER received his BFA degree from Atlantic Union College in 1976. He is founding partner and creative director of Dever Designs and its FreshArt illustration subsidiary in Laurel, Maryland. For twelve years he taught illustration and graphic design at the Maryland Institute College of Art. Jeff's three-dimensional illustrations have received numerous awards. His polymer clay vessels have been published widely, and he has been represented in several national survey exhibitions. Jeff is a much sought-after polymer clay instructor.

*After many years of working in the visual arts and making numerous calculated color decisions daily, the process of color selection for my artwork has become almost intuitive. It's as if color has become a visual language that I rarely slow down enough to articulate. When I do consciously think about color, contrast is one of my main concerns, whether it's contrast in value, saturation, or what I think of as color temperature (cool vs. warm). More contrast is animated, assertive, and intense, while less contrast is still, quiet, and soothing. Therefore, my question when selecting a color for a piece is what is the voice of the piece, and which is the appropriate color vocabulary? When on rare occasion I feel stumped, I look to the natural world, where plants, animals, and sea life open whole new vistas of color combinations. Some days I'll devote myself purely to experiments with color, removed from any structural context. Wherever the process takes me, there is still that epiphanal moment when the color just speaks to me and it feels right. Listen for that voice, but make sure you've studied the language.*

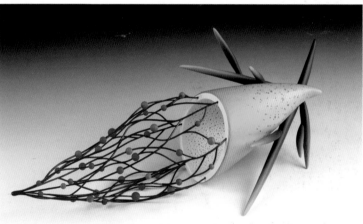

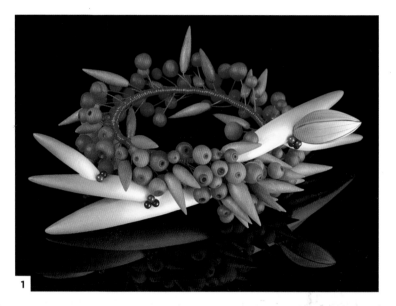

**1.** *Summer Opulence.* 5¼ x 3¾ x 1½ inches. Polymer clay, memory wire, beading cable, card stock, glass-headed pins, and plastic-coated wire.
The blue-violet accents help to unify the composition and provide counterpoint to the three different pod shapes and color blends.

**2.** *As Summer Wanes.* 18 x 8 x 6 inches. Polymer clay, aluminum wire, leather cord, and plastic-coated wire.
The spruce-green to ochre blend on the long spear pods is complemented by the crimson and scarlet reds of the berry shapes in the wire basket structure.
Photos by Gregory R. Staley

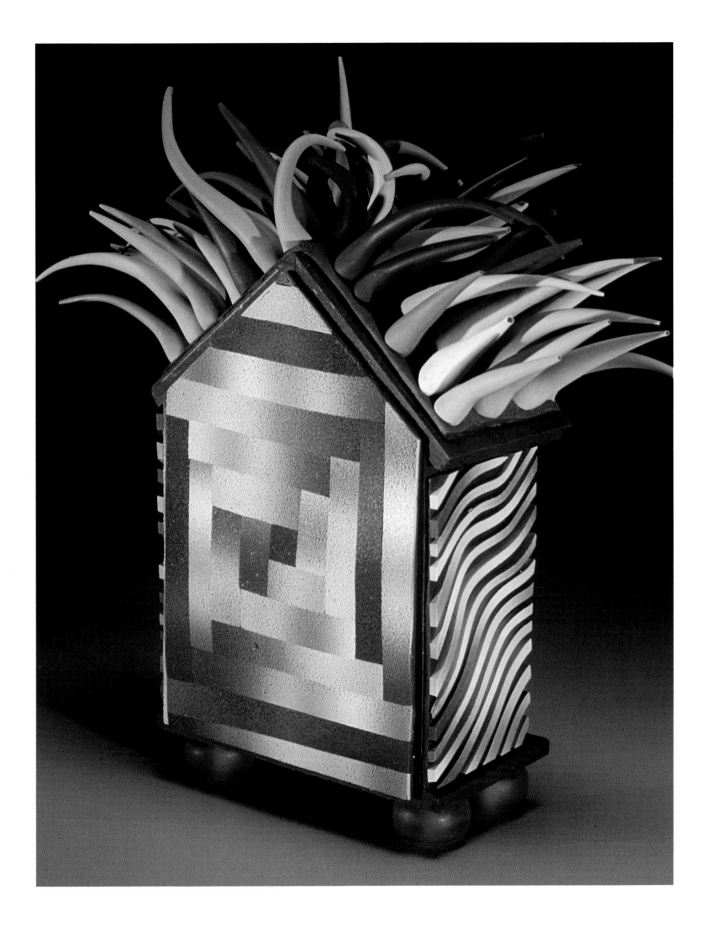

CHAPTER TEN

# Putting It All Together

AS AN EXERCISE IN COMBINING knowledge with instinct, we offer the final project in this book. Using your Color Inspiration Collage and what you have learned so far (plus, perhaps, snippets of leftover clay from earlier projects), you will now make a dimensional collage from polymer clay—a wooden box covered with polymer clay elements inspired by your Color Inspiration Collage. How literal you are in replicating the imagery in your collage is up to you. On any or all of the surfaces you can use any style, ranging from photorealism to abstract. What is most important is that you strive to translate the colors and their relationships in your Color Inspiration Collage to a collage made from polymer clay.

# PREPARING FOR THE PROJECT

POSSIBILITIES FOR YOUR BASE structure include: a wooden cigar box, a wooden box from your local craft store, or a piece of wood. The size of your project will be determined by the size of your oven and your personal preference.

When wood is used as a base to be covered with polymer clay it needs to be prebaked at 270 degrees F for a half-hour. Baking helps eliminate warping, cracking, or sap seepage onto your completed piece in the final baking stage. After the base has cooled completely, apply a thin coat of PVA glue (Sobo brand) to all the sides and any edges you wish to cover. Allow the glue to dry. This dried coating of glue makes it easier to adhere sheets of polymer clay to your piece prior to baking.

It is easier, and a lot more fun, to have a large selection of prepared polymer clay sheets on hand before you begin composing your collage.

Make between twelve and twenty pieces of polymer clay texture, pattern, and caning samples. These canes and sheets can range anywhere from 1 x 1 inch to 5 x 9 inches and may or may not include dimensional elements. If you like, you can use the samples you made in the previous chapters or the ends of canes you made while doing the projects.

As you make your collection of polymer clay swatches and canes, remember that, just as you eventually discarded and replaced some of your magazine clippings because they didn't enhance the color harmony of your collage, you may eventually end up not using all your swatches. You may not be using these sheets right away; a good place to store them temporarily is a baking sheet lined with waxed paper.

A good starting point is to pick an area of your color inspiration collage that includes an area of ombré-blended color (a blend in which color is graduated from light to dark) and make a Skinner blend.

Depending on your collage, this blend may be:

- HUE TO HUE—FOR EXAMPLE, YELLOW TO BLUE
- LIGHT TO DARK—FOR EXAMPLE, LIGHT CREAM TO YOUR VERY DARK MUD
- BRIGHT TO DESATURATED—FOR EXAMPLE, LIME-GREEN TO GRAPE
- A DESATURATED TINT TO A SLIGHTLY MORE DESATURATED VERSION OF THE COLOR WITHOUT THE TINTING—FOR EXAMPLE, CREAM-YELLOW TO CARAMEL

The most important thing is that the blend be based on your collage. Follow the instructions on pages 16–17 to make a two-color Skinner blend.

Once you have assembled your collection of polymer clay swatches for possible inclusion in your collage, arrange them so you can see all of them at once on your tabletop along with your collage. Are all the colors in your collage represented? Or do you need to mix more colors?

Are certain color combinations that appear in your collage as small accents magnified by the sheer volume of the polymer clay swatch you have made? Do you need to limit the amount of some combinations? Are the lights in the collage represented proportionally? Are the darks represented proportionally? Is there the same variety of scale and proportion of patterning as in your collage?

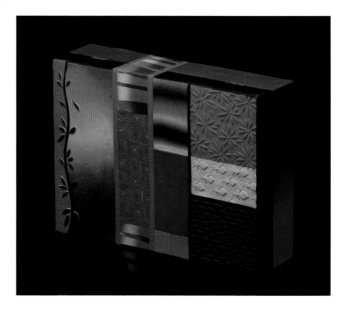

MAGGIE MAGGIO. *Color studies box.*
8 x 10 x 2½ inches. Wood and polymer clay.
Primary colors and straight lines reflect
Maggie's collage.
Photo by Doug Barber

## Collage Box

Project design by Lindly Haunani

RETRO CANE SLICES IN FOUR DIFFERENT
COLOR COMBINATIONS

**1**

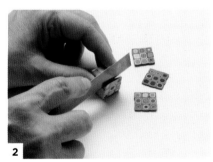

**2**

FOR THIS PROJECT YOU will cover a wooden box with polymer clay elements inspired by your color collage. If you have leftover canes or clay from previous projects, feel free to use them. This can be an opportunity to experiment with different patterns or textures. Covering the box gives you the opportunity to work on a larger scale and to experiment with combining diverse elements.

### Four Techniques

Here are four different techniques you can add to your working repertoire: an extruded "retro" cane, a tiger-roll cane, a zipper cane, and Voulkos "linoleum." All offer an opportunity to bring in some of the essential colors featured in your collage.

#### Extruded "Retro" Cane

In the four samples pictured, analogous color combinations with high value contrast were used to create the canes.

| MATERIALS | |
|---|---|
| | • 5-7 DIFFERENT COLORS OF CLAY (2 OUNCES TOTAL) |
| | • EXTRUDER WITH LARGE, SQUARE DIE |
| | • ³/₄-INCH CIRCLE CUTTER |

**1.** Sheet each of the colors on your pasta machine's thickest setting. Cut out as many circles as possible using a ³/₄-inch circle cutter. Stack the cut circles into a cylinder, press together gently to secure the pieces, then set the cylinder on your work surface and roll gently to reduce the stack until it is the same diameter as the barrel of the extruder.

**2.** Load the stack into the extruder and extrude the clay by turning the handle. Cut the extruded clay into nine equal segments, and combine. Press gently to consolidate into a square log. You have many options for slicing. You can make very thin slices as elements of a laminate or different thickness to create architectural interest.

**1**

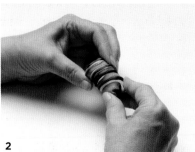

**2**

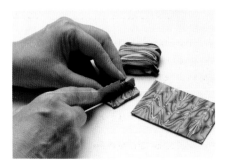

**CUTTING TIGER-ROLL PIECES**

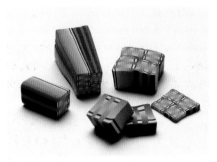

**ZIPPER CANE**

**1**

## Tiger-Roll Cane

Polymer clay canes may be twisted, cut lengthwise, and used to make flat sheets. The tiger-roll cane got its name from the resemblance to the irregular stripes found on a tiger.

**MATERIALS**

- 1 OUNCE OF A LIGHT-VALUE COLOR CLAY (FOR ONE PART OF A TWO-COLOR SKINNER BLEND)
- 1 OUNCE OF A MEDIUM- TO DARK-VALUE COLOR CLAY (FOR SECOND PART OF A TWO-COLOR SKINNER BLEND)
- ½ OUNCE OF A DARK-VALUE COLOR CLAY (TO WRAP YOUR CANE)
- 2 OR 3 WALNUT-SIZE PIECES OF DIFFERENT CONTRASTING COLORS OF CLAY

**1.** Make a two-color Skinner blend (see page 16) using the light-value and the medium- to dark-value colors. Follow the instructions on page 18 to make a wrapped log cane. Set the cane on end. Cut it in half, then realign the pieces into a "butterfly." Fashion snakes of clay out of the walnut-size pieces of the accent colors, and use these to pack the in-between areas. Then gently compact the cane into a log.

**2.** Twist the entire cane lengthwise six times. Flatten this log into a flat rectangle that is half of its original height. Slice this cane across the stripes. You can join the edges of adjacent slices to create mirror images.

## Zipper Cane

Using just stripes in different combinations offers almost unlimited possibilities when making canes. In this variation, the orientation of the lights and darks in the stripes are alternated, creating the illusion of a zipper.

**MATERIALS**

- 1 OUNCE OF A LIGHT-VALUE COLOR CLAY (FOR ONE PART OF A TWO-COLOR SKINNER BLEND)
- 1 OUNCE OF A MEDIUM- TO DARK-VALUE COLOR CLAY (FOR SECOND PART OF A TWO-COLOR SKINNER BLEND)
- ½ OUNCE OF A DARK-VALUE COLOR CLAY (FOR THIN STRIPES ON EDGE OF CANE)
- ½ OUNCE OF A LIGHT-VALUE COLOR CLAY (FOR THICK STRIPE ON EDGE OF CANE)

**1.** Make a two-color Skinner blend (see page 16), and following the instructions on page 19, make an accordion-fold stack about 3 inches deep. Press gently to adhere and remove any air bubbles. Flip the block so that the lightest end is on your work surface. Sheet your dark-value color on your pasta machine's medium setting and place your block on top of this sheet, then trim the edges. Sheet the remaining light color on the machine's thickest setting, and place your block on top of this sheet and trim the edges. Place your block on top of your dark-value sheet and trim the edges. You now have a stacked blended block with three stripes on the lightest end.

2

**LINOLEUM SAMPLES IN THREE DIFFERENT COLOR COMBINATIONS**

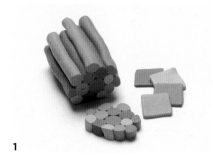

1

2

**2.** Cut the stacked blend at ¼-inch intervals into thick slices. Reassemble by flipping every other slice so that the light stripe alternates throughout the face of the cane. Compress and reduce.

### Voulkos "Linoleum"

This technique is a direct outgrowth of Pier Voulkos's method for conditioning clay. For several design series, rather than using areas of flat color in her millefiori canes and inlays, Pier incorporated areas of activated color. Instead of one golden-yellow, she used five different tints of yellow and little specks of lime-green and orange, adding richness to her color combinations. Best results are obtained when there is contrast between colors.

| MATERIALS | |
|---|---|
| | • FOUR TO SEVEN WALNUT-SIZE PIECES OF PRECONDITIONED CLAY (1–2 OUNCES TOTAL) |
| | • BRAYER OR ACRYLIC ROD |
| | • *OPTIONAL:* PEA-SIZE PIECE OF VERY DARK MUD FOR WATERMELON "SEEDS" |

**1.** Roll each of the colors you have selected (except the dark seed color) into snakes 5 inches long. Bundle them together, roll, and reduce them until they are 10 inches long. Cut the bundle in three and recombine. Roll and reduce until the log is 10 inches long, cut it into four pieces, and recombine. Cut off an end and decide whether you find it pleasing at that scale; if not, continue reducing the pattern.

**2.** Using your brayer or an acrylic rod, roll the outside of the bundle to form a square log. You can use slices as pieces of flat laminate, alternated with another surface technique or decorated (as in this case) by the addition of small seeds fashioned from the dark-mud clay.

### Making Your Box

You can apply clay pieces directly to the box—starting in one area and abutting adjacent pieces until the top and sides are covered. Or you can make a paper template of all the sides you plan to cover and arrange the pieces of clay on the template as a trial run before final application.

Instead of covering all five sides of your box at once in anticipation of one final baking, you may find it easier to first cover only two sides and then bake the box. Allow it to cool before adding the other three sides. If you add elements to an area that has been already been covered with Sobo glue prior to the first baking, there is no need to add more glue. If you are adding elements on top of already baked polymer clay, use liquid polymer clay to make a secure attachment before baking again.

### Evaluate

Once you've arranged your composition and pulled everything together, distance yourself from the piece. Take a walk around the neighborhood. When you return, move the piece 12 feet away to get another perspective, or wait until another

day before you finalize (bake) your piece. Certainly, changes can be made after baking, but things are easier to manipulate and change before.

Ask yourself if the contrasts of saturation, value, and hue are exactly as you hoped they would be when your colors were combined. Or do you need to make adjustments? Are there enough darks? Are the lights representative of the proportions in your collage? Is the composition pleasing to your eye? Or are there certain elements that garner too much attention? Is there a central focal point, or do your eyes move in a pleasing rhythm throughout the piece?

After you have taken your second look, you can opt to:

- LEAVE THINGS JUST AS THEY ARE.
- REMOVE CERTAIN ELEMENTS.
- EXAGGERATE OR MINIMIZE CERTAIN ELEMENTS.
- ADD DEFINITION TO YOUR FOCAL POINT(S).

Sometimes the easiest way to experiment with options is to fashion an element out of clay and gently set it into your composition. Let's say you decide that what might be missing is a spice-note color. Mix small amounts of several unexpected alternatives or variations on colors you've already chosen. Then audition each color, one at a time, by placing three small elements throughout the composition. Does adding the color improve or distract from your piece? Is the balance between concentrated colorful pattern and subtle texture similar to the feel of your collage? Are the placement and proportion of elements similar to your collage, or do changes from your original collage make more sense? And keep in mind that there are dangers in over-thinking a piece.

The balance and overall feel of your final piece is totally up to you. We hope that the discussions, exercises, and projects we've presented in this book have provided you with greater ease and confidence as you make your color choices. Remember to have fun while combining your knowledge and instinct, and enjoy your enhanced confidence in working with color.

## Walking Blade

WHEN CUTTING CURVES THAT will be abutted, we use a technique we call *walking blade*. Lay the two sheets you'll work with on your work surface, and flex your tissue blade (see page 11) into the arch you want to cut. Cut down and set the excess clay aside. Bring your blade back to the cut edge and flex it back to the curve you used when cutting your first piece. While holding that curve, "walk" the blade to the second piece of clay, make your cut, and remove the excess clay. The two pieces will fit together exactly.

**LINDLY HAUNANI.**
*Color inspiration box.* 5 x 5 x 7 inches.
Polymer clay with wooden box base.
For many of the sections, Lindly used "leftover" pieces of clay from the projects in this book. As in her collage, there are lots of diagonals and curved edges.
Photo by Doug Barber

LAURIE MIKA, a California native, did graduate work in art history at San Diego State University. The influence of her extensive travels to Kenya, Ethiopia, India, Nepal, and China can be seen in all her work. Her current focus has been combining her handmade tiles with mosaics, beads, and jewelry to create "contemporary icons." They reflect her interest in Byzantine art, illuminated manuscripts, and Mexican folk art. All these influences also inspire her color choices.

*When it comes to art, I am a color freak. It is color that always draws me in first, before shape or texture. I have had a love affair with color as far back as I can remember. When I was in my early twenties, I thought about going to college to study art restoration, primarily because I loved the romantic idea of touching up old masters' paintings. What appealed to me was the challenge of looking at a color, then mixing other colors to get an exact match. While I never used a color wheel or really studied color theory, my sense of color is an integral part of who I am.*

*I didn't go into art restoration as a career but became an artist instead. Today it is still color that inspires me to create. This love of color has influenced the direction my art has taken into mixed-media mosaics, where I am able to hand-paint my unique palette of tiles. Making my own mosaic tiles allows me to create colors that are not commercially available. When it comes time to finally assemble a piece, I am in color heaven.*

**1.** *Hope Springs Eternal.* 9 x 7 x 2 inches. Polymer clay, jewelry parts, beads, and collage image.
The repetition of squares and rectangles is balanced by the large, focal-point triangles.

**2.** *Waking the Muse.* 18 x 13 x 2 inches. Polymer clay, jewelry parts, and beads.
The three different blues—cobalt, ultramarine, and turquoise—Laurie used provide counterpoint to the darker-value warm colors and help unify the composition.

Photos by Colin Mika

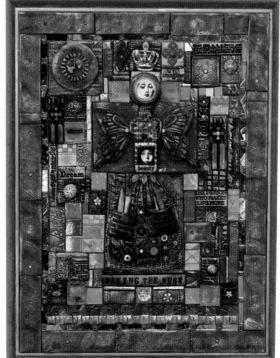

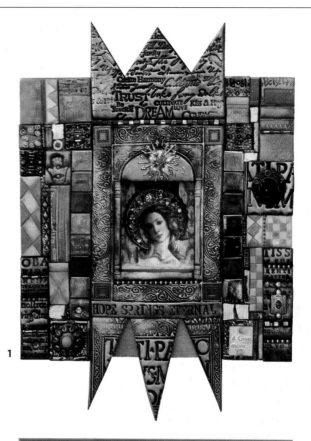

# APPENDIX: Worksheets and Diagrams

**Clay Measuring Templates**

These illustrations provide guidelines for cutting blocks of clay for four brands—Fimo, Studio by Sculpey, Sculpey III, Premo!, and Kato—and indicate what portion of each 2- or 2.8-ounce block makes ½ ounce.

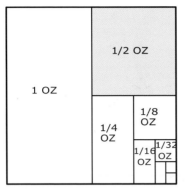

1/2 BLOCK = 1 OZ
1/4 BLOCK = 1/2 OZ
1/8 BLOCK = 1/4 OZ

## FIMO
56 GRAMS - 2 OUNCES

## SCULPEY III
## and PREMO!
56 GRAMS - 2 OUNCES

## KATO
56 GRAMS - 2 OUNCES

2 OUNCE LINE

## STUDIO by SCULPEY
79 GRAMS - 2.8 OUNCES

## Color Sorters

These four illustrations can help you sort colors by hue, value, and saturation while you work on the exercises and projects in this book. For full discussions, see the Classic Color Sorter, page 26; for the Pastel Color Sorter, page 26; for the Value Scale, page 27; and for the Saturation Zones, page 28.

Using a good color copier, copy each page at full-size, then laminate for use in the studio.

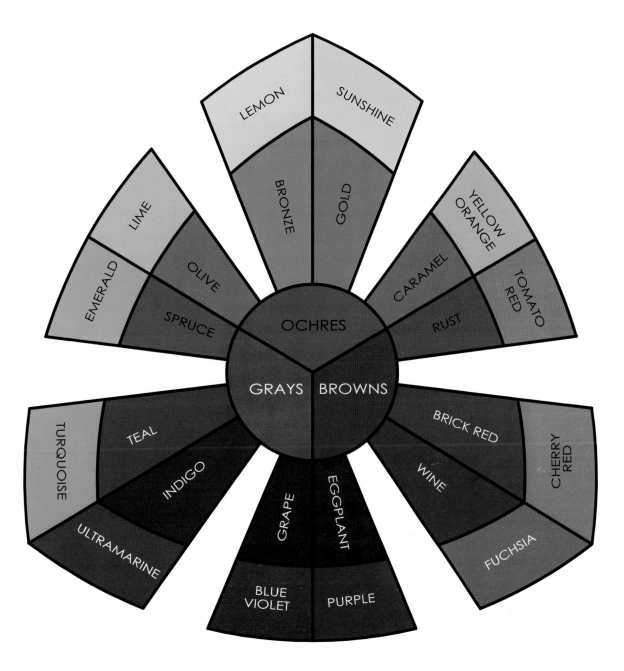

**CLASSIC COLOR SORTER**

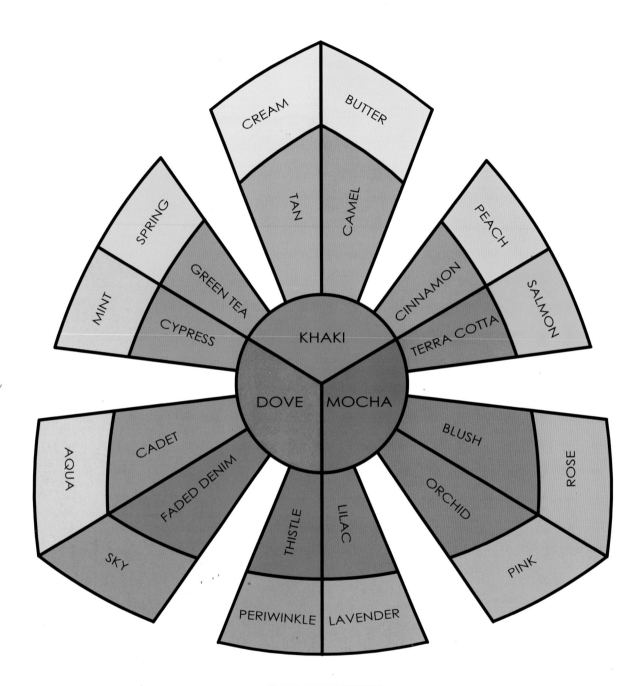

**PASTEL COLOR SORTER**

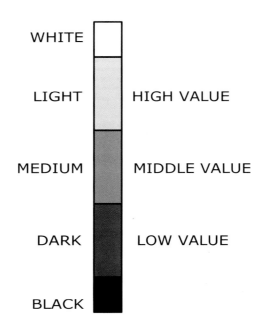

WHITE

LIGHT     HIGH VALUE

MEDIUM     MIDDLE VALUE

DARK     LOW VALUE

BLACK

**VALUE SCALE**

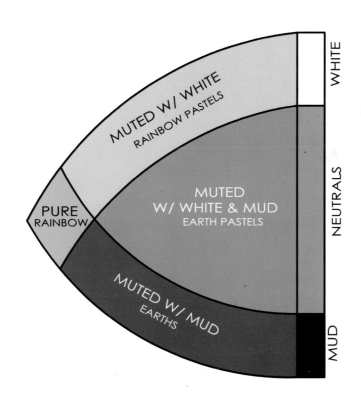

MUTED W/ WHITE
RAINBOW PASTELS

PURE
RAINBOW

MUTED
W/ WHITE & MUD
EARTH PASTELS

MUTED W/ MUD
EARTHS

WHITE

NEUTRALS

MUD

**SATURATION ZONES**

## Color Scales Worksheet

When you mix your first few color scales, using this worksheet is extremely helpful. To best use this diagram as a working tool, copy it at full size and have it laminated. For more on this worksheet, see page 68.

# COLOR SCALES FOR POLYMER CLAY

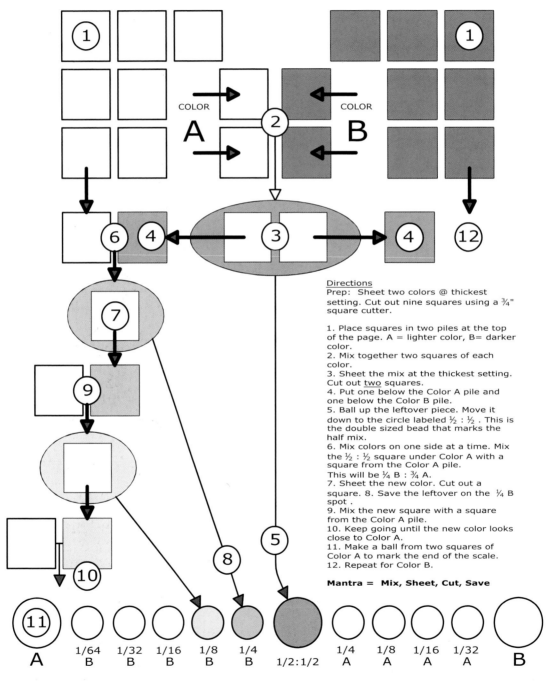

Directions
Prep:  Sheet two colors @ thickest setting. Cut out nine squares using a ¾" square cutter.

1. Place squares in two piles at the top of the page. A = lighter color, B= darker color.
2. Mix together two squares of each color.
3. Sheet the mix at the thickest setting. Cut out two squares.
4. Put one below the Color A pile and one below the Color B pile.
5. Ball up the leftover piece. Move it down to the circle labeled ½ : ½ . This is the double sized bead that marks the half mix.
6. Mix colors on one side at a time. Mix the ½ : ½ square under Color A with a square from the Color A pile.
This will be ¼ B : ¾ A.
7. Sheet the new color. Cut out a square. 8. Save the leftover on the ¼ B spot .
9. Mix the new square with a square from the Color A pile.
10. Keep going until the new color looks close to Color A.
11. Make a ball from two squares of Color A to mark the end of the scale.
12. Repeat for Color B.

**Mantra =  Mix, Sheet, Cut, Save**

## Color Triangle Worksheet

Copy the worksheet at full size, then use it to help keep track of the seven color scales as you mix your color triangle. You can even bake the beads on this paper, then string them after baking. For more on this worksheet, see page 72.

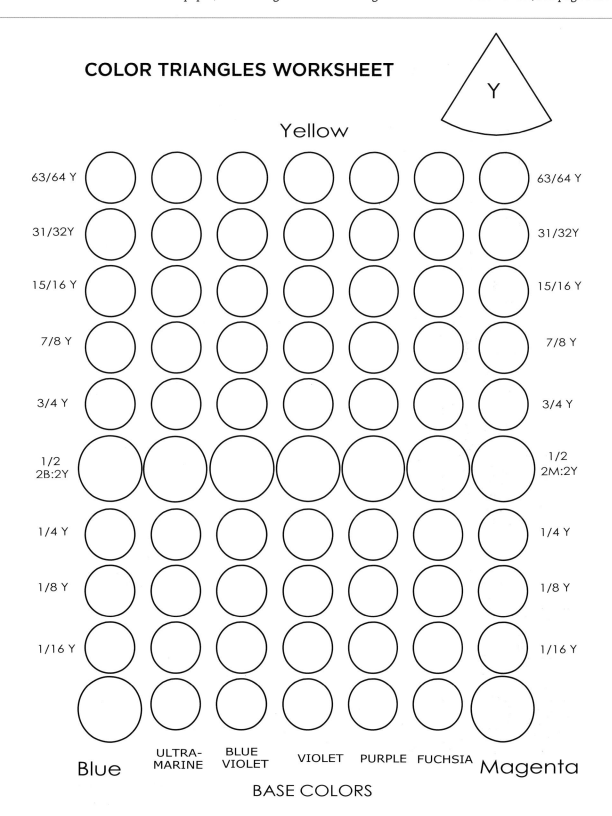

**COLOR TRIANGLES WORKSHEET**

## Polymer Primaries and Secondaries Chart

Each polymer clay manufacturer makes a variety of primary and secondary colors in polymer clay. This chart shows the hue bias, pigment strength, and darkening info for Premo Sculpey, Sculpey III, Studio by Sculpey, Fimo Classic, Fimo Soft, and Kato brand primary and secondary colors that are currently on the market.

The hue bias is shown by the location of the package colors around the color sorter. For example, Premo's cobalt-blue is shown close to the point in the blue section of the triangle because it doesn't contain much yellow or magenta. Premo's turquoise is shown closer to green because it is biased with some yellow, and Premo's ultramarine is shown closer to violet because it is biased with some magenta. Knowing the bias of the package colors will help you select the right clays to mix for the colors you want to use in a project.

The pigment strength of each of the package colors shown on the chart was identified by making test-mix samples as described in Chapter Two (see page 31). Knowing the pigment strength will help you decide on proportions to start with when mixing new colors. For example, if a clay has high pigment strength, you will not need to use as much of it when mixing it with other colors. The chart shows a plus sign (+) if the pigment strength is high, a minus sign (-) if the pigment strength is low.

Most clays darken slightly during baking. To determine which clays darken most noticeably, the text-mix samples were baked and then compared to the same colors of unbaked clay. The clays that darken the most are indicated by a (d) after their name on the chart. You may want to add a small amount of white to these colors to offset the darkening. The amount to add depends on the clay brand. We suggest you start by adding 1/16 part of white and baking a test-mix sample.

## POLYMER PRIMARIES AND SECONDARIES CHART

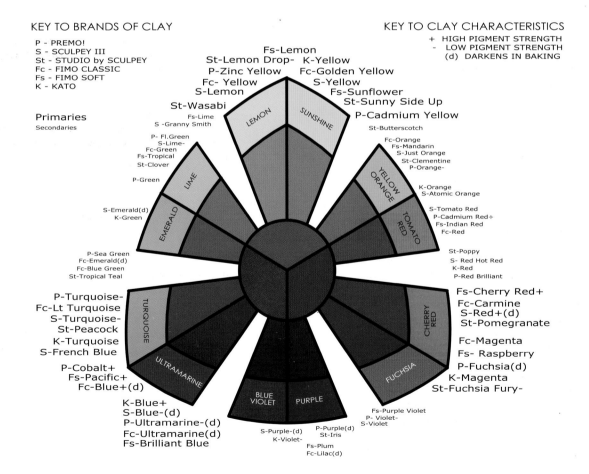

KEY TO BRANDS OF CLAY

P - PREMO!
S - SCULPEY III
St - STUDIO by SCULPEY
Fc - FIMO CLASSIC
Fs - FIMO SOFT
K - KATO

Primaries
Secondaries

KEY TO CLAY CHARACTERISTICS
+ HIGH PIGMENT STRENGTH
- LOW PIGMENT STRENGTH
(d) DARKENS IN BAKING

# RESOURCES

Polymer clay's popularity as an artistic medium has grown exponentially over the past twenty years. Its increase in popularity has been paralleled by the growing acceptance of the Internet as a communication and research tool. Many of the early mavens in the field were quick to adopt this technology as a way of sharing information with other artists. A quick Web search for "polymer clay" will reveal that, if you include personal websites, online tutorials, blogs, Twitter, news groups, and photo-sharing sites, there are thousands of resources out there. Here are a few of our favorites.

## Information of General Interest to Polymer Clay Artists

### ARTREPENEUR
www.judydunn.blogspot.com
Judy Dunn's subject is the business of craft from a polymer clay artist's point of view. The site provides links to craft business resources.

### INTERNATIONAL POLYMER CLAY GUILD
www.npcg.org
News, events, local guild information, and links to members' websites.

### POLYMER ART ARCHIVE
www.polymerartarchive.com
Elise Winters provides historical documentation of polymer clay as an artistic medium.

### POLYMER CLAY DAILY
www.polymerclaydaily.com
Cynthia Tinapple's blog offers daily posts about the work of polymer clay artists, including trends and developments from around the world, tempered by her discerning eye for good design.

### POLYMER CLAY WORKSHOPS
www.polymerclayworkshops.com
Barbara Forbes Lyons features a nationwide listing of polymer clay workshops.

## Websites That Feature Polymer Clay Encyclopedias

### ELVENWORK TIPS AND TECHNIQUES
www.elvenwork.com/tips.html
Katherine Dewey provides observations, hints, and tips for sculpting with polymer clay gleaned from her decades of experience.

### GLASS ATTIC
www.glassattic.com
Currently this site, hosted by Diane Black, includes a polymer clay encyclopedia organized into ninety different categories.

### POLYMER CLAY CENTRAL
www.polymerclaycentral.com
Hosted by Leigh Ross, this site offers online tutorials, monthly polymer clay swap opportunities, contests, and several "live" chat rooms.

## Online Color Inspirations

Thousands of websites offer information about color, commentary on color trends, inspirations, tips for picking paint colors for your home, and interactive quizzes, troubleshooters, and games. Many are specifically designed to inform graphic designers who are composing color schemes for viewing on the Web.

### CLOFORD.COM
www.cloford.com
On its "500+ Colours" page, this site lists more than 500 colors by name and includes their hex color codes (mathematical formulas to help Web designers specify a color).

### COLOURLOVERS
www.colourlovers.com
Color trends, and palettes, and several online chat forums for graphic artists working with color. With more than 150,000 registered users, this is an active and interesting site.

### GURNEY JOURNEY
www.gurneyjourney.blogspot.com
Each Sunday the focus of James Gurney's thoughtful blog posts is the study and interaction of color, as inspired by his current illustration work or his student's questions.

### KRIS'S COLOR STRIPES
www.color-stripes.blogspot.com
Online color diary by an Italian fashion designer.

### PANTONE ONLINE
Pantone.com
Color forecasting and color swatch decks.

### SENSATIONAL COLOR
www.sensationalcolor.com
Kate Smith hosts this site featuring book reviews, design trends, a resource guide, and color news from the perspective of fashion, interior design, and business.

## Design Inspirations

The expression "The world is your oyster" is particularly applicable to searching the Web for design inspiration. Here are a few of our favorite design sites.

### APARTMENT THERAPY
www.apartmenttherapy.com
Color and other trends in decorating and design.

### DAILY ART MUSE
www.dailyartmuse.com
Talented polymer clay artist Susan Lomuto, drawing inspiration from different media, provides three or four daily posts.

### THE CARROTBOX
www.thecarrotbox.com
Great source of jewelry design inspiration (mostly rings).

## Magazines

As evidenced from the Color Inspiration Collage exercises in this book, full-color magazines and their pictures are wonderful sources of inspiration. Here are a few of our favorite magazines that focus on jewelry design and wearable art.

### AMERICAN CRAFT
The magazine of the American Craft Council. Reviews and news of gallery and museum shows, artist profiles, historical commentary, and design inspiration from all contemporary craft media.
www.americancraftmag.org

### ART JEWELRY
In-depth how-to articles that include glass, PMC, metal, and polymer clay jewelry projects.
www.artjewelrymag.com

### BEAD & BUTTON
Projects, design ideas, and tips for beaders, with some polymer clay projects.
www.beadandbutton.com

### BEADWORK
This magazine's emphasis is on the use of glass seed beads; it features projects, resources, and finishing ideas.
www.interweave.com

### BELLE ARMOIRE
With a title that's French for "beautiful wardrobe," this magazine marries fabric arts with rubber stamping and embellishments that include polymer clay.
www.bellearmoire.com

### THE CRAFTS REPORT
The business of craft, including marketing, craft booth design, photography, and accounting.
www.craftsreport.com

### ORNAMENT
Wearable art, including beads, artist profiles, history, contemporary work, and reviews of museum shows. A wonderful magazine.
www.ornamentmagazine.com

### POLYMERCAFE
Projects, products, and news about polymer clay.
www.polymercafe.com

## Tools and Supplies

The manufacturers of the tools and materials mentioned in this book will answer questions about their products and can direct you to the nearest retailers.

### FIMO POLYMER CLAY
www.eberhardfaber.com
Fimo Classic, Fimo Soft, and Fimo Decorating Gel (liquid polymer clay).

### KATO POLYCLAY
www.vanaken.com
Kato Polyclay, Kato Polyclay Repel Gel, Kato Polyclay Color Concentrates, and Kato Liquid Polyclay.

### KEMPER ENTERPRISES
www.kempertools.com
Shape cutters and ceramic tools.

### POLYFORM PRODUCTS
www.sculpey.com
Studio by Sculpey, Sculpey III, Premo Sculpey, and Translucent Liquid Sculpey (TLS).

### PRISMS
www.xump.com
This site sells inexpensive plastic and glass prisms.

# CONTRIBUTORS

Many of the contributing artists in this book have websites and blogs that offer insight into their design processes and color choices. Some of these sites, through archived posts and images of the artists' past work, serve as documentation of the evolution of their awareness of color as an important element in their work.

Cristina Almeida
Queijas, Portugal
www.kreatworld.blogspot.com

Gloria Askin
Baltimore, Maryland
www.gloriaaskin.com

Meisha Barbee
San Diego, California
barbeemk@yahoo.com

Jana Roberts Benzon
Salt Lake City, Utah
www.janarobertsbenzon.com

Merrie Buchsbaum
Cromwell, Connecticut
www.merrilymade.com

Rachel Carren
Chevy Chase, Maryland
rachel.carren@verizon.net

Dan Cormier
Sooke, British Columbia, Canada
www.dancormier.ca

Louise Fischer Cozzi
Brooklyn, New York
www.louisefischercozzi.com

Jeffrey Lloyd Dever
Laurel, Maryland
www.deverdesigns.com

Debra DeWolff
Shorewood, Wisconsin
debradewolff.wordpress.com

Dayle Doroshow
Fort Bragg, California
www.dayledoroshow.com

Judy Dunn
Acton, Massachusetts
Moms-studio.com
www.judydunn.blogspot.com

Kathleen Dustin
Contoocook, New Hampshire
www.kathleendustin.com
www.kathleendustin.blogspot.com

Dorothy Greynolds
Waterford, Michigan
claywear@yahoo.com
www.picturetrail.com/dgreynolds

Lindly Haunani
Cabin John, Maryland
www.lindlyhaunani.com
www.lindly.wordpress.com

Ginny Henley
Keller, Texas
www.ginnyhenley.com

Loretta Lam
Carmel, New York
www.lorettalam.com

Maggie Maggio
Portland, Oregon
www.maggiemaggio.com

Sandra McCaw
Westborough, Massachusetts
www.sandramccaw.com

Laurie Mika
Encinitas, California
www.mikaarts.com

Julie Picarello
El Dorado, California
www.yhdesigns.com

Margaret Regan
Helena, Montana
www.mregan.com

Rita Sharon
Washington, DC
ritasharon8@cs.com

Sarah Shriver
San Rafael, California
www.sarashriver.com

Ponsawan Sila
Indianapolis, Indiana
www.silastones.blogspot.com

Rita Sim
Singapore
www.photoplus.ws/polymerclay

Carol Simmons
Fort Collins, Colorado
carolsimmonsdesigns.com

Laura Tabakman
Pittsburgh, Pennsylvania
www.lauratabakman.com

Cynthia Toops
Seattle, Washington
www.home.earthlink.net/~cdbeads

Christelle van Lingen
Troy, Ohio
www.karooart-designs.com

Pier Voulkos
Oakland, California

Adam Vural
Fayetteville, New York
monetsgardendesigns@yahoo.com

Melanie West
Freedom, Maine
www.melanieweststudio.com

Elise Winters
Haworth, New Jersey
www.elisewinters.com

Naama Zamir
Zichron Yaacov, Israel
www.naamaza.com

# PHOTO CREDITS

# INDEX